Curating beyond
the Mainstream

Curating beyond
the Mainstream

The Practices of Carlos Capelán,
Elisabet Haglund, Gunilla Lundahl,
and Jan-Erik Lundström

Edited by CuratorLab 2020/21

Konstfack University of Arts, Crafts and Design, Stockholm

Anna Mikaela Ekstrand, Giulia Floris, Vasco Forconi, Edy Fung, Julius Lehmann,

Maria Lind, Marc Navarro, Simina Neagu, Hanna Nordell, Marja Rautaharju,

Erik Sandberg, and Joanna Warsza

THE GLASS OPENS WORLDS
Elisabet Haglund's Curatorial Work at Kulturhuset, 1986–95
Marc Navarro, Hanna Nordell, and Erik Sandberg

INVASION AND DISPERSION
Tracing the Curatorial Trajectory of the Artist Carlos Capelán
Giulia Floris, Edy Fung, and Hanna Nordell

MUSEUM IS A VERB
Mapping Jan-Erik Lundström's Curatorial Work, 1980s–Present

Edy Fung, Simina Neagu, and Erik Sandberg

Introduction

Maria Lind

Curating contemporary art is a young field, particularly in Sweden. The country's first professional curating course, CuratorLab at Konstfack, launched in 1999. However, there was certainly a lot of curating going on before that. The lead characters in this book—Carlos Capelán, Elisabet Haglund, Gunilla Lundahl, and Jan-Erik Lundström—each made significant and radically distinct contributions to the field, both within and beyond established institutions, from the 1960s until today. In various ways, their work resonates with the concerns of contemporary curating and visual art as a whole, for example: dialogical and collective methodologies, transdisciplinary approaches, facilitating art beyond the white cube, and issues of gender and decoloniality. For all their diversity, they share a non-hegemonic approach to both art and curating. Another thing they have in common is that they are forerunners of sorts, yet—so far—their achievements and impact have not received the attention they deserve. Hopefully this publication will do something to change that.

Through these four case studies, *Curating beyond the Mainstream* foregrounds some of the country's most inventive, experimental, critical, and affirmative curatorial practices. Capelán, Haglund, Lundahl, and Lundström made their mark at major institutions such as Kulturhuset and Arkitekturmuseet in Stockholm, Borås Konstmuseum, and Bildmuseet in Umeå, but also through exhibitions on trains and in parks in different parts of Sweden. The importance to the curatorial process of writing and publishing often comes across in their work. They were forerunners of what is today called "social practice," and of decolonial methods and concerns, embracing art and artists from all parts of the world, far beyond the NATO territory which for decades was mistaken for "international." This book highlights their under-researched work through extensive interviews, presentations and essays, accompanied by unique photographic documentation and an intriguing mind map.

Each of the book's four chapters is devoted to the work of a single curator and focuses on specific projects, periods, or themes in their practice rather than the individuals behind them, moving the spotlight away from the curator as hero or celebrity. It has instead been important to account for the context in which these projects took place and to look at the significant factors influencing them. The Covid-19 pandemic limited the scope for archival research but this was compensated by numerous Zoom conversations and

the generosity of the four protagonists in sharing their time and their materials with us. The chapters can be considered curated projects in and of themselves, taking place on the printed page rather than in physical space. The projects and people they profile shape the discussion, allowing the voices of the curators, those of some of their colleagues, and the artists they worked with, to be heard. Hence the chapters are individual and "situated." The research and the curating of each chapter were conducted by four groups of participants in the CuratorLab course 2020–21, under the guidance of course leader Joanna Warsza, course assistant Vasco Forconi, and myself as a guest lecturer. A "sister publication" which came out of the same course, *Assuming Asymmetries: Conversations on Curating Public Art in the 1980s and 1990s,* was edited by the very same course participants with an introduction by Warsza.

Curating beyond the Mainstream kicks off with Gunilla Lundahl's multifaceted and truly transdisciplinary practice, which is situated rather than institutional. It spans sixty years of curating, writing, editing and organizing across art, architecture, craft, design and pedagogy. And still ongoing—Lundahl recently co-curated a project on bread and baking as well as one on the work of animator Lilian Lindblad Domec. Anna Mikaela Ekstrand, Julius Lehmann, Marc Navarro, and Marja Rautaharju present her involvement in contemporary classics such as "Modellen—En modell för ett kvalitativt samhälle" ("The Model—A Model for a Qualitative Society") at Stockholm's Moderna Museet in 1968, and "ARARAT" at the same museum in 1976, next to lesser known exhibitions such as "Himla skönt!" with Riksutställningar (the Swedish Exhibition Agency) on a train in 1989–90 and "Kvinnorum: Porträtt av arkitekter" at Arkitekturmuseet in 1991–92. "Kvinnorum" was one of the first exhibitions world-wide to foreground women architects, proposing an alternative definition of quality in architecture. This chapter, entitled "Collective Projects: Gunilla Lundahl's Feminist Approaches to Art and Architecture," also highlights Lundahl's influential writing in the design magazine *FORM,* over nearly thirty years, which among other things addresses communal housing, graduate exhibitions at design schools, and consumer trends.

Interweaving art historical research with an interest in art and culture beyond the Western hemisphere and its traditional artistic hierarchies, Elisabet Haglund's refreshing approach to curating during her nine year tenure at Stockholm's Kulturhuset (1986–95) is the focus of this book's second chapter. From its conception in 1974, Kulturhuset set out to provide the urban center of the capital with non-commercial culture, occupying an experimental building with a glass facade next door to the parliament. As a professional embedded in this context and working as part of a team whose members moved between different

roles, Haglund chose to explore indigenous art, comics, and craft over the reproduction of mainstream narratives. She presented a local interpretation of the problematization of the global art system similar to those that animated groundbreaking large-scale international shows such as the Bienal de Habana, and the exhibition "Magiciens de la Terre." The projects she worked on were "viva BRASIL viva," "Änglarnas demon," and "Möt Indien: Folklig konst." There were also smaller projects such as "José Bedia och Carlos Capelán: Resa i Sverige" and "6 konstnärer från Katalonien." Marc Navarro, Hanna Nordell, and Erik Sandberg describe how Haglund's time at Kulturhuset overlapped with the rapid development of globalization and its impact on the conditions for showing art in a municipal house of culture, working within, and sometimes around, the broad guidelines laid down by local politicians, funding policies, and public diplomacy, while pursuing her aspirations as a curator closely involved with artists.

In the middle of the 1990s, Carlos Capelán was one of the Sweden-based artists who most frequently exhibited overseas as part of the emerging global art scene. Capelán's interest in the fluidity of categories, in rearticulating the art institution while thinking through dichotomies such as center-periphery and inversion-dispersion, the structure of exhibitions and what can be included in them, led him to also take on the role of curator. In the third chapter of this book, Giulia Floris, Edy Fung, and Hanna Nordell discuss how, as part of his artistic practice, Capelán curated major museum projects, such as "This Is Where Blanes Viale Dreamt: An Exhibition by Pablo Uribe" at the National Museum of Visual Arts, Montevideo, and co-curated the Uruguayan pavilion at the Venice Biennale in 2013, "Time [Time] Time," showing the work of Wilfredo Diaz Valdez in the pavilion. However, he has not shied away from smaller initiatives, curating a series of international exhibitions at Lund's Café Ariman in the 1980s, for example. "Five Gardens" in Simrishamn and Ystad in 1995 took the notion of "the garden" as a starting point, and spread out from a municipal art center into the public space of Scania. In 1997, together with Elisabet Haglund, then director of Borås Konstmuseum, he brought the work of influential artists such as Xu Bing, Jimmie Durham, Chohreh Feyzdjou, Gülsün Karamustafa, and Nedko Solakov to Sweden for the first time.

In the fourth and final chapter, Edy Fung, Erik Sandberg, and Simina Neagu ask how a museum can be a verb. Mapping Jan-Erik Lundström's route through the territories of art, critical theory, and curating, they reveal a practice where the museum becomes a site of ongoing inquiry and activity. The editors pick up on Lundström's longstanding interest in critical cartography, manifest in numerous curated projects. In the extensive interview which makes up the core of the chapter, we also learn about Lundström's

firm grounding in the practice and theory of photography, as played out during his directorship at Fotografiska Museet (then part of Moderna Museet) in the 1990s. Solo presentations there by Lewis DeSoto, a North American artist of Cauhilla heritage, and Pia Arke, whose work addresses the effects of colonialism on her native Greenland, exemplify his early curatorial undermining of received norms and value systems, as do the exhibitions highlighting a new postmodern generation of photo-based artists in Sweden, mostly women. His experience from curating biennials in Tirana, Prague, Bucharest, and Thessaloniki in the 2000s is underscored, alongside his long-standing engagement with Sámi artists, and his directorship of the Sami Center for Contemporary Art in Kárášjohka/Karasjok. During his time as the director of Bildmuseet in Umeå, he and the team staged exhibitions such as "Cosmos" with Britta Marakatt Labba (2009), "Contemporary Arab Representations: The Iraqi Equation" (2006), "Mirror's Edge" (1999), and "Democracy's Images: Photography and Visual Arts after Apartheid" (1998), testifying to a planetary connectedness rare in Sweden.

At a moment in time when facts are increasingly being neglected and/or defied, whether for political reasons or because of romantic ideas of free-floating existence with no need for any anchors, it is ever more important to acknowledge those who came before us. This goes hand in hand with the decolonial turn in cultural production which, in essence, is precisely about acknowledging—referencing, quoting, and crediting—suppressed knowledge, experience, achievements, and people on whose work ours often depends. But it is equally necessary to do the same in relation to those who surround us right now, in other geographies, contexts and situations, signaling other ways of thinking and acting in the world. This can serve as a useful reminder of how much magnificent curating has already been done, and that is continuously happening, at the same time that it helps us avoid constantly—and tediously—reinventing the wheel.

The curatorial projects discussed in *Curating beyond the Mainstream* and the methodologies of the people behind them have yet to be processed by the dominant modes of academic art history writing. In parallel to this, the major art institutions are themselves engaged in writing their own less formal but still influential history of art and curating. They have tended to look only at what went on within their own walls or with the other big institutional players. There is an increasing awareness of the importance of exhibitions as a vehicle for making art public, and hence the necessity of making them part of history in their own right. Nonetheless, experimental curated projects that cannot be described as mainstream but which develop new methodologies, tend to be overlooked. These projects do not fit squarely into an existing canon. What if we were to change our point of view

and look at them through a different, less mainstream, lens? This would be analogous to the Gall-Peters projection's world map and its challenge to the Mercator projection which are discussed in the chapter on Lundström's curatorial work. Whereas Mercator's map privileges areas closer to the North Pole, such as Sweden, making them appear larger than in reality, the Gall-Peters gives us the correct size of all areas relative to each other, accurately representing Africa as fourteen times bigger than Greenland, rather than equal in size, as it is in Mercator's version. While the resulting map might be perceived as too complex and therefore less attractive, it might help us to set things in a more correct, precise, and appropriate curatorial perspective, too.

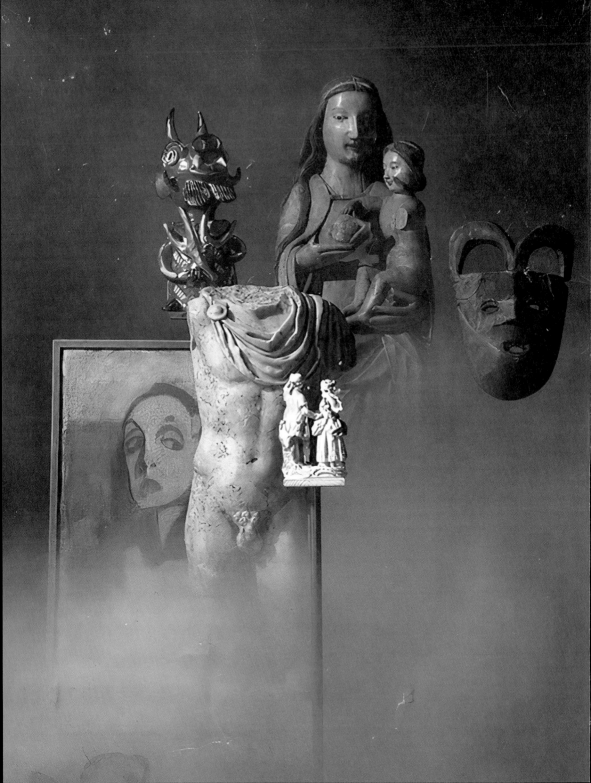

COLLECTIVE PROJECTS
Gunilla Lundahl's Feminist Art and Architecture

Anna Mikaela Ekstrand, Julius Lehmann, Marc Navarro, and Marja Rautaharju

With "Himla skönt" Gunilla Lundahl proposed a model of coexistence for objects from disparate cultural contexts and eras, such as a rococo figurine, a classical sculpture, a wooden madonna, and a self-portrait by painter Helene Schjerfbeck. Photo: Olof Wallgren/Riksutställningar

Introduction

Driven by the belief that communities can come together to design a better world, Gunilla Lundahl (b. 1936) and her professional trajectory are unclassifiable in contemporary institutional terms. Her inter-disciplinary practice as author, editor, and organizer spans several decades and encompasses art, architecture, pedagogy, craft, and design. Revisiting some of Lundahl's key organizational roles, this chapter portrays an engaged, dialogical, and collective practice. We explore her role in developing Adelyne Cross-Eriksson's pedagogical project, Levande Verkstad (Living Workshop); her work with the decentralized group Aktion Samtal (Action Dialogue); and her curation of three major exhibitions: "Modellen— En modell för ett kvalitativt samhälle" (The Model—A Model for a Qualitative Society, 1968); "ARARAT" (1976); "Himla skönt. Vad är egentligen vackert?" (Beautiful! But What Does Beautiful Mean?, 1989–90); and "Kvinnorum, Porträtt av arkitekter" (Female Space, Portraits of Architects, 1991–92). Moving between childhood and adulthood, Lundahl's pedagogy sometimes blurs their boundaries but is always devoted to questions of social justice, freedom, and beauty.

A versatile practitioner for whom collective process and intuitive learning are generally prioritized, we recognize Lundahl as a contributor to, organizer of, and innovator in shared feminist undertakings with a hybrid approach. In most of her activity she developed and drew on multidisciplinary networks and viewpoints. She was one of the initiators of the innovative playground exhibition "Modellen," realized together with artist Palle Nielsen and a group of students, and had an important role as editor in the exhibition and research project "ARARAT," which is now seen as a key moment of alternative architecture in Sweden. However, as a curator and organizer she has been largely overlooked in the research literature.[1] There are several reasons for her exclusion: she was a woman working in male-dominated social hierarchies; and, her practice was not anchored within institutions and their theoretical framework. As a critic she did not write about her own work and due to its collective nature, her impact is often invisible in the archives.

Hailing from the north of Sweden, a town called Byske, Lundahl consistently returns to the region by highlighting its craft, industry, and indigenous population in her design criticism and curatorial work. Her deep-seated disillusionment with the nuclear family and openness toward intuition and alternative pedagogy can be traced to her childhood: during her early formative years she did not attend school, instead, she spent her days exploring the forest landscape. Despite her unorthodox upbringing she participated in the

upper echelons of the Swedish cultural and policy sector. Thus, she had a strong foundation from which to develop and disseminate non-traditional ways of living and thinking, with consideration for all social classes, age-groups, and genders.

Situated rather than institutional, Lundahl's projects are reliant on her own political positions and personal engagements. Her first employment was in 1955 with the syndicalist magazine *Arbetaren*. Later she became an active member of Hyresgästföreningen ('Tenants' Association), a membership organization for renters, and Vänsterpartiet kommunisterna (Communist Party of Sweden/Left Party—the Communists) which influenced her writing. Lundahl worked predominantly as a design critic, her most longstanding position was as an editor for *FORM*, a non-profit publication run by Svenska Slöjdföreningen (The Swedish Society of Crafts and Design). At *FORM* she helped develop the pedagogical program, Levande Verkstad, its Bauhaus-inspired methodology focusing on intuition shaped her social practice projects. Lundahl contributed to many other publications as a freelance writer, including the architecture publication *Arkitektur* from the 1960s to 1990s. For her empathetic, engaged, and versatile work as an architecture journalist she received the Swedish Association of Architect's critic prize in 1993. To date there has been little research tracing the development of Lundahl's writing in the context of her exhibition-making, organizing, and participation in associations—all of which were intertwined, as this chapter shows.

Lundahl's work in Stockholm in the 1960s is an important precursor to what we today call social practice. Founded in 1968 Aktion Samtal, of which Lundahl was an active member, was an urban action group that aimed to empower city-dwellers—mainly children—to become agents in their social environment. In a 1968 commission by the city for Barnens Dag (Children's Day) they transformed a central park in Stockholm into a construction site or workshop for children, one of several urban actions. Later that year Lundahl, together with artist Palle Nielsen, brought a similar concept to Moderna Museet. The show "Modellen" ignored social and material hierarchies by encouraging children to alter their environment and allowing them to play in it—dressing up, painting, and moving freely around the museum space. Traces of Levande Verkstad's Bauhaus-inspired methodologies relying on intuition clearly emerge in the curatorial framework of both projects. Identifying Lundahl as an organizer allows a deeper engagement with her methodology.

"Intuiting Radical Change: Gunilla Lundahl's Writing, Organizing, and Communal Life, 1960s–80s" connects her critical, and curatorial practice with her lifestyle choices—all of which were equally original and subversive in their time. For example, in the 1960s Lundahl

moved into collective housing with her toddler daughter and she increasingly praised this mode of living in *FORM*. In 1976, she became one of the founding members of the all-female research group Bo i Gemenskap (BIG) (Living in Community) that convened around the practice of communal living. Although they never managed to realize their dream of creating their own communal housing complex, they published two books on collective housing in the 1980s. A private person, Lundahl did not advertise these affiliations in her writing for *FORM*, however; her choice of subject matter, collaborative partners, and visionary, often utopian, positions within her design criticism are clearly linked to her leftist ideals, many of which were popular undercurrents in Swedish society at the time.

In "Det växer i Skellefteå. Men hur?" (Skellefteå is Growing. But How?, 1972), Lundahl critically approached the process of urban expansion in Skellefteå, a city predominantly nourished by its mining and forestry industry in the north of Sweden. With a deep understanding of the social and material culture—economics, indigenous communities, handicrafts, and daily life—she transformed a governmental commission, into a critique of the abstract ideas that usually drive urbanism. Ideas that very often have nothing to do with the reality of places, and the specific needs of their population. Lundahl engaged with informal communities, temporarily established around the possibility of an exhibition, as an attempt to break rigid logics of showing and displaying while observing processes taking place beyond the museum. Although "Det växer i Skellefteå. Men hur?" is not one of our chosen case studies it is necessary to mention as an example, like "Modellen," of Lundahl's practice and its foundation in an architectural and urban critique where democratic participation is a requirement, guiding the project's conceptualization and presentation.

Lundahl's wide networks and her commitment to social and environmental issues lead her to work in a variety of roles in alternative exhibition processes. A formative experience was her participation in the unusual experimental exhibition project "ARARAT" (Alternative Research in Architecture, Resources, Art and Technology), which opened at Moderna Museet in 1976. During its run from April to July, the show transcended and literally dissolved the boundaries of the institution. The exhibition extended from the museum's interior to the outdoor spaces around the building and manifested itself as an open collective process involving a diverse and permanently growing network of people from a wide range of backgrounds. Her own contribution to this hybrid project, presented later in the same year in the Nordic Pavillion at the Venice Art Biennale, was the publication of the humble yet programmatic accompanying brochures printed on recycled paper. The issues are dedicated to various fields of ecological knowledge, for example, human ecology (Vol. 1 and 2), and the "elements" of sun, earth, water, and air. Based on email correspondence with

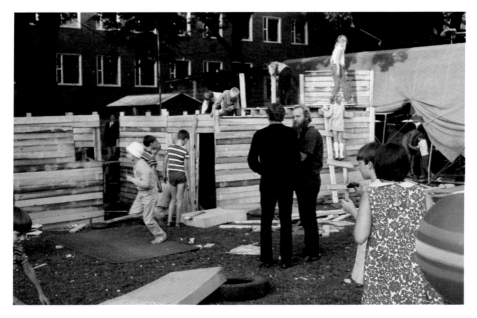

The urban action group Aktion Samtal (Action Dialogue), of which Gunilla Lundahl was a member, organized Barnens dag (Children's Day) an event sponsored by the city of Stockholm in 1968. The event was well received by both press and participants; however, it outraged city officials. Film still from *Aktivering Samtal* (2020). Courtesy of Mats Eriksson Dunér

Gunilla Lundahl "ARARAT" is examined as a training ground for utopian thought and as a model for transdisciplinary collaboration in the museum context.

Plurality is present throughout Lundahl's work, when the Swedish Railroad Company offered a train to Riksutställningar, the national Swedish exhibition agency, Lundahl was invited to organize its travelling exhibition. Including a wide range of artworks and material culture of diverse provenance, different styles and historical moments, Lundahl designed a show dealing with the ambivalence of beauty. On one hand, beauty seems to be addressed only by specialists, but on the other hand, everyone has a personal conception of what is beautiful and what is not. The exhibition was conceived as a place for discussion where the public was able to confront plural definitions of beauty. The objects were arranged in such a way as to force overlaps and frictions. Lundahl's innovative curation is equally present in "Himla skönt" where curatorial imagination becomes deconstructive strategy. On one hand, she subverts the idea of a "national collection" and transforms it into something sensuous and anti-academic, and on the other, she estranges the idea of beauty and questions its normativity.

Authorship emerges as a topic that historians interested in Lundahl's organizing, or curatorial practice must tackle. Her processes include multiple voices and collective decision-making; she seems to refuse the notion of authorities, and even of authorship itself. She explained that the idea of "Himla skönt" was shaped only after having multiple conversations with Stefan Ahlenius, the architect of the exhibition. Should we, then, refer to her practice as conversational, a process in which discussion and a multiplicity of voices is decisive and essential? If so, it is also relevant that her projects gave an opportunity to non-specialized practitioners to articulate some issues intuitively, outside of academic and official discourse.

This is most clear in "Himla skönt" where the objects on display invite the audience to reconsider their assumptions about the representation of gender—specifically as regards feminine and masculine beauty. The masculine emerges as dark and aggressive, imaged in the form of threatening animals and objects associated with war, while the is feminine appears in a celestial room and is represented by a bridal dress, flower arrangements, and a mirror, implying the role of women. These are direct and bold representations of femininity and masculinity as social roles and they are staged in relation to art history via the national art collection. Yet, by intuitively presenting these gendered scenarios juxtaposed with visual markers of power a counter-narrative questioning normativity in collecting, consumption, and society emerges.

Questions of femininity were explored further in "Kvinnorum," a show curated by Lundahl and dedicated to pioneering contemporary female architects in Sweden. In the chapter "A Gendered Space for Reviewing Quality in Architecture" we explore this early instance of gender-aware curating in the architectural field. Lundahl organized the show in 1991 during her one-year position at Stockholm's Arkitekturmuseet (Museum of Architecture), transforming its exhibition hall into a feminist and pluralist space by flouting the unwritten rules of the architecture show. Consciously asserting a gendered space generated alternative definitions of quality in architecture, in the process attracting harsh criticism from Sweden's leading architecture magazine. Lundahl's aim was to show off the versatility of women architects and the excellence of their work, while stressing the public museum's task of presenting it to a wider audience than architecture professionals alone.

All along her professional trajectory, Lundahl has consistently made women visible by considering their experiences and needs within a decolonial framework. At odds with the contemporary CV-driven curatorial career, she continues to make intriguing contributions that traverse different fields. Bringing visibility to aging, at Konsthall C, a non-profit art

center in Stockholm, Lundahl worked on a project about the artist Lilian Lindblad Dome which involved Swedish Hemtjänst—a national health service that provides support to the elderly in their homes At Konsthall C Lundahl also initiated Brödmassan (Bread Mass), a series of public bread-making sessions showcasing domestic work as a driver for social change. Lundahl has found a long-term collaborator in Jenny Richards, formerly co-director of Konsthall C, with whom she is currently collaborating on the project "Bodies of Care."[3] Through interviews and conversations the project engages with care work from an intergenerational and intersectional feminist perspective. These projects simultaneously tackle racism and ageism, attesting to Lundahl's acute awareness of contemporary issues. To review Lundahl's socially impactful work requires looking at the interrelation between projects, and is crucial in a moment when an independent and collaborative approach to curating is no longer the exception but the rule.

1. This omission was later corrected by two institutional projects: The exhibition "Den fria leken: modellen, ballongen och konsten som aktion" at Västerås konstmuseum, and The New Model, a seminar series at Tensta konsthall. See: Lars Bang Larsen and Palle Nielsen, *The Model—A Model for a Qualitative Society (1968)* (Barcelona: MACBA Collections, 2010); *Den fria leken: modellen, ballongen och konsten som aktion* (Stockholm: Folkrörelsernas konstfrämjande), 2017; Lars Bang Larsen and Maria Lind, *The New Model: An Inquiry* (Berlin: Sternberg Press, 2020).

2. Tensta konsthall also hosted Brödmassan from autumn 2018 to summer 2019. One of the participating organizations was K.Ö.K (Kvinnor Önskar Kollektivitet).

3. For more information about the projects staged by Richards and her co-director Jens Strandberg at Konsthall C see Jenny Richards and Jens Strandberg, eds., *Home Works—A Cooking Book: Recipes for Organising with Art and Domestic Work* (Onomatopee: Eindhoven, 2021).

Intuiting Radical Change: Gunilla Lundahl's Writing, Organizing, and Communal Life, 1960s–80s

Anna Mikaela Ekstrand

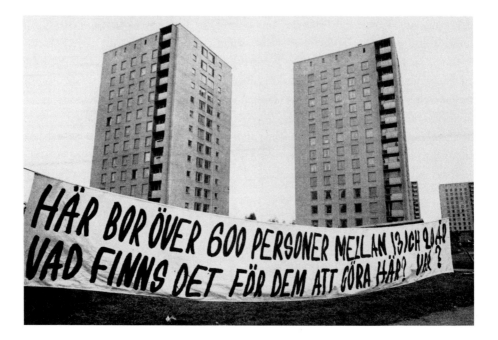

The group Aktion Samtal highlight the needs of youth in new suburban areas during an urban action event in Årsta, Stockholm. The banner reads: "More than 600 people between the ages of 13 and 20 live here, what is there for them to do? Where?" Film still from *Aktivering Samtal* (2020), reproduced in *Paletten*, issue 4 (1968). Courtesy of Mats Eriksson Dunér

Issues around women, children, or how to use design and public policy to better lives appeared in almost all of Gunilla Lundahl's articles in the design publication *FORM*. With a mission to better Swedish design, *FORM* was governed by the non-profit organization Svenska Slöjdföreningen (The Swedish Society of Crafts and Design).[1] Lundahl was an editor there between 1965 and 1969 and contributed as a writer until the 1990s. Her writing was ripe with social critique, relating to a broad public and situated in particular contexts, she also covered exhibitions—including graduate exhibitions from the major design and art schools, new designers, and consumer trends. Lundahl had free rein to choose her topics and project-managed several thematic issues that deepened the public debate on policy and life on topics like children, building for women, the environment,

and food. Besides writing, Lundahl was active in associations, and an organizer of public actions, educational initiatives, and exhibitions during the time.

Absent from most accounts from this period, Lundahl was in fact an important voice in debates which resonate with many concerns of the 2020s. By reviewing her personal lifestyle choices and organizing within the context of her editorial work at *FORM*, this essay considers three spheres of impact and their intersections. From 1962 to 1968 she created the foundation for Levande Verkstad (Living Workshop), a pedagogical philosophy formulated by Adelyne Cross-Eriksson that became a household name in Sweden in the 1970s. Lundahl was an active member of Hyresgästföreningen (Tenants' Association) and in the mid-1960s she moved into Kollektivhuset Marieberg (Collective House Marieberg) and in 1976 she co-founded the all-female research group Bo i Gemenskap (BIG) (Living in Community), focused on collective housing. Relying on her research on children, she co-organized two projects in 1968, Aktion Samtal (Action Dialog), an urban action group that reached into communities, mainly to children, offering them help to change their environments and "Modellen—En modell för ett kvalitativt samhälle" (The Model—A Model for a Qualitative Society) an experiential participatory playground and workshop for children incorporating pedagogical research centered around an intuitive approach to art at Moderna Museet (Museum of Modern Art). Both were contributions to the debate on public space. As Swedish life, cities, and consumption was rapidly changing Lundahl emerges as a change-making critic whose coverage aims to better society, an organizer, and a woman not only living at the forefront, but also engaging in radical change.

Towards the end of the 1960s Sweden was shifting out of the social welfare state model, or Mixed Economy.[2] Gender studies theorist Yvonne Hirdman describes women as moving from a "housewife contract" to an "equality contract" with state public policy focused on granting women more autonomy.[3] However, at the same time, women's and children's rights, opportunities, and social provision remained unequal to men's. The issue was heavily debated, and although overall social change was rapid, its success was uneven. In the municipal elections of 1966, the sitting Social Democrats lost the majority vote in the capital Stockholm allowing right-bloc politicians to advance their policies. This surprising defeat was largely thought to be a cause of their poor handling of the growing housing crisis. As a result, the government, which remained Social Democratic, built over a million dwellings in Stockholm between 1965 and 1974 following a unanimous decision in parliament at the beginning of the '60s. There was a large regional exodus of people to the cities. During these years, Lundahl fervently detailed and debated ways to enact

structural change through furniture, interior design, and city planning, while stressing the urgent need for social services such as childcare and education. Her reporting on material and social conditions worked to improve lives in communities that were rapidly changing across the country.

Lundahl consistently melds social critique and design criticism, building on a Swedish tradition of social reform. Since the turn of the century, progressive forces in Sweden had worked towards equality through law, politics, design, and consumerism to improve the social fabric of everyday life. Ellen Key, who published *Century of the Child* in 1900, advocated for women and children's rights and well-being. Her ideas for social reform have left a strong legacy. Another political figure who supported these causes was Alva Myrdal. Through her political, diplomatic, and research activity she campaigned for women's rights, disarmament, and better alternatives in education and housing. Being a mother, her professional trajectory was erratic but also long.[4] She is colloquially referred to as the architect of the Social Welfare State, together with her husband Gunnar. Pedagogues Karin Modin and Emarie Widakowich are also relevant here, as they founded Sweden's first Waldorf School in 1949, and Lundahl was involved in preserving this pedagogy in Stockholm. Building on this largely socialist legacy that reached out from but also into the world, the decades from 1960 to the '80s brought rapid social change and higher quality of life for many people, especially women and children.

In the introduction to an issue of *FORM* dedicated to the subject of women, Lundahl highlights the need for expanded research that considers the whole population: "Shouldn't we be thinking about people? Well, yes. Yet the conditions of everyday life of life for half our population, namely women, is largely unknown."[5] "Catering to the needs of women will help build a humane society," she writes in another thematic issue from 1979. Although alternative pedagogy and leftist ideals figure in Lundahl's writing in *FORM* she does not delve into theoretical concepts nor discuss her projects beyond the magazine. Instead, sewn throughout most of her journalistic writing are ideologically grounded but digestible suggestions on how social change can be implemented.

Cultivating Intuition: Levande Verkstad (Living Workshop), 1962–69

During the 1960s the mission of Svenska Slöjdföreningen (Swedish Society of Craft and Design) was to raise awareness about the environment by shaping environmentally conscious

consumers.[6] Through exhibitions, educational initiatives, support to the industry, and the society's magazine *FORM*, the non-profit organization aimed to promote and advance the quality of Swedish design.

The growing dominance of the market economy together with rising building and living standards overall led to a need for more designed goods. Good and bad design and the production of discourse and debate around it, ongoing since the 1920s, emerged now as a central concern in the public sphere. As a first foray into practical pedagogy Lundahl, together with educators Odd Brochmann and Ibi Trier-Mörch, organized a class for designers, fabricators, and pedagogues with an ambition to deepen the language around design. Lundahl had invited Kurt Olsson and Adelyne Cross-Eriksson to speak, with the latter presenting a design ideology based on exploration, intuition, and the unlocking of creative potential rather than focusing on technical finish and the imperatives of capital. Lundahl saw an opportunity to pivot toward a human-centric mode of design, giving Slöjdföreningen's educational program a radical turn and introducing more substance and originality into the design debate.

The vision for Lundahl and Cross-Eriksson's workshop was born out of the Bauhaus. Cross-Eriksson emigrated from the United States to Sweden in the 1950s.[7] In Chicago she had worked in the development of Illinois' cultural sector, managing a Roosevelt- administration-funded program for the unemployed, and in San Francisco she worked in art therapy for war veterans. However, it was her time at the New Bauhaus in Chicago, later known as the Institute of Design, from 1938–43 that became the foundation for Slöjdföreningen's pedagogy, and which would later develop into Levande Verkstad (Living Workshop).[8] At the New Bauhaus, Cross-Eriksson worked closely with László Moholy-Nagy who had taught at the Dessau Bauhaus and founded the school in Chicago on many of that institution's pedagogical principles.[9] An interdisciplinary art school open for only fourteen years, Bauhaus had no unitary aesthetic style and did not propagate a specific approach to making and teaching. It was guided by a number of core principles, however, and, after its closure, various design schools and programs adopted these and its (oft mythologized) ethos.

In the summer of 1963, Cross-Eriksson, Lundahl, and Olsson organized a two-week-long Bauhaus-inspired summer school. To decentralize the design debate from Stockholm the course was held at Hantverkets folkhögskola, a college in the Northern town Leksand. It was an experiment, and the results marked a clear breakthrough for a new pedagogy of expression. In 1965 the social debate about the impact of environmental factors on children—from design, furniture, and school buildings to teaching—became centered on

people—especially teachers—and creativity was given a more important role within the primary school curriculum. To cater to the needs of a growing textile and craft teacher corps, Slöjdföreningen's educational department decided to focus on educators. The program became increasingly popular and in 1966 Slöjdföreningen could not accept all applicants.

The exercises that emerged were centered on building equality, confidence, sensitivity, and clearing creative blocks. A foundational principle emerged, the invitation to join in —"du också"—and it would become a catch-phrase for Cross-Eriksson: "you, too." The course was based on a series of simple prompts to participants: fold a piece of paper in multiple ways; paint a memory from your childhood; explore volume, scale, and distance by working with black and white media; make a mask out of clay and set it in a cast; walk around in darkness, hand in hand with fellow participants or while passing objects around.[10] After this creative activity, participants were encouraged to share their feelings and reactions. Each course ended with a democratic exhibition where everyone's work was put on view, emphasizing fairness and giving an overview of the whole process that would instill feelings of accomplishment and achievement.

Lundahl's writing began to develop an ever greater emphasis on childlike intuition and other traces of the Levande Verkstad ethos. While her authorial perspective is mostly that of an adult she often evokes the spirit of childhood play, freedom, and movement—as in "Ängelens bild," an article about Fontessa-De Geer's clothing designs in which Lundahl espouses the idea that adults require a space to behave like children.[11]

In 1967 programming expanded to Stockholm and, through concerted efforts, to newer publics. A Bauhaus week was organized together with Nationalmuseum and Bo and Ann-Mari Lagercrantz organized a workshop at Stadsmuseet. Giving the pedagogical philosophy a wider spread, "Du också," a documentary film by Lars Swanberg based on footage from the summer, premiered and was also shown on public television. Bo Lagercrantz, a museum professional who had attended the summer course, published his thoughts in FORM 1/67. In 1968, Slöjdföreningen's courses moved to Sunderbyns folkhögskola, a college in the North of Sweden, and an environmental seminar was held that focused on local issues in Västerbotten, also in the Northern region of the country. Participants now came from a wide range of industries, hospitals, elderly homes, prisons, youth centers, study organizations, the cultural sector, and schools.

Based on her work with Slöjdföreningen, Cross-Eriksson founded Levande Verkstad, a day school with study circles in 1967 at Birkagården in Stockholm.[12] In 1969 Slöjdföreningen

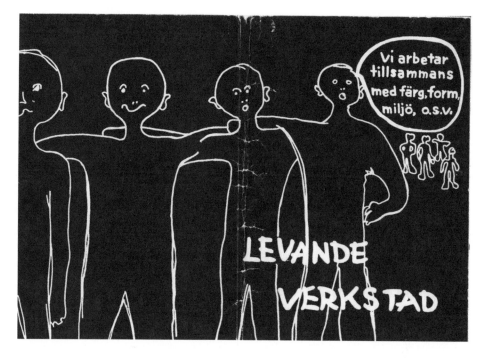

Levande Verkstad grew beyond Svenska Slöjdföreningen. The cover of a 1970s book reads: "We work together with color, form, environment, etc." Resembling a child's line drawing, the image captures the way vulnerability and mutual support become tools in the day school's courses. Photo: Swedish Labor Movement Archive and Library

offered courses in cooperation with Levande Verkstad. The latter's philosophy, based on participants working in a variety of media with exercises that sparked intuitive creativity, had crystalized.

Equality, sincerity, and bonding were of the utmost importance to Cross-Eriksson and at the core of the Levande Verkstad pedagogical program. Märit Ehn, course administrator and contributor to *FORM* writes: "Right there, somewhere in the intense confrontation across established boundaries and institutional walls and in the effort to reproduce all involved, above all through the emphasis on the creative right to expression, I personally found something important, a demand for justice."[13] Their work together made a great impression on Ehn's professional life. Ehn regenerated the pedagogy when shaping public programs for children at Bror Hjorth's (1894–1968) museum in Uppsala, and she later became integral to the preservation of the museum. During her time at *FORM*, Ehn juggled child-rearing and family domestic duties with her position at the museum. For her, Lundahl was a great

ideologist and their editorial work together sparked joy and creativity.[14] Participants and organizers of Levande Verkstad developed their inner worlds in order to make an impact on the world beyond. Energized by their collaboration and guided by the program's key principles, Cross-Eriksson, Lundahl, and Ehn each attained positions of leadership in their fields of practice.[15]

Provoking New Social Frameworks, or Curating as Social Practice: Aktion Samtal (Action Dialogue) and Modellen (The Model), 1968–Present

FORM often worked with thematic issues. In 1967 Lundahl conceived an issue on young children and the public. In this context, Lundahl praises "Hon" at Moderna Museet, an interactive exhibition by Niki de Saint Phalle that presented a *nana*—one of her signature brightly-colored sculptures of women—housing a multimedia environment that visitors entered through the figure's vaginal opening. Lundahl acclaims it for allowing children to touch the installation. Shaping, or at the very least anticipating, future trends in museum design, she calls for an area dedicated to children at the museum: "Why not create a children's area for climbing, play, and sensory experiences—destroyable, exchangeable, and often renewed (multi-art)?"[16] she does not confine her proposals and criticisms to Moderna Museet, she also takes up Barnens Dag (Children's Day), a national event for children, that she calls both boring and frustrating. A year later she realized new solutions for both of these institutions.

For the Swedish population, associations such as Hyresgästföreningen (Tenants' Association) and Vänsterpartiet kommunisterna (Communist Party of Sweden/Left Party—the Communists), of which Lundahl was a member, were important vehicles through which to effect social change.[17] With directors, boards, mission statements, and formalized membership requirements their structure was rigid, and change came slowly. Offering an alternative organizational form, the urban action group Aktion Samtal (Action Dialogue) co-founded by Lundahl borrowed processes from activism, experimental theater, and art—especially happenings—to engage and empower communities through public actions and publishing.[18] In addition to co-organizing actions, Lundahl wrote flyers, which helped expand and decentralize the group, allowing others to organize under a common mission. Communications emerged as an important tool for the group; journalists who attended actions acted as deterrents to police intervention and the press spread Aktion Samtal's

FORM

8
1968

Offentlig miljökonst: dekorera eller aktivera? Pris 4:50 inkl oms

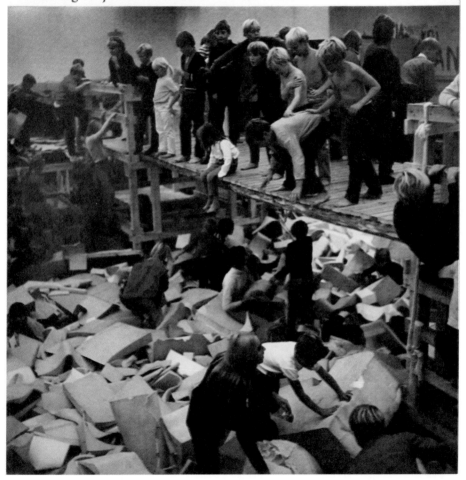

"Modellen" serves as the cover image for *FORM 8* (1968), a thematic issue: "Offentlig miljökonst: dekorera eller aktivera?" (Public Art: Decorate or Activate). Film still from *Aktivering Samtal* (2020). Courtesy of Mats Eriksson Dunér

message. Following positive press coverage, Aktion Samtal was invited to host Barnens dag. Together with the event's young participants they transformed parts of a central park in Stockholm into a DIY jungle gym—using building materials such as planks, disused tires, and ropes, children tinkered with saws, hammers, and nails and developed their collaborative skills. With the needs of children at the core of their practice, Aktion Samtal activated public space through six disruptive but neighborly actions in 1968.[19]

Amid a world in crisis, 1968 was a year of social upheavals: student protests, a sharp rise in social movements responding to wars, environmental crisis, consumerism, and colonialism. Inspired by her work with Aktion Samtal, Lundahl felt the need to stage a physical renegotiation of social contracts. To the writings of French philosopher André Gortz, who advocated emancipation from isolation and exploitation through community building, and Herbert Marcuse's popular book *One-Dimensional Man*, she added advocacy of design for children, to mount the exhibition "Modellen—En modell för ett kvalitativt samhälle" (The Model—A Model for a Qualitative Society).[20] It was a provocation and an experiment investigating alternative structures for the burgeoning new society. "Modellen" was a four-week long intervention co-organized by Lundahl—responsible for seminars, research, and funding, and the Danish artist and architect Palle Nielsen, who designed the event's environment with help from Carlo Derkert, head of public programs at Moderna Museet, who was instrumental in getting the proposal accepted by the museum.[21] Deeply rooted in the aesthetics and modes of the counterculture—community building, DIY, and decentralized alternative groups finding new solutions for society—Lundahl chose not to refer to it as an exhibition. Posters in the space announced that this was not art. Similarly, to Levande Verkstad, the project centered on unlocking human potential.

Staging "Modellen" at Moderna Museet was not entirely uncomplicated. It caused conflict within Aktion Samtal as Tomas Wieslander, a member of the group, chose not to include the event under its banner due to its institutional ties. Conversely, officials at Moderna Museet attempted to close the exhibition prematurely; there was conflict within the institution itself and between organizers and officials. The main structure, a jungle gym of sorts in wood, enclosed a pool of foam plastics to jump and play in. There were paints, clothes, wood, hammers, nails, and saws available to children who took their own initiatives to create their own environment. There were no pedagogues directing the children, instead researchers were in a control room where they surveyed and studied how children interacted with their surroundings.[22] This element was required for Lundahl to secure funding from the city, but it also mirrors the intentions of the exhibition—learning from children.

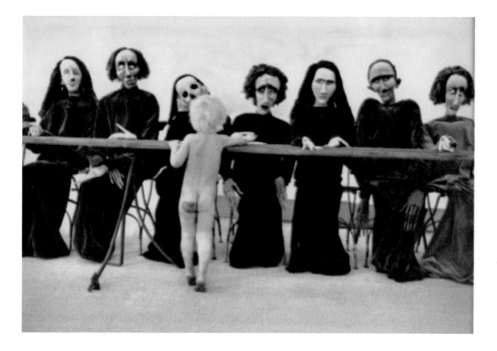

In the visionary exhibition "Modellen" children were encouraged to interact with art in the museum. Paint-stained after using the slide, Mårten Ehn engages with Eva Aeppli's sculpture *La Table*, 1967. Photo: Ragnhild Haarstad, 1968. Courtesy of Märit Ehn

Museum officials were shocked by the noise, movement, and unusual activities in the space and subsequently the fire department were called to shut down the event. With the assistance of Derkert, Lundahl successfully advocated to museum officials for the show to reopen, using the media as a tool. To make visual their political dissent, Lundahl had red flags installed throughout the space. With more than 25,000 visitors, "Modellen" became the most visited exhibition in the history of the museum.[23] The reluctance of Moderna Museet to support the event despite its apparent public success raises the question: who is the public museum for, the general public or a cultural elite?

"Modellen" and Aktion Samtal's urban action projects relied on intuition, play, and adjustable or unstable designed environments. At the same time Lundahl wrote about what good design for children is, or is not, in *FORM*. She favored plastic toys, rather than wood, for their vibrant colors and durability, and commented on children's furniture, childcare, and living solutions. About a decade later, Lundahl writes about *Erfarenhetsverkstan* (Experience Workshop) in Sätra, an underprivileged suburb of Stockholm where a group of

architects and designers set up a workshop where children could learn how to build.[24] In the 1970s *Parklek* (Park Play)—jungle gyms and parks—expanded rapidly in Stockholm under the direction of the city.[25] But, in Sätra children were still building their own contraptions—often dangerously.[26] Lundahl's consistent dedication to promoting communal life and paying attention to children appears throughout her life and her criticism helped advance emerging public policy. "Modellen" worked within the institution with the intention of breaking it down, while reaching into activist circles, and looking to its target group, children, for clues on how to rebuild. For museum professionals looking to deepen ties with their communities, move towards equitable practices, and to invigorate their programming, "Modellen" emerges as an excellent case study in curating as social practice.

From Radical to Mainstream: Hyresgästföreningen and Bo i Gemenskap (Tenants' Association and Living in Community), 1976–Present

The public, or municipal, housing sector was an integral part of the social welfare system and grew rapidly from 1965 to 1972 through the public housing initiative Miljonprogrammet (Million program). Lundahl was an active member in Hyresgästförening (Tenants' Association), a popular movement and decentralized organization that advocated for the rights of renters. They lobbied for protective legislation and negotiated rents and repairs, among other things.[27] In 1965 Lundahl was invited to participate in open seminars in Kungsträdgården, a park in central Stockholm, in response to widespread discontent around the city's housing shortage, poor housing conditions, and the politicians and associations who governed these policies in the growing city. An indication of the robustness of the debate was that the seminars' organizers criticized the Tenants' Associations of which Lundahl herself was a member.

Lundahl's contributions to the housing debate in *FORM* are centered on bettering conditions for women through state subsidized childcare, championing communal living, and developing ways to share responsibilities within the local community while improving public space. A dramatic increase in her writing on the topic of housing occurs after 1964 when, with the birth of her daughter, Lundahl became a working mother. Married in 1956 but later divorced, Lundahl found the idea of the nuclear family narrow and ossifying. Seeking other more dynamic ways to strive and live for equal development and socialization, Lundahl and her daughter moved into the communal living co-operative Kollektivhuset Marieberg in 1966.

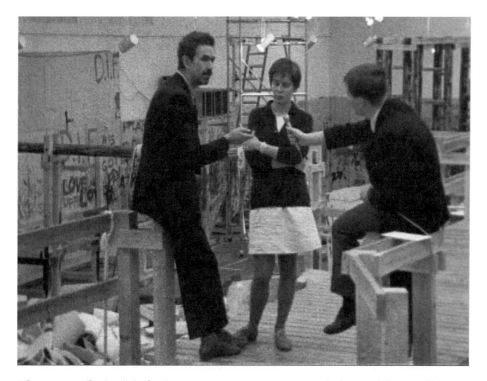

After museum officials call the fire department in an attempt to prematurely close "Modellen," Gunilla Lundahl and Carlo Derkert, head of Public Programs at Moderna Museet, argue for it to remain open in a Public Television news broadcast. Film still from *Aktivering Samtal* (2020), Aktuellt, SVT (1968). Courtesy of Mats Eriksson Dunér

In the Swedish manifesto of modernist architecture "acceptera," written in 1931, its six visionary architect authors predict that one third of the Swedish population will be living in communal housing by the 1960s.[28] They were incorrect, but certainly, the utopian ideal of communal forms of living remained present in the public imagination. Professional and single women were integral to the development of early collective housing. Several were run by women's organizations to ensure working women safe, respectable, and affordable housing. In Stockholm, the organization Yrkeskvinnorsklubb (Professional Women's Club) ran YK-huset which provided collective housing for families and working women. Kvinnliga kontoristernas förening (Organization for Female Clerks) ran another such house. A real estate developer with a commitment to social development, Olle Engkvist, built Smaragden for single women in the 1940s, and over the next decade completed eight collective housing solutions in Stockholm, one of which, intended for families in Marieberg, was Lundahl's home.[29]

Lundahl often incorporates the ideology of communal living into her critical writing on design. In an article questioning agribusiness she discusses solutions for strengthening the relationship between food and sustainabilty, listing ways to limit food processing in the supply chain ("we must not eat 'machine-food'," she adjures the reader).[30] In a thematic issue of *FORM* dedicated to living and building on women's terms, Lundahl criticizes the concept of "work-time" and "free-time," as domestic duties and childcare constitute unpaid labor in the home and are carried out by women in their "free-time."[31] The title of the issue—"Building and Living on Women's Terms"—was borrowed from a conference held in Kungälv the same year. At the time women were invisible in housing and data collection on urban living: the family was defined by its head—the man—and legislative rights pertained to men as landowners, homeowners, and leaseholders. The plan of action for better conditions, suggests Lundahl, is rescarch focused on identifying the existing conditions women live under. Lundahl's work seems prescient in our current moment and urgently in need of rediscovery.

With the buildout of state subsidized daycare, Lundahl criticized the government for devolving responsibility for its expansion to municipalities. She believed this would lead to uneven quality in provision, potentially confining women to child-rearing in the home and prohibiting them from joining the waged workforce.[32] These years were a decisive moment in which centralized conversations on social issues and changes in policy were taking place with uneven implementation. Today, the Swedish childcare system is fully developed and available to all. However, childrearing still holds women back in the work force since paid parent-leave, a social service, is utilized substantially more by women than men.

In 1976 Lundahl co-founded the all-female research collective Bo i Gemenskap (BIG) (Living in Community) based on the principle of economizing material resources while freeing human resources to lessen the burden for women who disproportionately take responsibility for domestic work. Their initial goal was to form an alternative to existing collective housing solutions, however, that was never realized. Instead, they researched, lectured, traveled, and published propaganda promoting collective living. BIG's fantasy house differed from the hierarchical structure of the *kollektivhus* (collective house), which employed staff to cook communal meals, clean, and manage childcare facilities. BIG was closer aligned with *storfamiljen* (large family), an intergenerational form of living where several families come together to create one unit. Large families resided in villas, former schoolhouses, and homes for the elderly. Set in the 1970s, Lukas Moodyson's film *Together* (2000) dramatizes the travails and dysfunctions of families who chose this form of collective

living. As evidenced in the film, shared kitchens and bathrooms serve to erase the individual household, sometimes imposing social entanglements that robbed residents of autonomy. BIG's ideology centered around their residents' empowerment and combined aspects of the *kollektivhus* and *storfamilj*: residents lived in apartments complete with kitchens and bathrooms reserved for themselves, thus keeping the private sphere intact, while enjoying the social benefits of living, sharing, and carrying out domestic work with others as full participants, with no staff.

In the 1980s Lundahl and the members of BIG produced two books: *Arbete service och gemenskap i boendet* (1980) and *Det Lilla Kollektivhuset: En modell för praktisk tillämpning* (1982). Published by Byggforskningsrådet, BFR (Swedish Council for Building Research) they sought to popularize the collective's template of communal living.[33] The first book investigated service, ownership, energy, and decision-making processes within social structures related to living. The second functions as a handbook for readers who wished to replicate BIG's community model. The authors are meticulous in grounding their arguments. For example, with reference to a recent report they position their model as the more efficient urban energy solution.[34] In 1992 they published a report on fifteen successful *kollektivhus* run according to BIG's vision, *Femton kollektivhus: en idé blir förverkligas* (1992). By 2007, co-housing as a concept was mature and SABO (Public Housing Sweden) further normalized this form of living by publishing a textbook on collective living.[35] Meanwhile, many of the solutions advanced in the *kollektivhus* were being incorporated into society elsewhere: regular co-op and rental housing now had shared laundry machines, the state offered subsidized childcare through state-funded day-care facilities to all, schools provided school lunch for children and state-subsidized care facilities for the elderly. Although women remained responsible for domestic labor, these services fulfilled some of the *kollektivhus*'s propositions.

BIG's research launched a wide-ranging debate on co-housing and the visionary group continues to co-publish, lecture, and organize around the topic of co-housing.[36] In 2014 BIG members Ingela Blomberg and Kerstin Kjärnekull published a book on homes for the elderly.[37] They focused on living conditions. The same year that focus was widened in an exhibition co-curated by Lundahl, Jenny Richards, and Jens Strandberg at Konsthall C, "Se Upp! En dag är hemtjänsten en del av ditt liv!" (Watch Out! The Home Care Service Will One Day be a Part of Your Life!). The exhibition presented illustrations on postcards that the illustrator Lillian Domec had created together with her home care provider Thomas Gilek and material from interviews with other people using home care workers that revealed tensions between integrity and communality in their homes. This is just one of the many

examples of how Lundahl transcends the traditional professional trajectory as she continues to present, examine, and advocate for her core interests well past the age of retirement.

Conclusion: Urgencies, Then and Now

In the summer of 1969 forty-five adults and eleven of their children met for a seminar held as a communal vacation where during the day participants engaged in practical exercises, many of them from the Levande Verkstad curriculum, and in the evenings discussed topics related to sparsely populated regions, art therapy, arts education, and education more broadly. Born out of her work at *FORM*, this particular project borrowed from trends in collective living and focused on the topics Lundahl cared about most. As such it illustrates at once the foundations of her criticism and the way she put this social critique into practice. Lundahl's next curatorial project was commissioned by the government and its institutions and, in the northern mining town Skellefteå, illustrated how citizens could become influential on urban development: "Det växer i Skellefteå. Men hur?" (Skellefteå is Growing, But How?). This region was heavily present as a site for workshops organized by Svenska Slöjdföreningen.

Lundahl's work emerges from and engages with a whole matrix of relationships. Every year she reviewed student exhibitions at Konstfack, Nyckelviksskolan, and other design schools, maintaining a keen awareness of the future of design but also of future designers. In her writing she offers suggestions on how they can cater to society and how schools can better cater to their students. Whether it is an article on lamps, trends in furnishings, or designing better furniture for children, Lundahl's articles in *FORM* are critical and concise, always unmasking inequalities and proposing ways that these can be overcome. Focusing on the collective, she ranges over topics such as the distinction between nature and technology and the development of democratic values, while exploring social and environmental considerations.

There is an urgency in Lundahl's writing on housing and childcare: as a working woman and working mother supporting her child in the period from the 1960s to the 1980s her needs, and the needs of most women and children, were not perceived or met by the government, nor within the design industry. Lundahl's writing, organizational work, and her radical form of life improved conditions for her peers. Across her professional trajectory, equality is a consistent theme. As in 1968, the last couple of years have shed light on marginalized

groups: as mass school closures were introduced to limit the spread of COVID-19 from 2019 onward, many women left their jobs and became entirely responsible for childrearing; at the same time US American police brutality was revisited after the violent killings of George Floyd and Breonna Taylor sparked social upheaval and grassroots organizing on an unprecedented scale with the Black Lives Matter movement gaining momentum in the USA and reverberating around the world. The pandemic's enforced shift to digital living encouraged the formation of new groups through social media and other communication platforms to engage in important dialogues on self-care, community-support, diversity, representation, and public space. For those who have access to the technology, it is an opportune and necessary moment to revisit and broadcast Lundahl's diverse practice and cultural contribution. As curators, the most important lesson lies in exploring the ways she valued intuition and how her practice bettered human life, erasing boundaries between art, craft, design, city-planning, and architecture while responding to the political climate and operating untethered from hierarchical hegemonic institutional structures.

1. Later renamed Svensk Form.

2. Or, the Swedish model: an alternative macroeconomic policy that aimed to create an inclusive social welfare system. See: Per Thullberg and Kjell Östberg, *Den svenska modellen* (Lund: Studentlitteratur, 1994), 5.

3. See Yvonne Hirdman, Yvonne Hirdman, *Genus—om det stabilas föränderliga former* (Stockholm: Liber, 2001), 15.

4. Alva Myrdal was awarded the Nobel Peace Prize at the age of 80. See Hedvig Ekerwald, "Alva Myrdal: Making the Private Public," *Acta Sociologica* 43, no. 4 (2000) for a sociological perspective on her work.

5. Gunilla Lundahl, "Kvinnors erfaranheter förändrar 80-talet," *FORM* 75, no. 6 (1979): 2. Our translation.

6. Gert Z. Nordström, "Varför Kulturinformation?," *FORM* 63, no. 5 (1967): 301.

7. Cross-Eriksson fled McCarthy-era repression in the United States for Sweden together with her husband, a union activist.

8. Adelyne Cross-Eriksson, "Mina Bauhausminnen," in *Levande Verkstad*, ed. Carl-Axel Boström (Stockholm: Rabén & Sjögren, 1975), 220–222.

9. Several former Bauhaus professors and their students taught at or founded schools based on similar principles when they emigrated to the United States: Black Mountain College, Cranbrook Academy, IIT Institute of Design, and Yale's School of Art are among these.

10. Extensive descriptions of exercises are given in the Svensk Form archive and in Adelyne Cross-Eriksson's personal archive in Arbetarrörelsens arkiv och bibliotek, Stockholm, Sweden.

11. Gunilla Lundahl, "Ängelens bild," *FORM* 62, no. 1 (1966): 22.

12. Adelyne Cross-Eriksson's radical pedagogical method is reproduced and disseminated to teachers today through a two-year degree program at Södra Stockholms Folkhögskola.

13. Märit Ehn, "Svenska Slöjdföreningensform verkstad," in *Levande Verkstad*, 242. Our translation.

14. Interview with Märit Ehn conducted by Anna Mikaela Ekstrand, January 19, 2021. Recording in CuratorLab Archive, Konstfack.

15. When Ehn's family duties eased later in her life she resumed her professional trajectory, directing Gotlands Konstmuseum and Gävle Konstcentrum.

16. Gunilla Lundahl, "Kom och Lek!," *FORM* 63, vol. no. 1 (1967): 38.

17. Associations empowered citizens to take greater control of their economic and social conditions in most areas of Swedish life: politics, sports and leisure, charity, advocacy, and solidarity (including labor unions), industry, and housing co-operatives. They continue to be widely understood as a vital force for democratization. See Michele Micheletti, *Civil Society and State Relations in Sweden* (Milton Park: Routledge, 1995), 124.

18. Among them were Jujja and Tomas Wieslander and Gertrud Schyl-Bjurman.

19. For example, redirecting traffic to provide a safe environment in which children could play, helping apartment residents take down fences between their communal backyards, and workshops where children could build jungle gyms and play freely in urban areas. See Mats Eriksson Dunér, dir., *Aktivering Samtal* (2000).

20. See André Gorz, *Strategy for Labor: A Radical Proposal* (Boston: Beacon Press, 1967).

21. See Lars Bang Larsen and Maria Lind, *The New Model: An Inquiry* (Berlin: Sternberg Press, 2020), 27.

22. The results are held in Moderna Museet's Public Records Archive (MMA MA).

23. It also received praise and support from Olof Palme, the Minster of Education. Footage of the politician hurling himself into the pool of foam was widely circulated in the press and is easy to locate with an online image search.

24. Led by Agneta Ernström, Barbro Hedström, Bengt Carling, and Michael Crisp. Lundahl had come into contact with the group when they participated in "ARARAT."

25. A 1970 film on the subject of parks and jungle gyms commissioned by Gatukontorets parkavdelning (Public Office's Department of Parks), states that every child should have a park within 400 meters of their residence. Odert von Schultz and Kajsa Andersson, dir., *Barn på stan: en film om parkleken i Stockholm* (1970), video, 21:00 min. https://stockholmskallan.stockholm.se/post/19705, accessed February 5, 2021.

26. Gunilla Lundahl, "Erfarenhetsverkstaden," *FORM* 75, no. 1 (1979): 22.

27. In 1963 Hyresgästföreningen had 380,000 members. Peter Forsman, "Hyresgästföreningen under 100 år," *Hyresgästen* 92, no. 3 (2015): 8–14. https://www.hyresgastforeningen.se/globalassets/om-oss/var-resa/hyresgastforeningen-under-100-ar.pdf Accessed February 9 , 2021.

28. Gunnar Asplund, Wolter Gahn, Sven Markelius, et al., "acceptera," in Lucy Creagh, Helen Kåberg, and Barbara Miller Lane, eds., *Modern Swedish Design: Three Founding Texts* (New York: Museum of Modern Art, 2008).

29. BIG-Gruppen (Elly Berg, Ingela Blomberg, Kerstin Cavallin, et al), *Det Lilla Kollektivhuset: En modell för praktisk tillämpning* (Stockholm: Statens råd för byggnadsforskning, 1983), 17.

30. Gunilla Lundahl, "Produktion ar till för livet. Inte tvärtom," *FORM*, no. 4 (1979), 2.

31. Lundahl's response to the government promise of 20,000 new daycare spots was the traveling exhibition "Bygga för Barn" and was organized by Socialstyrelsen to stimulate municipalities to build daycare centers. See: Gunilla Lundahl, "Får vi ett familjedepartement?," *FORM* 63, no. 5 (1967): 305.

32. In the '60s the daycare debate was known as *Barnstugedebatten*. Later, in the '70s, *barnstuga/daghem* (daycare) became renamed *förskola* (pre-school).

33. The foundational requirements of the communes were that they were open to all, communal work was shared, and that rents and fees should be the same for all units regardless of move-in date. See *Det Lilla Kollektivhuset: En modell för praktisk tillämpning*, 31. Byggnadsforskningsrådet (BFR), the Building Research Council, was a Swedish government organization that sponsored research into construction and city planning in the years 1960–2000.

34. The report was part of Ola Ullsten and Carl Tham, *Regeringens proposition 1978/79:115 om riktlinjer för energipolitiken*, 1979. https://riksdagen.se/sv/dokument-lagar/dokument/proposition/om-riktlinjer-for-energipolitiken_G203115/html Accessed February 10, 2021.

35. Elsa Grip, Kerstin Kärnekull, and Ingrid Sillén, eds., *Gemenskap och Samarbete: att bygga upp och bo i kollektivhus* (Stockholm: Migra Förlag, 2007). This textbook on kollektivhus helped disseminate the ideas discussed by BIG's members in their publications and which Lundahl wrote about in *FORM*.

36. In April 2019 ArkDes organized a Witness Seminar with BIG's current members, Ingela Blomberg, Kerstin Kärnekull, Gunilla Lundahl, Ann Norrby, Inga-Lisa Sangregorio, and Sonja Vidén.

37. Inga-Lisa Sangregorio, *Kollektivhus idag* (Stockholm: Formas, 2000); Ingela Blomberg and Kerstin Kärnekull, *Bygga seniorboende tillsammans* (Stockholm: Svensk byggtjänst, 2014).

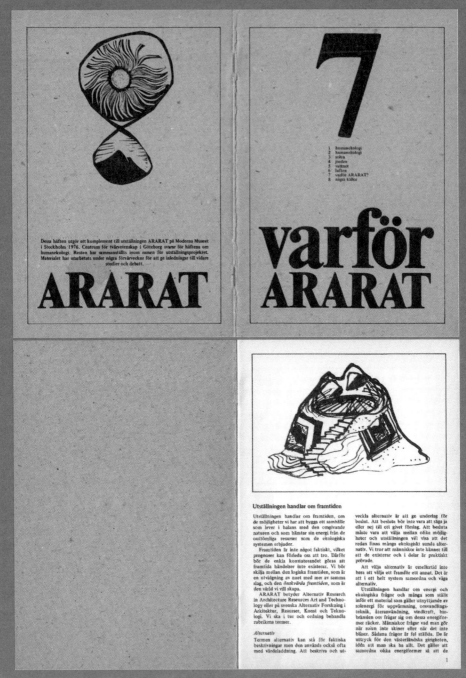

Denna häften utgör ett komplement till utställningen ARARAT på Moderna Museet i Stockholm 1976. Centrum för tvärvetenskap i Göteborg svarar för häftena om humanekologi. Resten har sammanställts inom ramen för utställningsprojektet. Materialet har utarbetats under några förvärveckor för att ge inledningar till vidare studier och debatt.

ARARAT

7

1 humanekologi
2 humanekologi
3 solen
4 jorden
5 vattnet
6 luften
7 varför ARARAT?
8 några källor

varför ARARAT

Utställningen handlar om framtiden

Utställningen handlar om framtiden, om de möjligheter vi har att bygga ett samhälle som lever i balans med den omgivande naturen och som hämtar sin energi från de outtömliga resurser som de ekologiska systemen erbjuder.

Framtiden är inte något faktiskt, vilket prognoser kan förleda oss att tro. Därför bör de enkla konstaterandet göras att framtida händelser inte existerar. Vi bör skilja mellan den logiska framtiden, som är en utvidgning av nuet med mer av samma slag, och den *önskvärda framtiden*, som är den värld vi vill skapa.

ARARAT betyder Alternativ Research in Architecture Resources Art and Technology eller på svenska Alternativ Forskning i Arkitektur, Resurser, Konst och Teknologi. Vi ska i tur och ordning behandla rubrikens termer.

Alternativ

Termen alternativ kan stå för faktiska beskrivningar men den används också ofta med värdeladdning. Att beskriva och ut-

veckla alternativ är att ge underlag för beslut. Att besluta bör inte vara att säga ja eller nej till ett givet förslag. Att besluta måste vara att välja mellan olika möjligheter och utställningen vill visa att det redan finns många ekologiskt sunda alternativ. Vi tror att människor inte känner till att de existerar och i delar är praktiskt prövade.

Att välja alternativ är emellertid inte bara att välja ett framför ett annat. Det är att i ett helt system samordna och väga alternativ.

Utställningen handlar om energi och ekologiska frågor och många som ställs inför ett material som gäller utnyttjande av solenergi för uppvärmning, omvandlingsteknik, återanvändning, vindkraft, biobränslen osv frågar sig om dessa energiformer räcker. Människor frågar vad man gör när solen inte skiner eller när det inte blåser. Sådana frågor är fel ställda. De är uttryck för den västerländska girigheten, idén att man ska ha allt. Det gäller att samordna olika energiformer så att de

1

A Model for Utopian Thought and Collective Action: ARARAT, 1976
Julius Lehmann

"ARARAT"—the title of the visionary show held at Stockholm's Moderna Museet (Museum of Modern Art) from spring to early summer 1976 immediately fires the imagination: an acronym for Alternative Research in Art Resources and Technology and at the same time an allusion to the dormant volcano on which, according to the Torah, Bible, and Quran, Noah's Ark was stranded after the mythical Flood. An idealized image of a dark era coming to an end, and the hopeful beginning of a new way of life. The workshop-like exhibition on ecological architecture, art, and experimental technology can be seen as a manifestation of ongoing collective work which transcended and literally dissolved the conventions and boundaries of the institution—turning the former Swedish navy base on the island of Skeppsholmen in central Stockholm into an ecological laboratory and a temporary utopian island.[1] The necessity of changing the prevailing circumstances gave rise to the guiding vision of the project. The exhibition pamphlet put the core conviction into words: "We need to distinguish between the logical future, which is a development of the present—and the desired future, which is the world we want to create."[2] And likewise, the press release for "ARARAT" emphasized how important it was that "we all participate in our different ways to advance and influence the development of a future society in balance between man and nature."[3]

The exhibition extended from the interior to the outdoor spaces with various vernacular structures in the yard in front of the museum, which, with provisional-functional constructions such as wind wheels, water stairs, entered into an unusual dialogue with Alexander Calder's mobile-stabile *The Four Elements*, an eye-catcher at this spot since it was installed during the exhibition "Rörelse i konsten" (Movement in Art) in 1961: But while Calder's kinetic work is powered by electric engines to symbolize the four elements, "ARARAT"'s windmills used the elements to generate energy. As a collective endeavor the experimental exhibition project involved an extensive network of more than 100 people from different backgrounds: "nuclear power opponents and technicians, artisans, growers and ecologists, artists and architects, teachers and inventors," as listed by architect Olof Antell under the agitprop-style headline "Choose your Opponents!"[4]

The multifaceted project emerged after three years of preparation from the work of the activist group "ARARAT," which was formed in protest against the UN Conference on the Human Environment held in Stockholm in 1972. One of the starting points was a

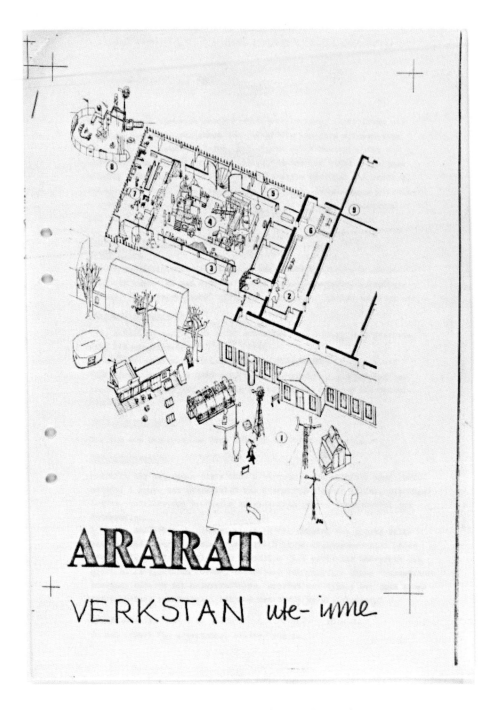

Sketch showing the experimental exterior structures and indoor installations of "ARARAT"

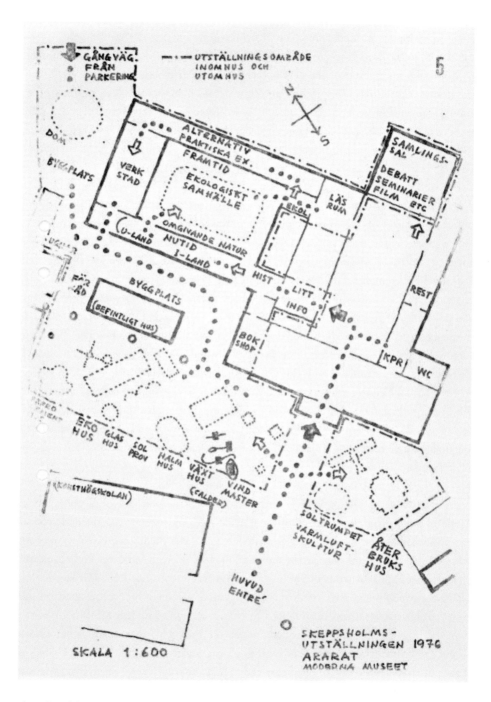

Floor plan of the exhibition. Courtesy of Moderna Museet Archives (MMA MA)

circle of architects around Hans Nordenström (1927–2004) and Klas Anshelm (1914–1980), who in the same year had unsuccessfully applied to the Building Research Council in Stockholm for a grant for the development of an experimental station with full-scale prototypes of buildings using ecological technology—a plan that was later to become the exhibition's outdoor section. They quickly joined forces with other activists, researchers and pedagogues in the milieu of the ecological movement, dividing up into subgroups with different areas of responsibility according to a principle of collaborative "participatory research."[5]

The resulting exhibition whose construction was begun half a year earlier at Torpedverkstan (a former torpedo workshop on Skeppsholmen) was a diverse *parkour*, a work in progress, and a platform for discussion dedicated to topical issues such as Western consumer societies' waste of resources, skewed distribution patterns between developing and industrialized countries worldwide, alternative building materials and a new way of life. Indoors "ARARAT" consisted of installations of alternative technologies demonstrating the possibility of sustainable natural resource use in a local *and* global perspective and, outdoors, experimental architecture deploying ecological building techniques: The Solar House, by artist Bengt Carling; The Helm House (also known as The Straw House), designed by Klas Anshelm; and The Design House, constructed entirely from recycled materials assembled by Formverkstan (Form Workshop) by a group of students at the KTH Royal Institute of Technology School of Architecture, Stockholm.[6] Both aesthetically and technologically, these exterior structures of "ARARAT" can be understood as a riposte to the dominant architectural idiom of the time and a reassessment of architecture and city planning from below.[7]

On the basis of the photographic documentation and the plan drawings preserved in Moderna Museet's archive, the exhibition layout with its sequence of thematic spaces of experience can be reconstructed:[8] "In "ARARAT" the predefined circulation route started in the courtyard outside the museum, moving through buildings and structures that were standing in front of the museum. The route continued inside the museum where one would be exposed to information regarding sustainability," as the architectural historian Helena Mattsson records in a brief case study of Swedish exhibitions in the '60s and '70s. "Finally, the walk ended outside the museum in the outdoor workshops where the visitor could experiment with practical construction. If the walk started as a tour of architectural environments, it ended in *participatory work* where everyone was part of forming the future."[9] In a line of tradition with exhibitions and architectural interventions such as "Hon—en katedral" (She—A Cathedral, 1966)[10] and "Modellen—

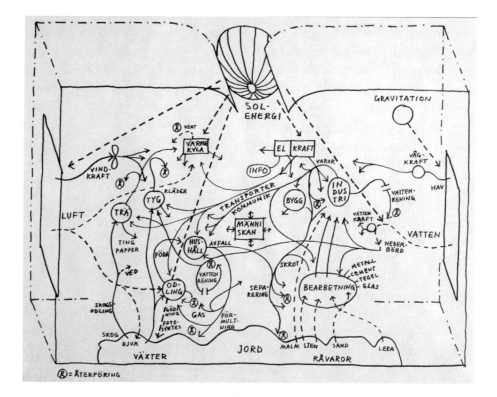

"Cycle—Society and Nature—long-term ecological Balance": The concept of the indoor environment explained in a schematic sketch by Hans Nordenström, Moderna Museet Archives (MMA MA)

En modell för ett kvalitativt samhälle" (The Model—A Model for a Qualitatitve Society, 1968), Mattsson describes "ARARAT" conclusively as exemplary for a curatorial practice of "demonstration": A mode of exhibition in which "through participation and bodily experience the visitors were prompted to think critically and to 'act.'"[11]

Of equal importance to the built structures and interactive stations, however, was the diverse transfer of knowledge that took place through the accompanying program. It included a 10-part series of seminars that built to a public discussion between members of the "ARARAT" Group and representatives of the political parties; additional lectures, film screenings and workshops for children and adults in which visitors could learn about, and gain practical experience in an array of things: energy generation using wind or bicycle powered turbines, climate change, marine currents, and how to bake pancakes with solar energy and methane gas obtained from reused elephant feces from the nearby zoo and

open-air museum Skansen. An integral part of the project was the exhibition's "Ekoteket" library in which selected literature was made accessible as well as an eight-part publication series, published under the responsibility of Gunilla Lundahl. Taking up the central themes of the interior installations—human ecology and the four elements of fire, water, earth, and air—these booklets, printed on recycled paper, brought together contributions from experts in a wide variety of fields of knowledge. The individual editions, with scientific texts, technical sketches, descriptive illustrations and occasional cartoons, share a vivid pedagogical and communicative character. They offered an introduction to various debates and an instructive invitation to further research and practical application, in a manner reminiscent of the "Access to Tools" and DIY spirit of *The Whole Earth Catalog* (1968, 1974), which as a publicist platform and "archive" of the Californian counterculture, in recent years has become a focus of research around the Anthropocene thesis.[12] The faith in the effectiveness of alternative technologies and collaboration that formed the basis of "ARARAT" is expressed in exemplary fashion in the exhibition newspaper printed for the later presentation in Venice, which declares with anti-capitalist verve: "We believe in knowledge and the dissemination of this information to get people to think along these lines. Knowledge is still the only thing we have to oppose economic power."[13] Congenial to the general idea to generate and distribute knowledge through participation the exhibition catalogue for "ARARAT" at Moderna Museet consisted of about fifty loose sheets that were displayed in boxes in the various parts of the exhibition for visitors to take away and put together themselves—and is consequently difficult to get hold of today.

"Our ambition with this immersive experience was not to make a perfect exhibition," as the artist and designer Kerstin Abram-Nilsson (1931–1998) later recalled. "We have constructed an experiment in different spheres of knowledge, the artist almost always coming in at the end. Sometimes it has been perceived as a hopeless a devaluation of the artist's role. Sometimes as positive because the exhibition expands in all directions and a working environment comes into existence where we are moving around each other banging, hammering, calling out, and explaining ad infinitum. Endless visitors. A public movement in the middle of building an exhibition. Difficulties? Sure."[14]

A personal account such as this one makes the atmosphere and the unusual character of this research project/exhibition and temporary community tangible. "ARARAT" was not a finished "product" but a collective process of projective work without curatorial supervision in the institutional sense.[15] Instead, the "curatorial" was enacted collectively by a larger group of people, appearing in a wide variety of ways in the fields of editing, mediation, or spatial staging.[16] The report shows at the same time how far the show had

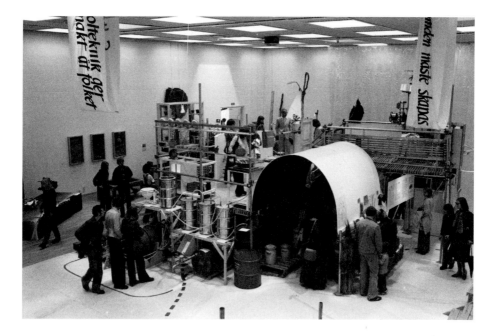

Inside "ARARAT": Visitors to the indoor environment, Moderna Museet

moved away from the conventions of the art world. To quote Helena Mattsson once again: "In 'ARARAT,' the museum as a privileged site was sharply questioned. In this case even the boundaries of its walls were transgressed along with the whole idea of the unique art object."[17] It was precisely this opening up of the institutional framework, the direct, interactive approach to visitors, and the renunciation of individual artistic and curatorial authorship that was the basis for the radical effect of the exhibition.

Against this background, it seems unusual if not peculiar that the exhibition, which—despite the overall positive reception and high attendance figure of 35,000 visitors—has only relatively recently found a place in Moderna Museet's own historiography,[18] was subsequently shown in parts in the Nordic Pavilion of the Venice Biennale, effectively re-located into the midst of the international 'art world machine'. It is hardly surprising that "ARARAT," according to some contemporary witnesses such as Gunilla Lundahl, lost its criticality once crammed into the corset of the biennial.

And today? Does the academic preservation of the canon in museums and the increasing professionalization of exhibition making with its cult of the curatorial, its authorial habitus,

and its immanent legitimation constraints stand in the way of a free spirit? Are the pressures of project and market economics—always disguised as a presentation of the "up and coming"—and the striving for prestige or profile raising through popular blockbuster shows—a self-constructed obstacle of large exhibition houses—something which can be overcome?

In recent years, work in interdisciplinary collectives and activist practices in the artistic context have seen a resurgence in response to the dominance of neo-liberalism,[19] and several institutions have opened up to the sociopolitical potential of these forms of critical art and counterhegemonic "artivist" practices. One example might be an institution like BAK (basis voor actueele kunst, Utrecht), with its program oriented towards hybrid exhibition-workshop formats and public forums, where *Trainings for the Not-Yet* and *Propositions for Non-Fascist Living* address questions of social engagement. Equally significant examples are The Showroom (London), Casco (Utrecht), Casa do Povo (São Paulo) and Tensta Konsthall (Stockholm). In addition, there are a multitude of non-profit art spaces and independent artist-led initiatives such as La Colonie (founded in 2016 by artist Kader Attia and others) that are more dynamically and directly involved in current discourses than the established—and in the less favorable case, stale—flagships of the institutional sector.

A revisiting of the idea of the museum as a critical space and an advocacy of open, collective and communicative processes would be desirable and a chance for participation, criticality, and public involvement. With a turn towards critical art practices, museums can—to speak with political theorist Chantal Mouffe—"become privileged places for escaping the dominance of the market."[20] Or, to quote Oliver Marchart, they may be turned into "potentially powerful *counterhegemonic* machines."[21]

To glimpse the booklets and pamphlets printed for "ARARAT" is still astounding. The idealistic spirit of the project with its occasional Marxist echoes and holistic belief in a new life may have a certain zeitgeist feel about it, yet the issues dealt with not only seem to be taken out of the now—in the face of accelerated capitalist globalism they are indeed more topical than ever:

"Awareness of the limitations of our planet and the delicate balance of the ecology must, in order to have any meaning, result in political action. We must take a standpoint against our exploitation of the peoples of the Third World and their share of the resources of the earth. We must be prepared to pay a fair price for goods we import. We must support the people who are fighting against oppression by a ruling upper class. We must come out openly against fascism, even at close quarters, both neo-Nazism in Germany

as well as the exercise of power by transnational companies in our own country. We must choose our enemies! Starvation is not a natural catastrophe. No technology can give food to people who are starving because the flow of protein passes from them to us. As long as the toil and hunger of others is the basis of our own prosperity we cannot rest content by solving our own "energy problem." The society and technology that we create must be based on a fair distribution of the world's resources. But this calls for planned housekeeping of energy and raw materials in our country. Planning in which a capitalistic society will never be interested. You must choose your opponents."[22]

Reverse side of the exhibition pamphlet for "ARARAT," printed bilingually for the 37th Venice Biennale in 1976

Perspectives on Collective Expression, Ongoing Process, and Open Institutions

The exhibition and collective research initiative "ARARAT" (1973–76) had a lasting influence on numerous biographies and professional trajectories. Further projects in ecological and social activism as well as architectural research followed and several groups and constellations that emerged from "ARARAT" have carried forward the thoughts and goals of the project, such as the cultural collective *Kapsylen*, which settled in a factory building in the working-class neighborhood of Södermalm in Stockholm in 1976 and is still active today.[23] Gunilla Lundahl, who was part of "ARARAT" over long periods as editor of the accompanying publications, identifies the project as a formative experience in her professional life. In a series of conversations and emails, she described the special nature of the exhibition as well as its productive aftermath and reflected on the role of collective work, open processes, and a possible transformation of museum institutions.

Julius Lehmann: "ARARAT" was an open process without predefined ending. A demonstration and, in a way, a model. How would you describe the character of the project and its genesis?

Gunilla Lundahl: You could say that "ARARAT" was both, an open process and an exhibition that took place between the beginning of April and the beginning of June 1976 on Skeppsholmen: The full title— "Alternative Research in Art Resources Architecture and Technology"—indicates that it was a research program which also manifested as an exhibition. It had begun already in 1973 with discussions in an inner circle. It was unpaid work at first but over the years it was supported by institutions, departments,

Moderna Museet, Konstakademien (Royal Academy of Fine Arts). New people connected with the project. For example, one little seed was *Ekoteket* which initially was a collection at my editorial room for *Arkitekttidningen* (AT): In the beginning of the '70s much information about ecological questions and ecological technology was flowing into the architectural world but it was not easy to get access to it and to have an overview. A lot of information landed on my editorial desk and I proposed that it could be taken over by an institution with more resources where more people could use it and build further on it. Which is what happened. Twelve persons went to the US for a month to study technology and architecture. Others went to England. The content

was always growing and often disputed in surrounding and connected circles.

The first constructions and experiments took place in Torpedverkstan near to the museum a half year before the opening. The planning group was constituted by almost twenty people with different responsibilities. Almost all members continued afterwards with the topics they were engaged in there, finding new partnerships and new ways to continue. The exhibition was a moment and an experiment. It was not decided in advance that the exhibition should take place at Moderna Museet but it turned out to be convenient. Its character was open because the initiative came from different clusters that were interested in the same topic. It could have happened anywhere, of course, but it happened in Stockholm, a year after the deeply contested decision to build nuclear plants in Sweden.

When "ARARAT" took place Pontus Hultén was no longer the director of Moderna Museet; Philip von Schantz had succeeded him, taking over the responsibility to hosting it. Von Schantz was more interested in traditional art, he was friendly to "ARARAT" but not engaged. The museum also hosted seminars and programs. But "ARARAT" was excluded from the official history, not fully included in the archive. As was the case with "Modellen" which we staged in 1968.

"ARARAT" was not about artwork in the conventional sense. Still it was presented in Venice at the Biennale afterwards in the form of an artwork (with Björn Springfeldt as commissioner of the Nordic Pavilion). In my opinion, it lost its radical meaning as art there, when the pedagogical, inclusive, questioning aspects moved into the background in favor of an artistic, conceptual show.

JL: You were responsible for editing "ARARAT"'s supporting publications. What was the concept behind the different publication formats and how were they linked to other activities around "ARARAT"?

GL: There was a lot of research and access to research collected in the exhibition that became a resource for universities and was used by students at architecture schools. The exhibition broadened the debate. But there was also disappointment in the fact that in politics the show's traces were few. The publications, a complement to the exhibition, lost their home when the museum dropped them. Issues 1 and 2 were statements about "*humanekologi*" (human ecology) from a group of researchers from Centrum för tvärvetenskap (Center for Interdisciplinary Studies). Issues 3–6 featured essays from experts about sun, earth, water and air—the basic elements treated in the exhibition. Issue 7 gave

The Solar House under construction. Photo: Hans Thorwid/Moderna Museet

an answer to why and how "ARARAT" came to life through documentation of the project. Issue 8 introduced books on ecology, a selected bibliography of Swedish and English literature. The big catalogue described the exhibition and was an introduction. The front section of the catalogue presented the whole exhibition. All participants were represented with their own sheet.

The publications were far from glossy, printed on raw recycled paper which gave a hint of the mood of the whole project. I think it was the first time recycled paper was introduced in such a context. Their humbleness was a bit provocative both for the museum and some participants who had preferred something more impressive. The booklets were without a doubt helpful, but I don't think the time was ready for the books' overall expression. The design was created together with Kerstin Abram-Nilsson and the printers—owned by the Left party— were the ones I worked with as editor of *Arkitekttidningen*.

JL: Is the special openness and freedom that characterized "ARARAT" still conceivable in today's world of art institutions?

GL: I think that any museum could act today as Moderna Museet did—being a host but not a part of a project/ exhibition—and perhaps treat it as a way to learn or get new ideas. If museums stopped looking at themselves as institutions with a self-sufficient agenda and repositioned as a resources, an open workshop offering professional communications and rooms for groups and individuals, this could develop into a more radical way to make themselves important. I think Riksutställningar in Sweden could be a good example. But there are big obstacles. You can't overcome the difference between:

1) Paid and unpaid work in a capitalistic system. That determines the borders for work.

2) The difference between work as life and work within a regulated system. It influences your engagement.

3) The idea of art as a defined product in contrast with the view of art as an ongoing process or a collective expression.

Today you can see how smaller art institutions in suburbs round Stockholm and other places like Tensta Konsthall, Konsthall C, Botkyrka Konsthall, and Marabouparken are working to become resources for groups and interests that are formed in the society around them,

giving them support and space and thereby also redefining art. There's hope but still you have to rely on personal engagement and unpaid work. Much self-reflection is needed. Their work recalls for me much of the behavior and thinking that made "ARARAT" possible. In a way it was a mix of very aware creations and a fair ground, which is another possibility for reworking the museum that remains open in form.

JL: How did the exhibition affect your personal perspective and your way of working in the field of art and culture?

GL: For me "ARARAT" was an experience that taught me important things about the necessity of making room for opposing arguments, views and conflicts, to make friends and widen my horizons and networks. "ARARAT" was a wonderful social experiment too. Revolutionary for all involved. A training in inter-reliance. It was important for my future work in writing, giving lectures, maintaining contact with students. Throughout my life I have been interested in the existential questions concerning our way of life that were addressed by this exhibition. On occasion I have had a chance to work on a particular aspect of these questions: When I was head of the exhibition department at Arkitekturmuseet in the early 1990s I curated "Den naturliga staden" (The Natural City), where I

could give more emphasis to our connection to nature to arrive at an alternative conception of the urban. It was important to awaken the exhibition goers' curiosity and to create a place where people could meet. In 1992 there was an international conference on ecological architecture in Stockholm and I was invited to be guest editor of *Arkitektur* 1992/8 which involved writing an introductory paper for the conference. This was another opportunity to take the discussion around ecology further which at this point risked becoming very technical. There was a curious debate about the beauty of ecological building which implied that ecology was diminishing the artistic aspect of architecture. There was room here to open up a new question about art in architecture. As a member of Stadsmiljörådet, a state council for city planning, I could use my experiences from "ARARAT" to increase the attention paid to ecology and also to point out that the definition of good architecture must be a collective work, produced in ways of which, at the time, "ARARAT" was a unique example.

"ARARAT" was a great experience, and continues to resonate throughout my life. Even when it comes to art and working with exhibitions. Collective efforts can make another world possible. It's by giving form to utopias that one brings their potential into reach. Through exhibitions you can bring them alive. Collective work and flat structures are necessary, and you must give them the time to arise.

Make friends.

Best wishes
Gunilla

Email from Gunilla Lundahl to Julius Lehmann, February 27, 2021.

1. The island had been in use as a military base since the 17th century.

2. "A Question of Survival / Una questione di sopravvivenza," in *ARARAT*, eds. Rolf Börjlind, Monica Nieckels, Björn Springfeldt (Stockholm: Moderna Museet, 1976), 1.

3. "ARARAT. En utställning på Moderna Museet," press release, Moderna Museet, 1976. Moderna Museet Archives (MMA MA). Our translation.

4. Olof Antell, "Choose your Opponents! / Scegli L'avversario!," in Börjlind, *ARARAT*.

5. "Participatory Research! / Ricerca partecipativa!," in Börjlind.

6. For more information on the three houses, see: Christina Pech, *Arkitektur och motstånd: Om sökandet efter alternativ i svensk arkitektur, 1970–1980* (Göteborg, Stockholm: Makadam förlag, 2011).

7. Pech, *Arkitektur och motstånd*, 223–227.

8. A detailed and photographically illustrated documentation of the exhibition with excerpts from the catalogue can be found in the 40-page booklet "Utställningen ARARAT—en dokumentation, rapport från Ekoteket," no. 4–5 (1978).

9. Helena Mattsson, "Demonstrations as a Curatorial Practice: The Exhibition Scene at Moderna Museet from She to ARARAT, 1966–1976," in *Exhibiting Architecture: A Paradox?*, eds. Eeva-Liisa Pelkonen, Carson Chan, and David Andrew Tasman (New Haven: Yale School of Architecture, 2015), 133–146. See also: Helena Mattsson, "ARARAT," in *Exhibit A: Exhibitions that Transformed Architecture, 1948–2000*, ed. Eeva-Liisa Pelkonen (London: Phaidon, 2018), 186–193.

10. "Hon" was realized as a collaboration between Niki de Saint Phalle, Jean Tinguely and Per-Olof Ultveldt together with Pontus Hultén. The idea for the exhibition can be traced back to a discussion in 1955 between Tinguely, Ultveldt, Hultén and Hans Nordenström on how a "theater-art exhibition" could be realized. See Helena Mattsson, "Demonstrations as a Curatorial Practice," 137.

11. Helena Mattsson, "Demonstrations as a Curatorial Practice," 139; "On the Exhibition 'Modellen' (1968)," in *The New Model: An Inquiry*, eds. Lars Bang Larsen and Maria Lind (Berlin: Sternberg Press, 2019).

12. A meeting of countercultural actors from the US and Sweden took place in 1972, when the activist group around Stewart Brand, Hog Farm, settled on Skarpnäck during the UN Conference on the Human Environment, a situation described by Felicity D. Scott as "Woodstockholm." See: Felicity D. Scott, *Outlaw Territories: Environments of Insecurity/Architectures of Counterinsurgency* (New York: Zone Books, 2016). See also: Diedrich Diederichsen and Anselm Franke, eds., *The Whole Earth Catalogue: California and the Disappearance of the Outside* [exh. cat. HKW Haus der Kulturen der Welt, Berlin] (Berlin: Sternberg Press, 2013). See also: Andrew Blauvelt, ed., *Hippie Modernism: The Struggle for Utopia* [exh. cat. Walker Art Center, Minneapolis] (Minneapolis: Walker Art Center, 2015).

13. "Most Important Exhibition Ever," Börjlind et al, 4.

14. Kerstin Abram-Nilsson, quoted in "Gunilla Lundahl: Five Exhibitions Important in My Professional Life," unpublished manuscript, 2020.

15. Björn Springfeldt and Pär Stolpe were involved in the museum side of the organizational process.

16. For a conceptual reflection on collective practices in the art field, with a particular focus on the period from the 1990s to the present, see Maria Lind, "The Collaborative Turn," in *Taking the Matter into Common Hands: Contemporary Art and Collaborative Practices*, eds. Johanna Billing, Maria Lind, and Lars Nilsson (London: Black Dog Publishing, 2007), 15–31. On the concept of the "curatorial," following Chantal Mouffe's notion of the "political," see Maria Lind, "The Curatorial," in *Selected Maria Lind Writing*, ed. Brian Kuan Wood (Berlin: Sternberg Press, 2010), 57–66.

17. Mattsson: "Demonstrations as a Curatorial Practice," 142.

18. See: Hans Hayden: "Double Bind: Moderna Museet as an Arena for Interpreting the Past and the Present," in *The History Book: On Moderna Museet, 1958–2008*, eds. Anna Tellgren, Martin Sundberg, Johan Rosell (Göttingen: Steidl, 2008), 177–200; Annette Göthlund: "Activities in the Workshop and Zon: Art Education for Children at Moderna Museet," ibid., 257–280.

19. See Oliver Marchart, *Conflictual Aesthetics: Artistic Activism and the Public Space* (Berlin: Sternberg Press, 2019).

20. Chantal Mouffe, *Agonistics: Thinking the World Politically* (London: Verso, 2013), 101.

21. Marchart, *Conflictual Aesthetics*, 26.

22. Olof Antell, "Choose your Opponents! / Scegli L'avversario!," in Börjlind, *ARARAT*.

23. Examples of follow-up projects, along with various festivals, include "Project 80" organized by the SAR, Svenska Arkitekters Riksförbund (Swedish Association of Architects), which looked at future living environments and workplaces from an ecological perspective. See announcement in "Utställningen ARARAT—en dokumentation, rapport från Ekoteket," no. 4–5 (1978). A group called *Vindens villjor* (Will of the Winds), toured Sweden demonstrating potential uses of wind-power.

Photo: Karl-Olov Bergström/Riksutställningar

Beauty as Infrastructure: Himla skönt. Vad är egentligen vackert? (Beautiful! But What Does Beautiful Mean?), 1989–90

Marc Navarro

Throughout 1989–90 a peculiar train with four carriages traversed the Swedish landscape. It would stop at cities and small towns regardless of their size and population. Painted in vivid colours it stood out among the rest of the trains making their conventional journeys on the same tracks. Beyond its cheerful outward appearance, however, what was so particular about that train? Why were its visits to those towns so exceptional? Inside that train was the exhibition "Himla skönt. Vad är egentligen vackert?" (Beautiful! But What Does Beautiful Mean?).[1] Presenting objects from different Swedish museums and public collections, it gathered them together for the first time in the same space. Paintings, classical art, anthropological artifacts and even toys—all carefully selected by Gunilla Lundahl to raise a question that we rarely associate with public transport and its infrastructure: what defines beauty?

During a trip to Australia, Bengt Skoog, then director of Riksutställningar (Swedish Travelling Exhibitions), encountered the work of Patricia McDonald and in particular a very successful pedagogical project the pioneering museum educator had developed back in the 1970s: Australian Exhibition Trains. On his return, an agreement between Banverket (Swedish Rail Administration) and Riksutställningar made it possible to transform a four-carriage train into an exhibition space. Indeed, Riksutställningar's mission was to produce traveling exhibitions. Nonetheless this mode of transportation was unusual, challenging both practically and conceptually. The premise here was not the adaptability of the exhibition's elements to the different spaces in which they were to be installed, but rather how they would interact with the train's own architecture. From a practical perspective, the train made it simpler to move exhibitions from one town to another, moreover it brought to the fore questions of mobility, territory, and access to culture.

The use of trains for purposes other than passenger transportation is not new. The para-institutional possibilities of the train have been widely explored throughout the twentieth century. Before Patricia McDonald's mobile museum and school, as the train became a means of mass transport many other examples appeared. The so-called agit-prop trains toured Soviet Russia after the October Revolution, either to spread political propaganda, stage theater plays, or as part of the fight against illiteracy in isolated parts of the country.[2] Some decades later, in the '60s, Cedric Price projected the Potteries Thinkbelt, a mobile

higher education center for Staffordshire that, if realized, would have used train cars as classrooms.[3] By extending an invitation to Gunilla Lundahl, Riksuställningar was updating some of these seminal ideas and initiatives, exploring the possibilities of the train as a vehicle for display.

The invitation represented an opportunity to work with objects and artworks of diverse provenance loaned from the National Swedish Collections and hosted in museums all over Sweden. One of the conditions set in advance by the organization was that the project should in some way deal with "Swedishness." At this time, the development of a project usually began with a written synopsis or script that the institution commissioned from an external source. After putting together a first draft, those preliminary ideas would then be shared with the rest of the team. When Gunilla Lundahl presented the concept for "Himla skönt" to the organization, the question of national identity was immediately put aside. Instead, her project, would deal with beauty and its ambivalent character: on one hand, beauty seems to be addressed only by specialists, yet on the other, everyone has a personal conception of what is beautiful and what is not.

"Himla skönt" was not the first project of this kind that Riksutställningar had produced. One year previously, Lars Nittve, then chief curator at Moderna Museet, produced for the institution the exhibition "Landskapet i nytt ljus" (Landscape in a New Light). The show did what it said on the tin, using artworks in Moderna Museet's collection to explore the idea of landscape. Despite the exceptional opportunity and possibilities presented by the train as a way of literally situating landscape in relation to local contexts, the presentation was conventional both in terms of display and mediation. Indeed, the substantial differences between being in a museum or on a train were barely noticeable.

The intention of "Himla skönt" appears to have been more or less the opposite of the landscape show. Although the works of art in this case also established a narrative according to a specific topic, the design of the space and the interaction with the audience contributed to defining the concept and the experience of the show. The exhibition space was conceived to engage audiences in a discussion and in the process to confront multiple definitions of beauty. Objects were displayed dramatically in vitrines and theatrical settings, at times overlapping and introducing friction for the viewer. "Himla skönt" was immersive, playing with multiple layers of significance and approaching interaction in alternative ways. The exhibition became a place to read, listen to music, discuss, and play. An exhibition suitable for all ages, carriage after carriage played out as a subversive experience, dreamlike and intriguing, whether the viewer was a child or an adult. The mode of display assisted in

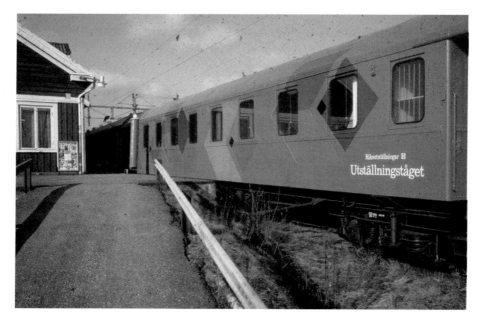

Photo: Karl-Olov Bergström/Riksutställningar

creating an environment loaded with meanings, and nuanced overtones. The space was at times sumptuous, like a *wunderkammer*, at others threatening, or—in the first car where the library was installed—intimate and welcoming.[4]

Exhibition design is by no means neutral. In 1968 Gunilla Lundahl visited Warsaw as a correspondent for the design magazine *FORM*. That trip gave her the chance to view constructivist art at close hand and to encounter a different museographical tradition. It was a revealing experience. Although the display of the artworks was simple, her impression was that the objects were shown as if they were subjects themselves, with agency. The architectural design for "Himla skönt" was infused with the aesthetics of post-modern style or, as Stefan Alenius likes to say of his projects of that period, "modern mannerism." The interiors were anything but simple, and the profusion of decoration and of materials— real or fake—emphasized the singularity of every object. In an email exchange Alenius recalls of the show that, from an architectural perspective, the space's thrilling dimensions made it especially difficult to find the oft demanded "narrative rhythm." A combination of drapery, columns, and mirrors with Stefan Wiktorsson's careful lighting design enabled the space to unfold with ceremony, playing with the audience's perceptions, just as do Mannerist architecture or fairy tales, for that matter.

"Himla skönt" brought art to faraway places never visited by "big cultural events." The train made it possible to take the exhibition wherever there was a railway track without any additional installation or technical requirements. Like many other projects produced by Riksutställningar, the aim was to make art accessible and the exhibition informative and democratic. However, here it also provided an effective medium that facilitated fresh perspectives on certain issues. The origins of the organization date back to 1965, when the Swedish government outlined a plan to promote culture with a particular emphasis on gender equality, childhood and interculturality. The priority target audience were children and young people, although all-audience exhibitions were produced as well. The agency's function was to disseminate culture throughout Swedish territory, designing and producing touring exhibitions that would provide critical tools to Swedish society to analyze its present. The pedagogical aspect, one of Lundahl's main areas of practice, was especially relevant to Riksutställningar, which, although it did not have a pedagogical department, always considered this question by opening discussions with the various core members of the organization.[5]

In order to better position the work Gunilla Lundahl developed for Riksutställningar we must here take into account the professional trajectory of the person in the organization who invited her to work with them, and briefly look at some of the exhibitions that she produced there since the late '6os. Eva Persson started working for the organization in 1967 and was behind a series of groundbreaking projects produced during the '6os and '7os dealing with particularly critical and incisive topics.[6] "Den rike mannens bord" (The Poor Man's Table, 1968–71), dealt with the unequal distribution of basic resources and "Förbud mot handikapp" (Disability: Prohibited, 1971–73) was a controversial project looking at the ways in which economic and social factors worsened the living conditions of functionally diverse people. Eva Persson's politically charged perspective complemented Gunilla Lundahl's concerns and engaged positions. How, then, is political thought manifested in a project about beauty?

"Himla skönt" put the polarity between center and periphery on the table for discussion. This was another concern also addressed in a previous project of Lundahl's on urban planning, "Det växer i Skellefteå Men hur?"[7] (Skellefteå is Growing. But How?, 1972). The project was commissioned by two state agencies: the Swedish planning department and the regional and local authorities in Västerbotten, a region in the north of Sweden. Lundahl—who was born there—was hired to explain the urban transformation about to take place in Västerbotten. Characteristically, she transformed this governmental commission into a critique of the abstract ideas that usually drive urbanism. These ideas often have little to

In the sculpture room, the representation of the human body took center stage. It included an archaic representation of a female body, a suit of armor, and a toy robot. The walls were covered with mirrors reflecting the audience and integrating them into the space of representation. Photo: Karl-Olov Bergström/ Riksutställningar

do with the reality of the places in which they are realized, nor the specific needs of a given population. The exhibition took the form of a series of environments and interventions constructed by a group of design students. In Lundahl's own words, these environments "reflected the topics under debate, making them recognizable in everyday life: the plans for forestry were explained by labels [the students'] attached to trees assembled ready for sale; the town planning was laid out on the walls of a street; regulations for housing were stitched into embroideries in a home, and so on." The exhibition was complemented by a program of meetings and discussions and with the crucial collaboration of organizations for popular education and assistance from a representative from Riksutställningar.

The reaction to the project was substantial: the government changed their strategy of communication and was forced to find out an alternative way to explain their urban plans

for the country. Several new organizations were created, four long-endangered rivers were finally saved, and even the name of the program was changed from "State Plan" to "Ground and Water" in an attempt to make it sound more neutral. "Det växer i Skellefteå Men hur?" acted as social glue, binding local organizations together, and offered them the platform of the exhibition.

The project fitted with some difficulty into the rigid logic of showing and displaying, and the inclusion of multiple voices left its mark on its final form—both in the way the project was presented and in its conceptualization. Irrespective of whether they take place in the street in the form of demonstrations or on a train, Lundahl creates situations and drives forward processes outside the museum, or by "parasitizing" the institution and breaking some of its deep-rooted behavioral rules. The public is not an abstract entity, it's a community who find in the exhibition a framework to reflect on their concerns, to represent themselves, and to collectively articulate their desires.

All this raises the question of how we are to approach Gunilla Lundahl's curatorial practice in terms of authorship. When she opens up a process to multiple voices and collective decision-making, Lundahl seems to refuse a certain notion of authority, but also of authorship. She explains that the final idea for "Himla skönt" arrived only after having multiple conversations with Stefan Ahlenius and the team. Yet should we refer to her practice as conversational, a method of working where discussion, and multiplicity of voices is decisive and essential? In that sense, it is also relevant that her objects offer an opportunity to non-specialized practitioners from diverse backgrounds to articulate some issues intuitively, outside of academia. For instance, in the publication accompanying "Himla skönt" Lundahl commissioned texts by authors such as Molly Johnson, Eva Ekselius, Anna Christensen, and Eva Lis Bjurman. Her intention here was to bring together academics with writers with a more working-class perspective.[8]

When Gunilla Lundahl reflects on her formation as a spectator, she refers to "Innocence— Arsenic" (1966), an exhibition designed by Lennart Mörk celebrating Swedish author Carl Jonas Love Almqvist. The show broke with conventions in terms of narrative and museography. Instead of presenting his life and works chronologically, Mörk created an environment in which artifacts and quotes from Almqvist were combined to create an immersive experience. Lundahl says that the show's "impressionistic," rather than pedagogical, exhibition design was something that made her think about the real constraints that come with exhibition making—in particular when it comes to text.[9]

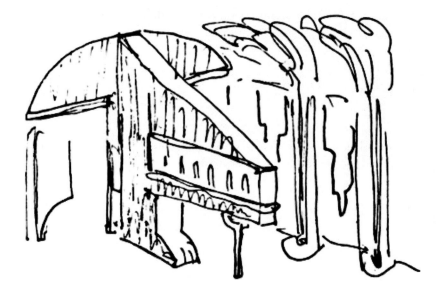

One of Stefan Alenius preparatory sketches for the design of "Himla skönt." Image: Stefan Alenius

Lundahl's convinction was that there should not be any text in "Himla skönt." Not a single word between the spectators and the artworks. Aesthetic theories of beauty are usually formulated by experts and, as Lundahl says, this is something that prevents us from establishing an intuitive relation with this topic. The relationship between the artworks and the viewer on Lundahl's exhibition-train was intended to be impressionistic, spontaneous, uncomfortable, and seductive by turns, and through its own specific means, just as the Carl Jonas Love Almqvist exhibition had been.

The refusal of textual information affected the mediation process, in particular if one takes into account the fact that the exhibition visited areas where museums were not common. In fact, for some visitors the train represented their first chance to visit an exhibition. This particular situation represented an opportunity to put into practice other possibilities and strategies, like introducing acting-improv sessions and mime. While in academia and in the museum the role of texts is to analyse, isolate, and contain beauty, by introducing performativity into the exhibition space "Himla skönt" destabilized the experience of the viewer and opened the door to something unexpected: to human intervention and disruption.

Elever ur Skellefteå-skolor i arbetet på utställningen.

Utställning väckte Skellefteborna!

"Exhibition brought to the people of Skellefteå!" reads the title of a 1973 article in the newspaper *Norländsk Tidskrift*. Gunilla Lundahl: "It was important to me that the exhibition should not look professional in the way familiar from advertising bureaus and common in the world of official communication. The young artists were building environments with an emotional mode of address and topics recognizable to anybody. That was basic for the whole concept." Photo: Gunilla Lundahl

Through her curating Gunilla Lundahl approached beauty not only as an aesthetic category, but as an ancient human phenomenon that manifests itself in myriad ways. In the early '90s British anthropologist Alfred Gell wrote a series of meditations on the agency of art and its role in social relations. In his text "The Technology of Enchantment and the Enchantment of Technology" Gell notes that "we recognize works of art, as a category, because they are the outcome of technical process, the sorts of technical process in which artists are skilled. A major deficiency of the aesthetic approach is that art objects are not the only valued objects around: there are beautiful horses, beautiful people, beautiful sunsets, and so on; but art objects are the only objects around which are *beautifully made* or *made beautiful*."[10] Gell's materialist definition of beauty puts production at the center: beauty can be *made* through art, therefore, beauty can be produced and redistributed. It would be imprecise to say that "Himla skönt" is only relevant because of its heterogenous approach to the idea of beauty. Gunilla Lundahl's curatorship also invites us to evaluate the role of beauty and artistry in relation to a specific community—as if a beautiful mask, a sculpture, a shield or a dress, were mediation tools for the members of those communities. As members of such communities it is our responsibility to evaluate the role that beauty and beautiful objects assume in relation to the people among whom these objects circulate. At the same time, we must ask ourselves: is beauty only a form of distinction? Who owns beauty? Does it belong to everyone?

Presenting more than one hundred artifacts, "Himla skönt" proposed an accessible and anti-academic approach to beauty. Quoting Eva Persson, "...[beauty] is a question that concerns the four-year-old who gets the wrong jacket for Christmas as much as the

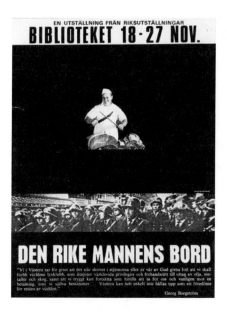

Poster by Sigvard Olsson for "Den rike mannens bord" (The Rich Man's Table), an incisive exhibition exposing the wealth gap between between the developed and developing world, produced by Eva Persson for Riksutställningar in 1968. Göran Palm was responsible for the script, and the artist Sigvard Olsson gave form to the show which toured forty Swedish public libraries. Image: Sigvard Olsson / Bildupphovsrätt 2021

80-year-old arranging a cosy corner on the geriatric ward."[11] This approach effectively deactivates certain conventions regarding reception of the work of art, proposing a more spontaneous mode of engagement. Gunilla Lundahl's curatorial approach is not about value, nor aesthetic and disciplinary coherence. Through this operation, Lundahl was estranging the idea of the "national collection" and questioning its hegemonic narratives. Although the exhibition was composed almost in its entirety of objects that came from the National Swedish Collections, this included many works of art and artifacts from non-Western countries. The integration of other artistic traditions invites us to question the formation of national heritage, and the assimilation of these objects into the museum's narrative. By emphasizing the itinerant character of these objects, Gunilla Lundahl de-territorialized the idea of beauty and gave a universal character to this phenomenon. By placing this heterogenous ensemble of objects within a structure that lacked a stable character, "Himla skönt" enabled a temporal framework of analysis that refrained from imposing a reading pattern—unlike so often when it comes to institutional mediation. If this is correct, what institutional model was Gunilla Lundahl trying out with "Himla skönt"? On one hand: an institution that proposes a transversal, dynamic approach to its objects and collection; on the other an open, accessible and flexible structure in which art is the vehicle, challenging us and provoking us to make connections and to reflect. Yet who, ultimately, is responsible for granting us access to beauty and art?

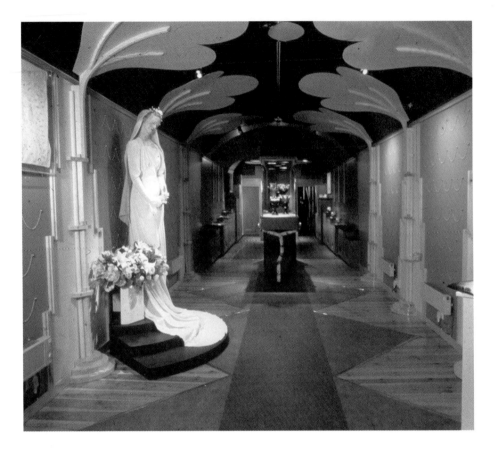

Installation view of "Himla skönt": Among the objects included in the exhibition by Lundahl were a white satin wedding gown and a gold sword. They exposed the anaesthetic effect of beauty in abstracting the violence of war and of social structures such as patriarchy. Photo: Karl-Olov Bergström/Riksutställningar

"In my opinion—Gunilla Lundahl affirms—beauty is a gift that enriches the soul of every human. The access to beauty is a human right and to a great extent the responsibility for this access belongs to the government. At present it is very unevenly distributed. There is also a serious lack of room for discussion around what beauty is and how one might claim a place for it in everyday life. This also concerns the opportunity to cultivate one's own openness to the gift of beauty and confront it together with others. If you are bringing those questions to a broader audience, you may also become aware of beauty's political strength."

Interviews with Gunilla Lundahl conducted between November 2020 and March 2021

Gunilla Lundahl on "Himla skönt. Vad är egentligen vackert?"

"Hïmla skönt"'s strong dramaturgical structure gave the exhibition a sense of story. The interior of the train placed the viewer into a space of opposites. Attachment or rejection seemed to be the best guide to navigating the show. Gunilla Lundahl explains how the exhibition was designed as follows:

My choices were guided by the theoretical content of each room. The first contained two benches next to each other, with overhead mirrors and masks on the walls. There visitors could sit down and start a conversation about beauty. Beauty in one's friends and in one's self, ways to hide or to enhance it, its importance, and so on. The next room was dedicated to the notion of the body beautiful and where such ideals come from. So, examples from antiquity were represented, as were children's toys, in styles such as rococo or modernist, in peace or war, hate or love. The next room was dedicated to facial expressions, what they expressed and how. So, contrasts were needed. This was followed by a room divided into two parts: feminine aspects of the production or appreciation of art in one, masculine in the other. Moonlight was given to the feminine part, sunlight to the masculine. Silver and gold. The needle that pricks and the rat trap. Objects that might provoke or intrigue the viewer. In the final room you could walk into paradise: A circular space for non-religious discussion of one's dreams of the unreachable. There were underlying themes and markers indicating the transition between sections—a (ceramic) lamb and a (taxidermied) wolf. Birth and death: a new born baby and the irondeath mask of King Karl XII.

The Indisciplined Train: A Conversation with Ulla Arnell

Ulla Arnell was in charge of "Himla skönt"'s pedagogical program. When she got involved in the project, Arnell had many years of experience at Rikutstallningar beginning in 1966, first as a sociological researcher, later as a curator and project manager. Over the years she worked for the organization her main area of interest was pedagogy. This led her to develop school-centered programs focusing on the relationship between education and contemporary art. In addition to questions of education, her tasks for "Himla skönt" included overseeing production of the exhibition, the mediation of the exhibits, and project liaison: establishing contacts with local associations, shop owners, and the press. Arnell was also responsible for the content of the library that was installed in the first carriage, and which included books for all ages, music related to the exhibition, and also, less conventionally, "a desk with boxes containing tactile objects such as small bridal crowns made of straw, and Mexican sugar skulls, as well as a comfortable chair in which to sit down and write your most beautiful thoughts."

Marc Navarro: How was the pedagogical program designed? Were any guidelines or goals imposed by Riksutställningar?

Ulla Arnell: When I was asked by Eva Persson to design an educational program for "Himla skönt," I had no direct practical experience of such work. Certainly I had worked as an exhibition producer at Riksutställningar focusing on schools, children and youth, which gave me vision, insight and pedagogical knowledge as I also followed the lively pedagogical discussion during the '70s and '80s. My previous work as a sociologist and the audience surveys that I worked with for ten years at Riksutställningar were also important.

These experiences became the basis of my pedagogical thinking.

Riksutställningar was a very open and permissive institution that gave us, the producers, great freedom for various experiments. Directives for our activities included trying out new and different forms of exhibition in new locations for new audience groups. We as producers needed to relate to the overall cultural goals laid down in cultural policy. On this basis, it was decided which exhibitions were to be produced and when. Once an exhibition idea, aims, and budget we presented to the management team was given the green light, we continued to work according to the guidelines we set ourselves. This was the case also in

"Himla skönt." It was the project group that formulated the goals.

One of the most important goals for Riksutställningar was to reach out throughout the country, to smaller and larger towns, to new exhibition spaces where we could meet new and unfamiliar audiences and also organizers. For this, the exhibition train was perfect.

MN: My impression is that "Himla skönt" was a project for all ages, from children to adults. When it came to the pedagogical program, did it take into consideration the public of all ages, or was it mainly concerned with children?

UA: I don't remember focusing on a specific target group. The exhibition train went all over the country and stayed for about a week or ten days in different places, smaller towns and cities. The train was in itself an unusual event and attracted attention, especially in the smaller places. We realized that we would have to relate to a very diverse audience with different interests and of all ages. In good time before the train was to arrive we invited the representatives of various kinds of local associations, study circles, and teachers to plan possible activities. On weekdays, there were all the scheduled school visits, including preschool, elementary school and special school. In the evenings and weekends, those

interested in art and culture—even those interested in trains—families with small children, young people, and many elderly people who had never visited museums and exhibitions. All curious were welcome. Many expressed their joy that their hometown had been visited by the exhibition train "Himla skönt."

MN: "Mediation" is a key word when it comes to contemporary artistic institutions. In "Himla skönt" the absence of text was compensated for with mime. This is a very imaginative and bold decision.

UA: I don't have any documentation and I do not remember much about this. Unfortunately, no summary evaluation was done as far as I know. Because the exhibition would not feature any text we decided to experiment with other forms of presentation such as mime. Through the Kulturarbetsarförmedlingen (Culture Worker's Employment Service) we could hire mimes and also dancers, artists, clowns, actors, art critics. Before we opened, they had a couple of introductory days in which to get to know the exhibition in discussion with Eva Persson, Gunilla Lundahl, the exhibition architect, and with each other. As I recall, the two worked for ten days in succession, with diferent mimes being present. When the train toured in 1989–90, the "guides" varied between the towns, some dropped out because

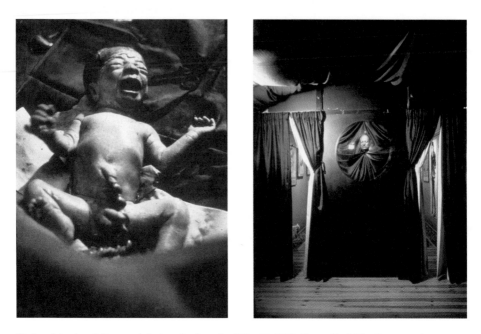

Birth and death: a delivery and the iron death mask of King Karl XII. Photos: Karl-Olov Bergström/ Riksutställningar

they had other engagements and new ones were added. The project group gave them a free hand to improvise on the basis of their different forms of expression, as did the visitors who thought it was exciting when something unexpected suddenly happened in an improvisation. When it came to school children and group visits, the "show" often began in the first room with the wall arrangement from which visitors chose a mask—expectant people sitting on the bench under "their mask." On the weekends when there could be very many visitors, screenings were sometimes held. The "guides" in different roles might have conversations among themselves and with the visitors, interspersed with improvisations and questions.

MN: Was the absence of wall texts a matter of debate?

UA: Exhibition texts were a recurring issue throughout all my time at Riksutställningar. There was no educational department. The question arose for each of the employees, especially the producers, and there were ongoing lively discussions around this. It's a complicated issue with many aspects ranging from readability to design to content. Some pushed the

issue of introductory texts. Texts at different levels, such as newspaper pages with introductions, easy-to-read texts. Labels next to the objects or texts collected in some places, texts at eye-level, layout, font, angle, etc. The discussion never really got that far until two of Riksutställningar's employees, together with a third person, published the book *Smaka på orden* (1991) [Texts in Exhibitions].[12] You probably know the book and its existence can well be seen as proof of a lively commitment to exhibition texts. The book also aroused international interest and in England the authors' method came to be called The Ekarv Method after one of the writers. The book is very much about stylistics and also asked the important question of who writes the text. The researcher? A journalist, writer, poet? Many courses were arranged and there were many in the museums who tried to apply the method. But it also received a lot of criticism for not being enough. Eva Persson has written several articles about texts in exhibitions in the web magazine *UtställningsEstetiskt Forum*, she emphasizes how for the text to be good it should be integrated with the design.

MN: In her book, written years after the exhibition took place, Eva Persson affirmed that—despite the conflicts—in the end this was a very successful idea. What was the position of the organization?

UA: There were different views among the employees at Riksutställningar about producing an exhibition without texts, of course. I have no idea what Riksutställningar as an institution thought, it was never stated and the project group was not prevented from implementing this idea. Eva Persson herself has talked about one critical voice who thought that the exhibition's lack of texts was completely rude to the visitor. And of course, there were visitors who wanted them. As compensation, there were the "guides" and knowledgeable staff from Riksutställningar who visitors were happy to discuss the show with. In addition, the photo binders in the library that we could refer people to were popular.

Interview conducted in January 2021

1. It is difficult to give an exact translation for "Himla skönt." In this article we have used: "Beautiful! But What Does Beautiful Mean?" However, Gunilla Lundahl's most recent English version of the title was: "Oh, beautiful! What does that mean?" To give another example, in a 2007 article Ulla Arnell proposed: "Good Heavens—Such Beauty. What is really beautiful?" In its most common and colloquial sense "Himla skönt" can be translated as "Heavenly," "So good," or "So nice."

2. Peter Kenez, *The Birth of the Propaganda State: Soviet Methods of Mass Mobilization, 1917–1929* (Cambridge: Cambridge University Press, 1985), 58–62.

3. Pier Vittorio Aureli, "Labor and Architecture: Revisiting Cedric Price's Potteries Thinkbelt," *Log*, no. 23 (Fall 2011), 97–118.

4. Eva Persson, ed., *UTSTÄLLNINGSFORM—I kroppen på en utställare 1967–1993* (Stockholm: Riksutställningar-Arbetets Museum, 1994), 132–141.

5. Ulla Arnell, "Riksutställningar: Swedish Traveling Exhibitions," in *Museums After Modernism: Strategies of Engagement*, eds. Griselda Pollock and Joyce Zemmans (Malden: Blackwell Publishing, 2007).

6. For more on Persson's trajectory at Riksutställningar, see Persson, ed., *UTSTÄLLNINGSFORM* (1994).

7. Björn Ed, Gunilla Lundahl, and Jaan Zimmerman, eds., *Det växer i Skellefteå Men hur? En utställning om planering* (Stockholm: Civildepartementet, 1972).

8. Gunilla Lundahl, ed., *Himla skönt. Vad är egentligen vackert?* (Stockholm: Riksutställningar, 1989).

9. Elisabet Stavenow-Hidemark, *Oskuld—arsenik: C.J.L. Almqvist i Nordiska museet* (Stockholm: Nordiska museet, 1966).

10. Alfred Gell, "The Technology of Enchantment and the Enchantment of Technology," in *The Object Reader*, eds. Fiona Candin and Raiford Guins (New York: Routledge, 2009), 210–211.

11. Gunilla Lundahl, "Exhibition Form: Under the Skin of an Exhibitor: 1967-1993," in *UTSTÄLLNINGSFORM*, ed. Eva Persson, 174.

12. Margareta Ekarv, Björn Ed, and Elisabet Olofsson, eds., *Smaka på orden: om texter i utställningar* (Stockholm: Carlssons, 1991).

Top left: The exhibition entrance with benches on either side and a collection of masks. Photo: Karl-Olov Bergström/Riksutställningar

Bottom left: The library featured a collection of books and articles, a desk inviting people to sit and write, and, most importantly, a table and chairs where audiences could discuss the show together. Photo: Karl-Olov Bergström/Riksutställningar

A Gendered Space for Reviewing Quality in Architecture: Kvinnorum, porträtt av arkitekter (Female Space, Portraits of Architects), 1991–92

Marja Rautaharju

"Kvinnorum," installation view. Photo: Stina Berglund

What if quality in architecture were to be defined in the terms of women architects and of their work? This was the question posed by "Kvinnorum, porträtt av arkitekter" (Female Space, Portraits of Architects). Gunilla Lundahl curated and organized the exhibition at Arkitekturmuseet (Museum of Architecture) in Stockholm while she held a temporary position as the museum's exhibition manager. Curatorially, her effort was to create a space both for the architectural profession's second sex and for an alternative understanding of quality in architecture.

Prior to "Kvinnorum" in 1991 there had been only a handful of exhibitions presenting female architects and their work internationally; in 1977, Susana Torre curated "Women in American Architecture: A Historic and Contemporary Perspective" for The Brooklyn Museum in New York. The project was based on the "Archive of Women in Architecture" collection initiated in 1973. In 1978, the international exhibition "Les femmes architectes exposent" was held in Centre Pompidou in Paris.[1] In Finland, Architecta, the association

of women architects, presented an exhibition on early female architects in Finland for Kunsthalle Helsinki in 1982. Later in 1984, the Finnish Museum of Architecture adopted the same materials for "Pioneering Women Architects from Finland," an exhibition that toured internationally, on view in Stockholm in 1986.[2]

Lundahl traces the starting point for the "Kvinnorum" exhibition process back to 1986, when Sveriges Arkitekter (Swedish Association of Architects) celebrated its fiftieth anniversary. To the great disappointment of many, few female architects were visible in the celebrations. A separatist association for female architects, Athena, was formed soon after in response. One association for women working in the building sector in Sweden had already been founded in the 1980s, Kvinnors Byggforum (Women's Building Forum). In years previous, Eva Rudberg, a researcher working at Arkitekturmuseet, had been researching and publishing articles about early pioneering female architects in Sweden. Lundahl gathered members and practitioners to discuss the possibility of making an exhibition on female architects. Arkitekturmuseet, both for its mission to present architecture and willingness to provide the necessary resources, became the longed-for meeting room for women architects. At the museum the where the history of the profession was felt Lundahl believed that highlighting the lack of female representation could instrumentalize a shift in perception.[3] Forty contemporary architects were invited to contribute to the exhibition, and only one declined the invitation.[4]

"Kvinnorum" was on view at Arkitekturmuseet for a period of three months in 1991 and the beginning of 1992. The exhibition brought together thirty-nine contemporary Swedish female architects to present themselves and most importantly their architectural work. The architects' presentations were complemented with information about early female pioneers of Swedish architecture, as well as works from contemporary female designers.

"Kvinnorum" was laid out in three rooms. Interior architect Karin Ahlgren was involved in the exhibition design process. Inspired by Thorvaldsen Museum in Copenhagen, Lundahl chose a strong color scheme to emphasize female presence in the exhibition space.[5] In the yellow room, female forerunners in Swedish architecture were presented alongside original material from the museum's archive. In the light blue room, contemporary landscape architects' and textile designers' work was on display. And finally, the aubergine-colored room served as the exhibition's core space, here the thirty-nine A1 panels presenting the contemporary women architects' works were installed. In the middle of the room there were big wooden tables. On the tables one could browse through architects' notebooks, and there were ceramic bowls filled with fruit and vegetables, creating an atmosphere of

togetherness.[6] Guided tours, debates, presentations, and celebrations as well as the two exhibition catalogues were each important elements of the exhibition.

Translating excerpts from Lundahl's own writing (the block quotes), the following text revisits the exhibition, a critical review, and Lundahl's response to this, revealing a case study of resistance and perseverance in feminist curatorial practice in the field of architecture.

I selected the 39 architects in "Kvinnorum." My choice was based on the quality of their practice and aimed to showcase variety, innovation, and empathy across a range of areas. Diverse means of expression and angles of approach, depth of knowledge, and breadth of experience were all considered.[7]

The making of the exhibition was a collective process in several ways, it arose from groups organizing and gathering for shared conversation. The invited architects were given a free hand to present their work on A1 panels. As a curatorial process this was open-ended and based on trust. As more and more people became aware that an exhibition was being planned, additional external resources were offered to the exhibition team. Friends working as ceramic artists loaned them ceramic bowls to place on the tables. Someone hinted about big tables that were available to be borrowed from Riksarkivet (Swedish National Archives).[8] A wide selection of writings and notebooks were laid out on the tables for closer study.

I chose work with A1 as a format as it was instinctive for architects. Each participant could present one project, though I made some exceptions. Contributors were given full freedom of expression within the format. The intention was to break with the conventions of architectural presentation; to demonstrate women's capacity to communicate through images in different ways, and to mediate ideas creatively. Now was the time. Consequently, the presentations were also productively diverse and included watercolors, drawings, sketches, private photographs, and images from established photographers.

"Kvinnorum" enabled a multiplicity to emerge within a simple, everyday presentation format. The A1 board was a universal object and tool of display for architects in the late twentieth century—a medium through which each had learned to compose, a simple format

allowing easy comparability but also personal expression. A well-established format in the profession, in schools, in architectural competitions, one might claim the A1 was mundane and unexciting. Yet at the same time, it was an accessible format for the exhibitors who all worked in the field. For visitors, the exhibition and its use of A1 was both an opportunity to get familiar with the architectural presentation and a chance to see many architects and styles rather than just one individual architect.

Holistic thinking was central to the presentation of "Kvinnorum." The 39 participating architects were presented as part of an assembly in which everyone was equal. Within this the collective offered each individual room for action. In the center there were two tables where visitors could sit—one for thinking and theorising, the other set with bowls and fruit, a place to be together which represented housekeeping. This was the framework. A statement of the feminine.

The exhibition space manifested a more inclusive and gendered perspective that had previously been uncommon in architectural discourse. Lundahl recalls that there were both spontaneous and scheduled events taking place during the exhibition, people gathering around the big table, happy to see each other.[9] Acknowledging "Kvinnorum" as a gathering, with gestures of socializing and domesticity present in the exhibition space, one is reminded of historical readings of the salon. The salon has been regarded as a social and cultural space situated between the private and the public sphere, serving as an intellectual and aesthetic forum. Salon culture is also seen as linked to the history of women entering the public sphere and intellectual life.[10] Associating "Kvinnorum" with the notion of the salon brings its exploration of public and private to the foreground.

Alongside the exhibition, Arkitekturmuseet published two titles dedicated to female architects' work. *Kvinnor som banade väg* (*Women Who Paved the Way*) which was about female architectural pioneers in Sweden, presenting twenty-four architects through interviews and archival material. The other publication, *Kvinnorum—porträtt av arkitekter*, included introductions from the thirty-nine participating contemporary women architects: a miniature reproduction of their exhibition panels, an autobiography, and a presentation of the single architectural project featured in the show. An introductory essay by Lundahl opened the publication, as well as two articles on the topic of women's architecture: one by Sigrun Kaul discussing female architects' practices, the other by Caroline Constant portraying Eileen Gray's work.[11] The formatting of the architects' biography was free in style, which allows the publication to deliver a diverse testimony

to women in Swedish architecture, and naturally also about architects' work in general in late twentieth century Sweden.

No "big name" architects participated. The anti-feminist onslaught had succeeded sufficiently widely that many considered it too risky to adopt a female perspective. If you participated in an all-female space, would you be associated with the B team? Would it annoy your male colleagues? Would you be placing yourself outside the "gender neutral" paradigm of modernism? The absence of famous names also indicated the harsh conditions endured by female architects.

"Kvinnorum" was harshly reviewed in the Swedish architecture magazine *Arkitektur* by Olof Hultin, its editor in chief. Hultin compared "Kvinnorum" unfavourably to the previous show at Arkitekturmuseet, "Aspekter" (Aspects), which presented the designs and philosophy of ten male architects in a more abstract and conventional manner: "If 'Aspekter' engaged with topical questions in architecture, 'Kvinnorum' is about something completely different. The question is, what? [...] All this is about as exciting as browsing the Athena member register, and one wonders if the show really does justice to the term feminism."[12]

Lundahl responded in a subsequent issue of *Arkitektur*, defending her curatorial approach and outlining her aims and the challenges she faced in organizing an all-female architecture exhibition. Lundahl's published response—from which some of the passages translated into English and reflected on in this chapter are drawn—should be celebrated as an early and generous record of a gender-aware and norm-critical approach to architecture exhibition making, a construction site for feminist curatorial thinking in architecture. Lundahl's observations on and questions about collectivity, architectural quality, hierarchies, feminism, and form have lost neither their appeal nor their topicality even now, thirty years later. She writes:

An engaged viewer would discover that the show communicated its ideas both through its content and its form. [...] "Kvinnorum" unfolded across three clearly delineated spaces, each with its own focus but linked together by a triadic color scheme. Temporary walls emphasized the materiality of the A1 presentations. Color and form shifted from drab to dissonant. The entrance to the show was decorated in the ostentatious richness of Empire-style but there were many soft and warm materials in the exhibition—linen,

cotton, rugs, ribbon, wood, glass, ceramics, plants, vegetables, and fruit.
Furniture was arranged to encourage the visitor to use the space, it was a
place for community and networking, not showing off. The lighting created a
kind of chiaroscuro effect, using shadow to delimit one work from another.
Was it feminine?

In Lundahl's introduction to the publication that accompanied the show, and in her
defence of her curatorial decisions in *Arkitektur*, the controversy over what it means to
be a female architect was as central as in Hultin's critique. Lundahl is careful to point
out differences in male and female architects' designs and way of working. She reveals the
motives behind the show's curatorial objectives in terms visibility—making space for a range
of women architects' work to be seen—and stating that an understanding of quality and an
appreciation of architecture is developed under patriarchal conditions. Importantly, she
also discusses the disadvantages of considering women architects as a homogenous group.

Some of the participating architects chose to discuss the question of associating as a female
identifying architect and participating in the exhibition in their autobiographical texts in
the pages of the exhibition publication. Diverse viewpoints and reflection are brought up.
Agneta Liljedahl writes that her career was built on terms set by men and recalls her two
daughters having had an absent mother. She states that she thought she was in the right
to act in a manner that would eventually lead to women's equality. Having reconsidered,
however, she states that a "Third Way" must be found, and that this is why she is curious
to participate in the exhibition.[13] The low number of female furniture designers is raised as
a topic worthy of discussion by Ulla Christiansson.[14] Elisabeth Edsjö writes that she does
not think that she has worked on different terms than men, and sees being in exclusively
female company in the exhibition as a coincidence.[15] Kerstin Kärnekull describes how her
experiences have made her see double, as if she had dirt in her eyes: she sees the ordinary
world where everything is a cross-section of the average, but also a world where men and
women have different rules and value different things, and where women have considerably
less opportunity to have a voice and get attention for what is important for them.[16] Eva
Asplund discusses architectural studies characterized by male thought and the high yet
gendered expectations projected on to female architects at work, also stating how she as a
woman would receive seemingly secondary assignments.[17] A recent experimental housing
project managed exclusively by women is depicted by Annika Schéele.[18]

An exhibition space in a public museum is in principle a public space, but during
"Kvinnorum" the museum space sought to discard some of its anonymous public quality,

creating a backdrop for questioning and looking beyond public recognition of architecture. The work of women in architecture was not widely discussed or debated in public, which implies that the discussion has taken place in more private environments and discursive spaces. By embracing the active form of a salon and playing with the dynamics of public and private, "Kvinnorum" sought to introduce concealed thinking and knowledge to the public discourse. Lundahl points to what is usually shown and what is overlooked when architecture is exhibited, stating that certain areas of architects' work is not well represented in various institutions, calling for a more inclusive range of topics and a more diverse understanding of what constitutes quality in architecture:

Bringing female architects and their practices to the forefront [...] is urgent, because it constitutes uncharted territory. Architecture can become richer and more interesting through bringing forward this dimension. Not because women have a monopoly on the topic of architecture, nor because their architecture would be better than that of men, but to create complementarity. Deciding what is important nevertheless remains a rather fixed masculine monopoly.

Lundahl's commitment to presenting female architects' work is linked to her interest in the notion of "home."[19] She conceives female architects as designing from the inside, proceeding towards the outside, since their personal experiences make them well aware of the functional requirements of architecture.[20] Her statements reflect on the historically gendered division of architectural labor. In the twentieth century, male architects were responsible for public buildings and other projects of higher visibility, whereas female architects have been receiving the "secondary" tasks of drawing housing, nurseries, and schools. What is more, the individual names written down in the history of architecture have been those of the principal designers of public projects—mainly men—even though architectural processes are collective in their nature. Considering the prevailing gender inequity in the field of architecture today, it is relevant to revisit Lundahl's writing linked to "Kvinnorum" as she explains and challenges gendered generalizations through deconstruction, unafraid to call for a shift in perception and more just practices.

The basic question is what is interesting, what is quality in architecture? Is it primarily facades, styles, philosophical abstractions, or is it also about frames of everyday life, processes of life, the spatial contents, interplay of users, and dialogue in society? If you look at what independently working women architects engage with, it is often about housing and care.

Presumably because they draw on their specific experiences and also find opportunities for these. The topics they work on are not visible in architecture magazines and museums. Yet they are what most concern the layperson. Is it, then, the women architects or the magazines and museums that are in the wrong?

1. Hanna Tyvelä, "Gendered Perspectives on Architectural Practices," *Finnish Architectural Review* 116, no. 2 (2019): 44.

2. Pirkko-Liisa Schulman, "The Changing Careers of Women Architects," *Finnish Architectural Review* 114, no. 2 (2017): 76.

3. Interview with Gunilla Lundahl, January 15, 2021.

4. Gunilla Lundahl, ed., *Kvinnorum: porträtt av arkitekter* (Stockholm: ArkitekturMuseet, 1991), 4.

5. Interview with Gunilla Lundahl, January 15, 2021.

6. Gunilla Lundahl, "Five exhibitions important in my professional life" (Unpublished manuscript, 2020), CuratorLab Archive, Konstfack.

7. All citations in blockquotes: Gunilla Lundahl, "Vad är kvalitet i arkitekturen," *Arkitektur*, no. 3 (1992): 62–63. Our translation.

8. Interview with Gunilla Lundahl, January 15, 2021.

9. Gunilla Lundahl, email message to author, February 25, 2021.

10. Ingrid Holmqvist, "Kvinnligt och manligt i Malla Silfverstolpes salong," *Kvinnovetenskaplig tidskrift* 16, no. 2–3 (1995): 34.

11. Lundahl, *Kvinnorum: porträtt av arkitekter.*

12. Olof Hultin, "Kvinnligt & manligt & mulligt," *Arkitektur*, no. 1 (1992): 71–72.

13. Agneta Liljedahl, "Agneta Liljedahl," in *Kvinnorum*, 60.

14. Ulla Christiansson, "Ulla Christiansson" in *Kvinnorum*, 52.

15. Elisabeth Edsjö, "Elisabeth Edsjö," ibid., 51.

16. Kerstin Kärnekull, "Kerstin Kärnekull", ibid., 77.

17. Eva Asplund, "Eva Asplund," ibid., 36–37.

18. Annika Schéele, "Annika Schéele," ibid., 65.

19. Interview with Gunilla Lundahl, January 15, 2021.

20. Lundahl in: Ingela Maechel, "Aspekter på manligt—kvinnligt," *FORM*, no. 1 (1992): 65.

LACE (Los Angeles Contemporary Exhibitions) created by Daniel J. Martinez

THE GLASS OPENS WORLDS

Elisabet Haglund's Curatorial Work at Kulturhuset, 1986–95

Marc Navarro, Hanna Nordell, and Erik Sandberg

Performance by Daniel J. Martinez in conjunction with the opening of the exhibition "Änglarnas demon" (The Angels' Demon) at Kulturhuset, Stockholm, 1990. Photo: Elisabet Hagund, from her personal archive

Introduction

By the beginning of the 1990s, the globalization of contemporary art had found its way to Kulturhuset (the House of Culture) in Stockholm—a relative periphery in the art world — where internationalism was mostly understood in relation to the geography of the NATO alliance. During this time, Elisabet Haglund was one of five curators employed full-time at the municipal institution. In her curatorial work some of the most urgent issues of the day were brought to the fore. Representation and the relation between art and geopolitics were among these. They are back on the agenda today, reminding us of her legacy in the context of curating in Sweden.

Haglund's trajectory in this period is testimony to a curatorial process that positioned contemporary art at the core of the institution, balancing cultural diplomacy with a kind of public promotion of transnationalism. Her work presented interesting examples of how to reject prevailing narratives by looking in other directions and reversing positions. For instance, choosing to work with indigenous art over mainstream historical trajectories, or questioning borders and hegemonic discourses rather than enforcing them. Haglund's exhibitions are animated by a palpable effort to dissolve the hierarchies that govern artistic disciplines—for example, when she includes comics or crafts within the field of contemporary art. Haglund continued to pursue and develop the work with which she was concerned in this period even after she left Kulturhuset in 1995, first as the artistic director of municipal Borås Konstmuseum (Borås Art Museum) in the southwest of Sweden, and then as the director of Skissernas Museum (Museum of Artistic Process and Public Art) in Lund, also in the south.

The selected exhibitions and projects in this chapter vary from those occurring within the framework of large-scale international exchanges like "viva BRASIL viva" to smaller exhibitions such as the presentation of works by artists José Bedia and Carlos Capelán. Together with "6 konstnärer från Katalonien" (6 Artists from Catalonia) and "Änglarnas demon" (The Angels' Demon) they demonstrate Haglund's fondness for collaborations with Spanish speaking parts of the world over the anglosphere. They can also be read as connected to a series of exhibitions that took place around this time and that problematized the discourse of the global contemporary art system. In this sense they are related to seminal exhibitions like the Bienal de La Habana in 1986 and 1989 curated by Gerardo Mosquera and "Magiciens de la Terre," an exhibition that took place at Centre Pompidou and the Grande Halle de la Villette in Paris in 1989, curated by Jean-Hubert Martin.

Whether the exhibitions were part of a larger framework, presentation of works commissioned for Kulturhuset, or touring exhibitions invited by the institution, Haglund's work shows a heterogeneous array of topics and research fields. In this sense, the genealogy of her projects before, after, and during her time at Kulturhuset traces a particular trajectory, trans-temporal and multidisciplinary, yet with artworks and artists always at the forefront. Haglund's interests range from popular culture and comics—her first exhibition at Kulturhuset was devoted to comic character Donald Duck—to the work of avant-garde artists such as Dorothea Tanning, Sigrid Hjertén, and Sonia Delaunay.

When Elisabet Haglund assumed the position of *utställningskommissarie* (exhibition commissioner) at Kulturhuset in 1986, the title curator had not yet found its way into the organization's lexicon. The function of the curatorial team covered the whole spectrum from what today would be the role of the producer to that of the curator. On the one hand, they had to oversee the production of the exhibitions, make and order texts, and ultimately supervise all the elements of a given project's organization and execution. The conceptualization of the exhibitions and their adaptation to the space were part of the usual tasks of the team, and its members changed roles depending on the project.

Tracing the trajectory of a few of Haglund's exhibitions gives an insight into how curatorial work was changing and being reconceptualized in the transition from the '80s to the '90s within this particular institutional framework. Kulturhuset was a large municipal organization with resources and networks, and an art department consisting of five curators with a technical team that together produced a variety of exhibitions and art projects. This enabled Haglund to work on research and relationships over time and across geographies.

Kulturhuset is a house of culture in the commercial center of Stockholm, with a glass facade revealing the activities taking place within as well as reflecting its surroundings. The idea of openness and transparency could also be used to describe Kulturhuset as a window on the world and a place for all forms of culture. Since its opening in 1974, Kulturhuset has become an emblem for citizenship and a symbol of the democratization of culture. An important and strategic asset in terms of cultural policy and cultural promotion.

Looking closer, Haglund's work in relation to the organization and program of Kulturhuset in this period gives an insight into possibilities for contemporary art in public institutions, with projects navigating between the house of culture as a free space for artistic production, and the structures of funding that enable it to exist. As a municipal organization Kulturhuset operates within the broad aims and directives laid down by the city's political

representatives. At the same time the institution relies heavily on support from government agencies—both in Sweden and abroad—to fund a program that in the period in question could include around 30 exhibitions a year, from small-scale presentations of contemporary art and photography to bigger events such as festivals and larger exhibitions taking place in several parts of the building.

Taking into consideration the characteristics of the projects hosted by Kulturhuset, some questions arise: how does the institutional setting intersect with the curators' aspirations? How do tasks such as programming, research, and organization shape curatorial work? Mapping curatorial work means looking into a wide range of processes, structures and situations that are connected to exhibition making. In this sense curating is connected to artists and artworks but also to the group of people one works with, the care given to professional relationships, the invitations extended to others, and the manner in which research is conducted. The curator is sometimes the initiator of a project, but they are also a host and a collaborator who supports the projects of others.

*

Elisabet Haglund was born in 1945 and grew up in the region of Scania in the south of Sweden. After studies in art history at Lund University, she continued doing research for a PhD. From 1971 she spent three years in Paris directing her attention to surrealism and psychoanalysis and the work of the surrealist artist Victor Brauner (1903–1966). Her dissertation on the subject was presented at Lund University in 1978. Haglund lived in Madrid until 1980 when she moved to Stockholm. For some years she wrote art criticism for the art magazine *Paletten*, among other publications. She was the Madrid correspondent, reviewing exhibitions and writing about artists from Spain for a Swedish audience. For short periods she worked at Nationalmuseum and Moderna Museet, and then later as the director of the Scheffler Palace, also referred to as the Haunted House, an institution with an important art collection belonging to Stockholm University. Haglund later served as the director of Borås Konstmuseum and Skissernas Museum in Lund, something that makes her one of few women in Sweden to lead a larger art institution. Writing has been at the core of Elisabet Haglund's practice and she has edited several publications in relation to the exhibitions she has curated. Her most recent publication has the title *Moln i konsten* (Clouds in Art) and was published in 2020. Elisabet Haglund currently lives in Stockholm.

Live performance by the French saxophone and dance group URBAN SAX in front of Kulturhuset, 1984.
Photo: Kulturhuset archive 1974–2013, Stockholm City Archives

A Cultural Haven in the City Center

Erik Sandberg

For almost 50 years Kulturhuset has served as a unique melting-pot for diverse cultural activities and forms of expression, a meeting place for people of all ages and backgrounds. Situated in the very center of Stockholm, almost on top of the central metro station through which all of the city's metro lines run, Kulturhuset is a distinctive piece of architecture and one of the first landmarks that meet the eye when one arrives there. Stockholmers take the iconic building for granted and don't really think about it today, yet it's position was not always a given. In 1945 the city council of Stockholm decided to restructure the lower Norrmalm district with the aim of creating a new and modern city center. Over the next three decades an extensive program of "city sanitation" was conducted. Known as *Norrmalmsregleringen* (Redevelopment of Norrmalm), it was met with both praise and criticism. The name of the process itself, *city sanitation*, sparked controversy. Residential blocks in the area known as *Klarakvarteren* were, in the eyes of the city council, run down and slum-like and consequently in need of cleaning up. Instead of large-scale renovation

they decided to demolish the mostly nineteenth-century architecture to make way for modern buildings with modern functions. By "modern" it seems that the city council primarily meant retail and business activities and, as criticism of the total lack of planned cultural activities in the ever more commercialized city center intensified, the city council countered with the plan to build Kulturhuset: a large, architecturally imposing building that could house a number of different cultural activities and artforms.

The idea of the house of culture was not new, originating as it did in France during the 1930s, but around thirty years later when the plans for Kulturhuset came into being, the term was not as widespread in Sweden as it is today. Since the 1940s so-called *Medborgarhus* (Citizen Houses) existed around the country which combined culture, entertainment and education under one roof but were not solely dedicated to cultural activities. Present in the greater Stockholm area from 1968 to the mid-'70s were informal structures of cultural practice and social engagement colloquially called *Allaktivitetshus* (House of All Activities), one being Gamla Bro, which was demolished in 1972 during the "city sanitation." The houses strived to achieve a non-hierarchical, horizontal and democratic organization where everyone was welcome to create and partake in cultural activities. The first institution to do so was Skövde Kulturhus, founded in 1964, which housed a theater, art museum, library, cinema and much more. The houses of all activities may have functioned as a model for Kulturhuset albeit in a more structured and institutionalized way. Part of the idea with Kulturhuset was to add culture to the new city center but also to function as a democratization of culture. Bringing all forms of culture together under one roof meant more people would be able to enjoy cultural activities, while placing this new cultural stronghold centrally would guarantee its accessibility and high visitor numbers. Kulturhuset would be built on a site at the very heart of the new city center, next to the central station, looking out over Sergels square and the start of the major street, Sveavägen.

> Kulturhuset is unique in Sweden for its size and location in the heart of Stockholm. It has become a welcoming counterweight to the otherwise commercial milieu around the city center. Because of its central location many visitors came to Kulturhuset. For many the proximity to Stockholm central station made Kulturhuset an important space to encounter art and culture.

In 1965 the architecture competition for Kultuhuset was announced and subsequently won by modernist architect Peter Celsing. Part of the Kulturhuset project was to design a new building for the state bank and temporary locations for the parliament during the renovation of *Riksdagshuset* (the Parliament House). Temporary offices for members of

parliament were housed in the newly built hotel Sergel Plaza while the debate chamber resided in Stadsteatern's (Stockholm City Theater) premises in Kulturhuset. In the initial stages of planning there was an idea of moving Moderna Museet (The Museum of Modern Art Stockholm) from its relatively remote location on the island of Skeppsholmen to Kulturhuset. The then director of Moderna Museet Pontus Hultén was in close contact with Celsing, discussing ideas for the new museum and its architecture and functions, but the long awaited relocation of Moderna Museet never came to fruition, partly due to a political power struggle between the city and the government.[1] Celsing thought of his winning proposal as a "sitting room for culture"—the five-story building with its large glass facade facing Sergels torg square and open-plan layout would bring the "atmosphere of the streets and possibilities of the workshop" into the institution.

> Because the building had several exhibition spaces and a large team we could produce many different exhibitions at the same time! Kulturhuset had the advantage of containing a programming department, library, child and youth activities and workshops, cafes, restaurants, and a roof terrace. The outdoor sunken plaza referred to colloquially as "Plattan" (the Slab) on the major public square, Sergels torg, opened up for outdoor performances, concerts, theater and film projection on the facade. The sculpture in the fountain outside marks the central point of Stockholm. The very idea of Kulturhuset is based on that diversity!

In 1971 the first stage of the building opened to the public, with the opening of parliament taking place in the city theater. The completed building would be inaugurated in 1974, with the last part of the parliament moving out in 1983. The theater's premises were occupied for another three years while they hosted the Conference on Security and Co-operation in Europe and the theatre itself would not move in until 1990. Both conceptually and architecturally Kulturhuset was a source of inspiration for the Centre Pompidou in Paris which opened in 1977 and was also thought out to be an open planned multicultural complex with the aim of decentralizing culture from the otherwise elitist culture institutions. The dynamic architecture of Kulturhuset with its large open floors, all connected by a spiral staircase, meant that every exhibition presented there could reshape the space using temporary walls and screens.

> The architecture with its modernist form and flexible open plan floors made it easy to relocate departments and realize refurbishments. Sometimes positive, sometimes negative—as for example when whole exhibition spaces have vanished.

The reconstruction of the entrance was unfortunately necessary as Kulturhuset only had stairs and two small public elevators plus the internal elevator for services and technical equipment. The new escalators installed in 1996 brought with them a wholly new flow of visitors but also a department store vibe and they took up a lot of space.

The openness of the architecture was also intended to increase collaboration and co-production in producing cultural experiences not limited by separate art forms. Throughout its history Kulturhuset's different departments have worked together to produce a diverse program aimed at an equally diverse audience.

> We often collaborated with Programavdelningen (the Programming Department), Läsesalongen (the Reading Salon), Allrummet (the Family Room), and with the center's youth activities, with positive results. Sometimes we competed for technology and carpenters, but it always resolved itself.

Collaborations were not only in-house. Combined efforts with external organizations were frequent as well. One example is the collaboration with a number of publishing houses to produce books. This was often in conjunction with exhibitions but the results were more elaborate than conventional catalogues, for instance *Boken om Serier* (The Book of Comics), 1986, or *viva Brasil viva—Konst från Brasilien* (viva BRASIL viva—Art from Brazil), 1991.

The art department of Kulturhuset was very productive in mounting exhibitions, with close to thirty individual shows a year that would present a wide array of themes and art forms. Since its inauguration there have been many exhibitions with an international approach focusing on specific geographical areas, often outside of the sphere of Western art.

> From the start the art department was committed to exhibitions of art, design, handicrafts, architecture, ideas and debate. The director at the time, Beate Sydhoff, viewed art in its cultural and social context, as was clear from exhibitions like "Mötesplats Afrika" (Meeting Place Africa), 1983, "Möt Indien" (Meet India), 1987, "De nya från Leningrad" (The New from Leningrad), 1988, "Från P till C—Kampen om Verkligheten, Björn Lövin" (From P to C—The Struggle for Reality), 1988.

The idea of gathering different cultural expressions and activities in one building was not the only inspiration drawn from preceding "houses of all activities." Kulturhuset had

ambitions to democracy and a flatter organization. Not least the art department in their process of selection and planning of exhibitions.

> Proposals for exhibitions came in from artists, action groups, photography associations, galleries, museums, private citizens, art schools etc., and were received by the art department. The proposals were then distributed between the curators in exhibition meetings that took place each Tuesday morning. The curators then presented the proposal and the group collectively decided if the proposal was interesting enough to take further. You also had to present attendant costs, technicians and carpenters' disposable time, available exhibition space, material costs, and so forth. The meetings were democratic and we could also propose our own exhibition ideas or other large-scale projects we collaborated on such as "Konstföreställningar" (Art Performances), 1987, "Frizon" (Free Zone), 1989, or "Revir" (Territory), 1994.

Kulturhuset has through the years received its fair share of criticism. Journalist, opinion-maker and notorious critic of Kulturhuset Kurt Bergengren wrote in his book *När skönheten kom till city* (1976) that Kulturhuset hosted all the cultural experiences that citizens could already find in the city, but now centrally. Seemingly unimpressed, he notes rather bitterly that while it is "at least something [...] No innovation in cultural life is noticeable."[2] It seems harsh to write off Kulturhuset in such a way a mere two years after it came into existence. Had Bergengren waited to vent his spleen he would have had the chance to take into account some of the groundbreaking exhibitions to come, and maybe his verdict would have been different.

> The first large scale video exhibition in the Nordic countries was Kulturhuset's "VIDEO/ART/VIDEO" in 1985 organized by Sissi Nilsson, Philippe Legros and Kerstin Danielsson, with contributors such as Wolf Vostell, Theresa Wennberg, Nam June Paik and Brian Eno. The Programming Department also participated in the project with "Stockholm International VIDEO ART Festival '85" and Allrummet with "VIDEO WORKSHOP."

There is a certain ambivalence to the whole Kulturhuset project. On the one hand there is the democratic idea of making culture readily available to everyone, and the creation, as Celsing put it, of a sitting room for culture where everyone could feel welcome. On the other hand, Kulturhuset was undeniably tied to the city sanitation project and the commercialization of the city and its people's lives. The concept of the well-populated

institution also meant a lot of potential customers for commercial activities either at Kulturhuset or in its vicinity. One can see Kulturhuset as compensation from the city council for all the informal cultural activities that were lost in the process of "urban renewal," for the lack of new planned cultural activities, and as part of a wider commercialization of culture. Yet cynical city planning does not have to imply a lack of dedication on the part of Kulturhuset's staff to creating plentiful high-quality cultural activities in the center of Stockholm, and this was not the case during Elisabet Haglund's tenure.

In 2013 a large-scale reorganization of Kulturhuset's structure took place. Instead of being directly under the control of the city's cultural department, Kulturhuset and Stadsteatern were integrated into a single city-owned stock company, with economic profit cited as the key motive. In response to this restructuring the director of exhibitions Margareta Zetterström, who had curated—among others—the shows "Leonardo da Vinci" (1994), "Lousie Bourgeois" (2002), and "Yoko Ono, Remember Love" (2004), left her position. As a part of the institutional overhaul the organizational structure of Kulturhuset was further compartmentalized. Fusing Kulturhuset and Stadsteatern was met with criticism not only for its commercial basis but also for a fear of loss in cultural diversity and quality. Still, Kulturhuset remains a living institution for many, the library Läsesalongen is still well populated, the youth library LAVA has since its inauguration been an important meeting place for many, and International Writers' Scene attracts important writers from around the world. Art, on the other hand, seems to have suffered from the restructuring of the institution. An obvious example of this is that Kulturhuset now only produces six exhibitions each year—a decline in quantity that unfortunately has not been accompanied by a rise in quality.

The indented parts of the above text are excerpts from an interview with curators Elisabet Haglund and Sissi Nilsson who worked together in the art department of Kulturhuset between 1986 and 1995. The interview was conducted via email by Erik Sandberg, Hanna Nordell, and Marc Navarro in January 2021.

1. For a more detailed account of Hultén's vision of a new museum and the political process behind Kulturhuset's genesis see: Kim West, "The Exhibitionary Complex: Exhibition, Apparatus, and Media from Kulturhuset to the Centre Pompidou, 1963–1977" (PhD diss., Södertörn University, 2017).
2. Kurt Bergengren, *När skönheten kom till city* (Aldus: Stockholm, 1976), 308. Our translation.

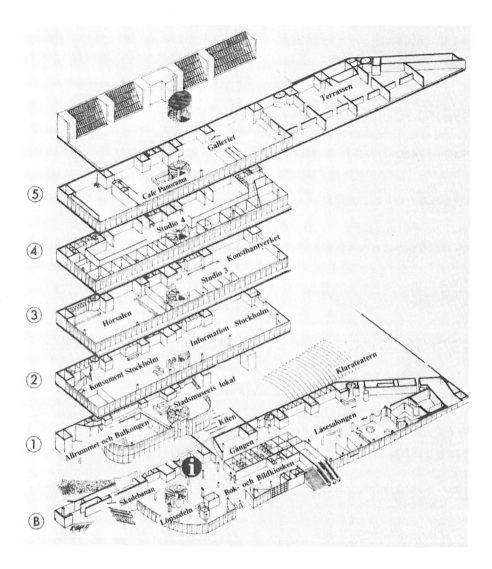

Plan of Kulturhuset in 1974, from the publication *Kulturhuset*, Stockholms Kulturförvaltning, 1984

A Conversation with Elisabet Haglund

Marc Navarro/Hanna Nordell/Erik Sandberg: Your trajectory has taken you from Kulturhuset in Stockholm, via Borås Konstmuseum, to Skissernas museum in Lund in the southernmost part of Sweden. In each institution, you have broken new ground, often working with artists from outside the so-called Western world, and often also with women artists. How did you relate to the international profile of Kulturhuset upon your arrival and what was Kulturhuset like as an organization at that time?

Elisabet Haglund: I have always been an international person. I started to work at Kulturhuset in 1986 after having spent around seven years in Spain and three years in France. The institution already had an international direction when I came there. Kulturhuset had been active as an institution since 1974, and when I started it was divided into two sections because one part of the building housed the Swedish Parliament. The director of the art department at Kulturhuset was also managing the other municipal art center in Stockholm: Liljevalchs konsthall (Liljevalchs Gallery).

During the years that I was at Kulturhuset the director was Beate Sydhoff, and we were around five curators working at the department. Beate Sydhoff was very open-minded, never said no to anything, and liked to listen to new ideas. When we first met, she asked me if I had a particular project I wanted to do. I responded by proposing a show about Donald Duck. She immediately agreed and we decided to make an exhibition with comics. In this project I collaborated with my colleague Philippe Legros, and in preparation for the exhibition I traveled to New York to meet various comic makers such as Art Spiegelman and Lee Falk. The exhibition took place in 1986 and I invited, among others, Robert Crumb who has done important work within the field of comics and art. He spent some time in Stockholm and made a painting for the large windows of Kulturhuset facing Sveavägen. Sweden's Prime Minister Olof Plame had been shot dead further down that street only a couple of months before, so the location of the work was of significance. The painting is now in the collection of Moderna Museet.

MN/HN/EF: How were the exhibitions distributed in the different spaces at Kulturhuset?

EH: We had several spaces for installing art exhibitions: on the fifth floor we had the whole area—there were not so

A selection of posters from some of the projects that Elisabet Haglund was involved in at Kulturhuset, 1986–95. Kulturhuset archive 1974–2013, Stockholm City Archives

many restaurants back then as there are now; on the fourth floor we had a space for photography; the third floor had a good space for exhibitions; the second floor was reserved for the library; and on the first floor there was Studio 1 for exhibitions, a workshop, and a space that was called "Allrummet," which was an area for children; the ground floor also included a lot of space for exhibitions—so the place was huge.

MN/HN/EF: Was it common for the curatorial team to work together, or did you work independently?

EH: It happened quite often that we collaborated. Sometimes we were two curators working together and in other projects, there were three of us. As for example in the exhibition "Revir"—a fantastic show that took place in 1994.

At that time, I was active in the Swedish Art Critics Association, the Swedish section of Association Internationale des Critiques d'Art (AICA), and the exhibition took place in relation to an AICA conference that we arranged at Kulturhuset. The conference responded to the global situation and the theme was "Strategies for Survival—Now." AICA invited speakers from all over the world to address topics such as identity, nationality, the mainstream, diaspora, and nomadism. "Revir" was curated by myself together with my colleagues at

Kulturhuset: museum lecturer Kerstin Danielsson and fellow curator Sissi Nilsson. We invited artists who in their work responded to what we felt was a state of crisis in the world, and who were searching for strategies that could be part of a plausible future. It was a large exhibition, and we displayed the works on several floors of the building.

Among the most memorable works was an installation by artist Ilya Kabakov who had created this large emptied, abandoned space, like a meeting room, a classroom with a scenography evoking the visual culture of the Soviet Union. The installation referenced the so-called Red corner, the space in a building dedicated to political propaganda and agitation. In the installation old Soviet songs were played at high volume. One of the other invited artists was Krzysztof Wodiczko whose work I had encountered during a visit to Fundació Antoni Tàpies in Barcelona. In the exhibition we showed his work *Alien Staff* (1992–93): an artifact in the shape of a pilgrim's staff to be used by immigrants as a way to create discussions between the bearer and the people they encountered in public space. Another work from that exhibition that comes to mind is a video work by Ann-Sofi Sidén called *Good Morning, America!!!* that was presented on the first floor. The installation consisted of five screens inhabited by five different

men, and the monitors were stacked atop one another like the bunk beds in a prison or a train.

MN/HN/EF: Looking at Kulturhuset and the program of exhibitions from the '70s, and particularly through the '80s and early '90s, it is striking that there was so much material from beyond the Western world. This contrasts with other institutions in Sweden during that time, for example, Moderna Museet. How do you understand this direction?

EH: We were freer in that sense. Institutions like Moderna Museet were more dependent on the artistic mainstream. We were not a museum and had no obligation—or desire—to represent contemporary art in Stockholm, or in Sweden for that matter. You also have to recognize who the director was. When I came to Kulturhuset and for some years before that it was Beate Sydhoff, as I have mentioned, and she had instigated projects focusing on for example the African continent. "Meet India" was another huge exhibition from this time that took place as part of "Indienfestivalen" (Festival of India) in Stockholm 1987–88. We invited craftspeople from India to come to Kulturhuset and work on-site.

MN/HN/EF: Many of the exhibitions that took place before and during your years at Kulturhuset appear to have been made in collaboration with organizations and governments connected with the geographical context that was the focal point for the different projects. They also often seem to have included support from governmental organizations in Sweden. How did that work?

EH: We had good contacts, for instance with the Swedish Institute. It was an important part of the structure when I arrived, and I learned from that. So, as is often the case in life—and also in art—contacts are very good.

MN/HN/EF: And how was the process of planning the exhibitions? How much time did you invest in research and traveling?

EH: Sometimes a lot. I had good opportunities to travel, and that was true also for my colleagues at Kulturhuset. But we could only travel in conjunction with the exhibitions that we were working on. Everything had to be linked to ongoing projects.

MN/HN/EF: When you had an idea for a project, how did it then come to fruition at Kulturhuset? Could you propose that project for a particular floor, or were you assigned a space to work with? Which came first?

EH: The project always came first. If it was a large project that seemed interesting, you could put it upstairs on the fifth floor. And if it was medium-scale it could be for the third floor. For instance: in 1992 the idea came up that we should do something in conjunction with the 500-year anniversary of the discovery of the American continent by Columbus. I did not like the approach and suggested that we should turn our attention to the native inhabitants that were already present in the region when Columbus arrived with his ships. The idea was accepted and became a huge exhibition that consisted of original works by indigenous people, including drawings and handicrafts. The project also included photographs documenting the struggle of the indigenous people in Ecuador against the exploitation of oil in the jungle. I was responsible for the works from South and Latin America with countries like Brazil, Paraguay, and Bolivia. And the curator Margareta Zetterström was responsible for North America. The show was called "Indianer på Kulturhuset" (Indians at Kulturhuset)—which was a very stupid title that I had nothing to do with.

MN/HN/EF: "viva BRASIL viva" was another project featuring art from South America that you worked on. How did that project come about?

EH: We received a proposal to curate an exhibition of contemporary Brazilian art. The proposal came from Ewa Kumlin, who today is the director of the Centre Culturel Suédois in Paris and who, at that time, worked for the Swedish Institute. She made the preparations for our research and arranged visits for us to galleries, artists and museums. I traveled there to do research together with Bo Särnstedt who was the director of Liljevalchs konsthall, and we met artists from all over the country. We selected the artists we wanted to invite to Sweden together and then I chose which of these I wanted to work with for the exhibition "Sex skulpturala projekt" (Six Sculptural Projects) that I curated. I proposed the name "viva BRASIL viva" as an umbrella for the whole project. The artists in this exhibition were primarily based in São Paulo and Rio de Janeiro—the most important centers for contemporary art in Brazil. But I also chose to invite Karen Lambrecht from Porto Alegre, in the South of Brazil close to the border with Argentina.

MN/HN/EF: The exhibition "Sex skulpturala projekt" that you curated at Kulturhuset included works produced on-site, for example, a large-scale installation by the artist Tunga. Was this piece made especially for Kulturhuset? And were there exhibitions taking place both at Kulturhuset and at Liljevalchs konsthall?

EH: Yes, the exhibitions at Kulturhuset and Liljevalchs konsthall opened at the same time. In conjunction with the exhibition, Tunga and his girlfriend came to stay with my family in our house for some days and his work was produced in Stockholm. The sculpture was called *Palindrome incest*, a palindrome being a word that reads the same from both directions. It consisted of two lathed thimbles, a needle, and inside of these forms there was a thread made of 13 kilometers of copper, and hundreds of pieces of magnetic iron that stuck to the thimbles, and thin copper foil. Afterwards, this work was sold—or more or less given—by Tunga to Moderna Museet in Stockholm to become part of their collection. It's so complicated to install, though, so it is seldom put on display. The Queen of Sweden wanted a copy of the piece in smaller dimensions for the King's 50th birthday. In the end she didn't go through with the idea as the very serious people working around her were afraid of giving such a strange present to the King.

MN/HN/EF: Were other installations also created on-site during the exhibition? And how did you communicate with the artists about their ideas?

EH: Yes, Mauricio Bentes, Jac Leirner, and Frida Baranek made works on-site. Some of the artists brought material with them from Brazil but the production took

place at Kulturhuset. It was a wonderful exhibition, and I think I claimed the best pieces for our show before Liljevalchs. We had three of Florian Raiss's sculptures in the exhibition. One of them was bought by Stockholm University after the exhibition and placed in the Latin American library.

MN/HN/EF: Another project that you worked on at Kulturhuset was an exhibition with Carlos Capelán and José Bedia. Could you tell us something about that exhibition?

EH: Carlos Capelán is a very good artist who came to Sweden from Uruguay in the 1970s, a time when many people were seeking refuge because of political oppression in the region. He was a guest teacher at the renowned art school Instituto Superior de las Artes in Havana at more or less the same time that I was doing some research in California, so I came to visit him in Havana as part of my trip. While there he also introduced me to José Bedia, and the three of us decided to make a show together. I lived with a Cuban family for a couple of days and Carlos Capelán showed me the art school and introduced me to local artists. Some of them were very well-known and it gave me very good connections. We had so many interesting conversations on numerous different topics during my stay there. I had been interested in naïve art for several years and I spoke a

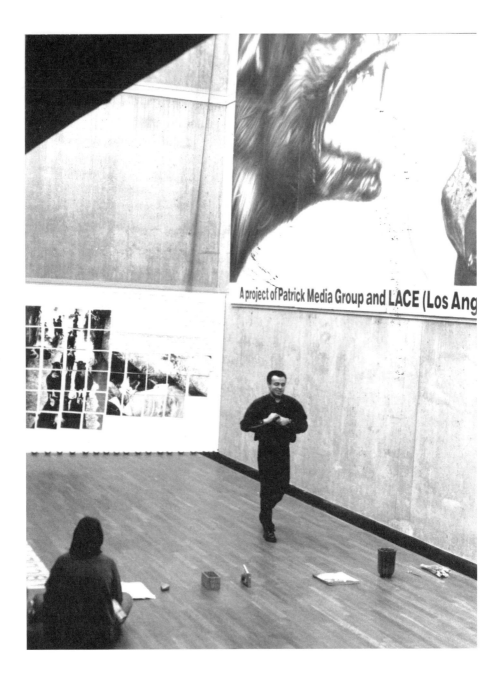

Performance by Daniel J. Martinez in conjunction with the opening of the exhibition "Änglarnas demon" (The Angels' Demon) at Kulturhuset, Stockholm, 1990. Photo: Elisabet Haglund, from her personal archive

lot about that with Bedia who also told me about the African diasporic religion Santería and Cuban Vodú, for example.

At Kulturhuset Carlos Capelán made new works on-site for the exhibition, which included collections of objects displayed in vitrines, and there were these piles of books on the floor with stones on top. The whole space was covered in mud and he did paintings of faces and figures and wrote texts directly on the walls. José Bedia recreated a series of works that he had done in Mexico a year before, elaborating on his ongoing interest in culture and traditions.

MN/HN/EF: What were the reactions to an exhibition such as the one with José Bedia and Carlos Capelán?

EH: Meeting the public was not always easy, with art coming from so far away. Today it perhaps sounds absurd to speak about the difficulties that we had during those years. There was always this pressure to get reviews from critics in the press, but I often had the feeling that the critics did not really understand what we were doing. And it was the same with many of the local artists. I remember when we mounted an exhibition with contemporary artists from Catalonia. We invited artists in Stockholm to come to the opening, but very few of them turned up. The Stockholm-based artist Eva Löfdahl said that it was such a pity

that so few artists were coming to see what was taking place at Kulturhuset.

I also recall a debate that took place in 1993 when there was a political discussion concerning Kulturhuset tied to budget cuts that had horrible effects on the work we were trying to do. We had, for instance, planned an exhibition with the artist Dorothea Tanning together with Malmö Konsthall, and I had just been in New York to meet with Tanning to prepare the exhibition. Suddenly it was canceled—I almost cry thinking about it. At that time there was a political desire to turn Kulturhuset into a commercial place, with shops and everything. In protest at these developments, I wrote a polemical article for the newspaper Dagens Nyheter, together with my fellow curators and producers Margareta Zetterström and Sissi Nilsson. No other colleagues at Kulturhuset wanted to sign it.

MN/HN/EF: What was the project you were researching in California?

EH: It was a show called "Änglarnas demon" (The Angels' Demon). This was the largest exhibition we put on at Kulturhuset together with another curator. It was a touring exhibition with Chicano artists—that is Spanish speaking artists mostly of Mexican descent living in California. The curator was a Frenchman called Pascal Letellier.

I went to California to meet some of the artists in the exhibition, and I organized the trip myself. I rented a Chevrolet in San Francisco and traveled the west coast on my own along on the famous Pacific Coast Highway, a beautiful but also dangerous route because of its crime rate. I went to Los Angeles and then later to San Diego. In this project, I thought about my work as part of the mediation of the exhibition. My personal meetings with the artists and their work were a crucial part of the process of taking the exhibition to Stockholm.

In Los Angeles, I met the artist Patssi Valdez in the studio where she worked at the time. We also went out into the streets of the neighborhood, and she spoke about the danger of the "barrio," which means the eastern part of Los Angeles, where the Chicanos have mostly been living. Patssi Valdez came to Stockholm for the exhibition and created an altar installation especially for Kulturhuset. I also remember meeting Daniel Joseph Martinez, who at the time was focusing a lot of his attention on the urban context of Los Angeles. He was working with billboards and smaller signs that he put up on lampposts, road signs, and so forth. His studio was in an area with skyscrapers that was being promoted as the new commercial center in Los Angeles, and he had almost an entire floor at his disposal. However, the building lacked electricity because

commercial businesses had not yet shown any interest in the facilities. We did a performance and a fax happening with Martinez who sent messages to Kulturhuset from Los Angeles, because the fax machine at the time was so new. We wrote to each other and then put the printed faxes up on the walls in the exhibition space.

The text is a composite based on conversations with Elisabet Haglund during fall 2020 conducted by Erik Sandberg, Hanna Nordell, and Marc Navarro.

"Thank you for the FAX!"—Message from Elisabet Haglund to Daniel J. Martinez, upon his arrival in Stockholm to participate in the exhibition "Änglarnas demon" (The Angels' Demon). The project brought together 16 Chicano artists and was curated by French curator Pascal Lettellier who Elisabet Haglund invited to host the exhibition at Kulturhuset. In conjunction with the exhibition Martinez set up a FAX-project that was printed and displayed at Kulturhuset. Kulturhuset archive 1974–2013, Stockholm City Archives

Political Pressure: A Risk

Erik Sandberg

Up until its merger with the city theater Kulturhuset was governed by the city's cultural committee, the members of which were politicians elected by popular vote. In the municipal election of 1990, the Social Democratic party lost its majority to a right-wing coalition led by the liberal-conservative party, Moderaterna, who proposed large budget cuts for culture and demands for profit. This affected not only Kulturhuset and its staff but also everyone who frequented Kulturhuset. In 1993 Kulturhuset curators/producers Elisabet Haglund, Sissi Nilsson, and Margareta Zetterström decided to voice their discontent through a debate article in one of Sweden's largest newspapers, *Dagens Nyheter.*

Art at Kulturhuset?

Tomorrow Stockholm's cultural committee will make a crucial decision regarding Kulturhuset's future activity: the decision on a forthcoming proposal to cut 13 full-time jobs across Kulturhuset because of the 1992 budget overspend. Strict new requirements to make a profit are to be applied to the organization. There is risk that the foundations for freedom of speech in art at Kulturhuset will be pulled away. The aim of Kulturhuset has up until now been to reflect the range of artistic expressions (theater, dance, literature, music, art, design) in society. With a particularly questioning aesthetic that does not aim to conform to trends or market interests, we have been trying to widen perspectives on the creativity and place of humans in society. We have been on the lookout for new forms of expression, but also attentive to the popular and vernacular in contemporary culture.

Currently there is a proposal from the politicians for a transformation of the organization with more conferences and "conventions," permanent leases to other institutions (it has been suggested that Moderna Museet should move to Kulturhuset), and a requirement for high-profit activities is forthcoming.

One example of this transformation is that the Dorothea Tanning retrospective in collaboration with Malmö Konsthall, in preparation for a year and a half and scheduled to start on the 27th of May, is now cancelled. It currently lies stowed away in Malmö Konsthall's basement.

A larger exhibition of two Spanish photographers, Ouka Lele and Cristina Garcia Rodero, planned in collaboration with the photography convention in Gothenburg, is also cancelled. The large-scale project City—about the city of Stockholm—will probably be postponed indefinitely. Is the situation really that precarious that we have to end the conditions for a vibrant cultural life by "throttling" Kulturhuset in Stockholm, a city with ambitions to become the cultural capital of Europe. Why not follow Minister of Culture Birgit Friggebos' proposal and instead increase the economic grant by a couple of million?

We understand that politicians have to oversee the economy of the municipality, but we hope for intelligent and imaginative solutions that don't harm cultural life indefinitely. Humanity needs a cultural haven in the city center.

Elisabet Haglund, Sissi Nilsson, Margareta Zetterström
Curators/Producers in Kultuhuset's exhibitions department

Elisabet Haglund and Sissi Nilsson on the Political Situation in 1993

In the years leading up to 1993 we had a good balanced budget. But in 1993 we were surprised by an unexpected backlash when the city cultural committee's budget proposal contained large cutbacks and requirements for profit. A few different plans circulated: closing Kulturhuset; renting it out to commercial businesses; a movie theater; tearing the building down to make way for residential property; moving the city library to Kulturhuset. Luckily there were large protests, letters to the press and demonstrations from many groups who were also affected by the proposed cutback. Kulturhuset among them, of course. Kulturhuset is owned by the city and its citizens. Elections have a great effect on the policies of the institution because politicians set the larger agenda. They wished to increase Kulturhuset's revenue and we were forced to organize an open call art salon, like at Liljevalchs, because they thought that was where there was money to be made. It became a Stockholm-themed salon which failed to spark the interest of potential exhibitors or the public.

With the exception of that exhibition we cannot remember any political pressure that affected the content of Kulturhuset's exhibitions. But the downsizing naturally resulted in us having fewer economic resources to work with. Collaboration with other institutions and sponsors was something we had always worked with, but after the cutback it became even more important. However, the sponsorship never went so far that it influenced our productions. However, as a result of the politicians' attempt to commercialize Kulturhuset, it lost "[The tabloid]" after "Löpsedeln," its beautiful exhibition space with large windows overlooking Sergels Torg. The space's charm was to directly connect with people shopping in the city. Instead it was now rented out to Designtorget a Swedish design retailer. Other innovations followed in the same space. We opened Stockholm's first internet café— Café ACCESS—with producer Ingemar Arnesson as project manager. Allrummet was given a new direction in September 1996. A task force headed up by Pernilla Luttropp, responsible for youth activities, initiated the new youth effort, LAVA, comprising: Demo Live (music), Videotek (film), Fanzines (comics), and Distro (DIY culture).

Four Projects: Contributions by José Bedia, Carlos Capelán, Elisabet Haglund, Ewa Kumlin, Joan Rom, and Patssi Valdez

Edited by Marc Navarro and Hanna Nordell

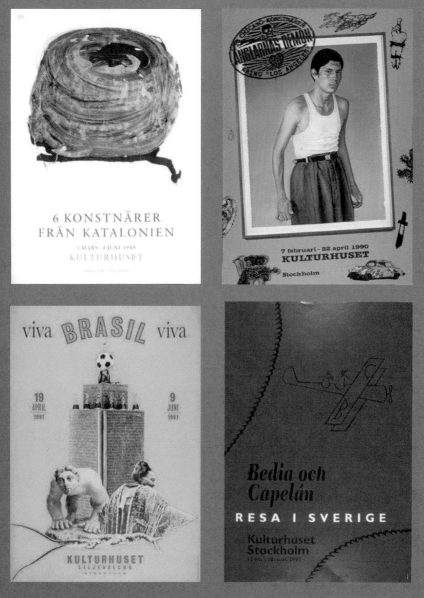

A selection of posters from some of the projects that Elisabet Haglund was involved in at Kulturhuset between 1986 and 1995. Kulturhuset archive 1974–2013, Stockholm City Archives

Joan Rom's studio in Mont-roig del Camp (Tarragona) as it appeared in the catalogue for "6 konstnärer från Katalonien." Photo: Carles Fargas

"6 konstnärer från Katalonien" (Six Artists from Catalonia), 1989
Kulturhuset, Galleri 5, March 3–June 4
Artists: Pep Agut, Frederic Amat, Tomás Bel, Lluís Claramunt, Charo Pradas, and Joan Rom
Curators: Elisabet Haglund and Philippe Legros

6 konstnärer från Katalonien (Six Artists from Catalonia), 1989
Marc Navarro

The year 1989 was a special one for Barcelona. The end of the '80s marked the beginning of the "Olimpíada Cultural" (Cultural Olympics), a series of cultural events planned in conjunction with the Olympic Games to which the city would play host in 1992. As part of its submission to the International Olympic Commitee, Barcelona included not only a plan to improve the city's infrastructure but also took advantage of the exceptional opportunity the Games represented for promoting the city through culture. In the three-year run up to the Olympics, the city would launch an annual series series of events devoted to themes such as sports, arts, or the future. The Olimpíada Cultural was at once an opportunity to rethink the city's architectural and artistic heritage and a platform through which to try out new relations between tradition and modernity in the context of Catalan culture. In the mid-'80s the city signaled a radical, if initially only cosmetic, overhaul of its image. The campaign of beautification moved up a gear with the regeneration of the coastline—it's often said that that until 1992 Barcelona lived with its back to the sea. However, this ambitious program of urban renewal actually began back in the late '70s and had the aim of creating a more democratic, modern, and integrated city.

"Katalansk vår" (Catalan Spring) should be understood as a product of this climate of change, openness, and pre-Olympic euphoria. This major project devoted to Catalan arts and culture was held across a number of Swedish cultural institutions during the spring of 1989. The project was conceived as a "cultural and scientific exchange" between Sweden and Catalunya. Some months before, during the autumn, a series of exhibitions promoting Swedish culture took place in Barcelona under the title "Suècia avui" (Sweden Today). A lack of cultural infrastructure forced the organization to establish alliances with Sala Metrònom and Sala Vinçon, two emblematic private initiatives that introduced new tendencies in art and design to the local scene. Sala Vinçon showcased Swedish innovation in design for functionally diverse people, including the work of the Ergonomi Design Gruppen AB collective. The exhibition was curated by Gunilla Lundahl and designed by Björn Ed. At Sala Metrònom an exhibition was co-produced with NUNSKU (the national committee for exhibitions of contemporary Swedish art abroad), and featured the work of artists Stina Ekman, Ingrid Orfali, Anders Widoff and Frederik Wretman. While the Sala Vinçon show was organized remotely, in the case of Sala Metrònom a committee traveled to Sweden to select the four artists who would exhibit their works in Barcelona. The Generalitat de Catalunya's secretary of Energy and Industry stated in

As part of "Suècia avui," a Swedish industrial design exhibition was held at Sala Vinçon in Barcelona. The exhibition focused on everyday objects designed for functionally diverse people. The photo shows one of the objects by Ergonomi Design Gruppen AB included in the show. Lola Durán, Sala Vinçon's director during those years, recalls how some visitors organized a spontaneous demonstration in front of the shop: although they tried to make the exhibition accessible to all audiences, the stairway was too narrow for some wheelchairs. Image: Promotional flyer for the exhibition. Fons Vinçon, Museu del Disseny, Barcelona

a press conference that commercial exchange between Catalunya and Sweden must be complemented by better cultural knowledge enabling a better understanding of each other's reality. At the same time, the Swedish consul in Barcelona, expressed hope that this exchange would help to stimulate "new interests" besides touristic ones.

The Swedish branch of the project included numerous exhibitions and events covering a wide range of cultural fields, from literature to architecture. Moderna Museet hosted an exhibition about Dalí and books, and Arkitekturmuseet (the Museum of Architecture, now ArkDes) presented a show exploring the construction of public buildings in Catalunya, such as hospitals and schools, during the '80s. Three major exhibitions were hosted at Kulturhuset: An exhibition about modernism, "Modernism i Katalonien" (Modernism in Catalonia); "Katalansk design" (Catalan Design), which profiled new trends in industrial design emerging in Barcelona; and "6 konstnärer från Katalonien" a group show introducing the work of six Catalan contemporary artists curated by Elisabet Haglund and Philippe Legros and installed at Galleri 5.

Installation view of the exhibition at Sala Vinçon

Elisabet Haglund was very familiar with the Spanish art scene. She moved to Madrid in 1978, the year in which Spain approved its new constitution and took a definitive step towards democracy, leaving behind Franco's dictatorship. In Madrid she worked as an intern in the Spanish Ministry of Culture, and although Elisabet Haglund considers her time in this institution irrelevant to her professional trajectory, the truth is her years in Spain put her in contact with the city's dazzling emerging art scene.

"6 konstnärer från Katalonien" featured works by Pep Agut, Frederic Amat, Tomás Bel, Lluís Claramunt, Charo Pradas and Joan Rom. By the end of the '80s, Joan Rom's work was showing extensively both in Spain and internationally. Rom attributes this not only to the quality of the art produced, but also to the political situation in Spain: "Back then Spain's Socialist government wanted to project an image of the country's modernity and to show that actually, in Spain, there were also good artists. Politicians used the arts to reinforce that image. In that sense, I tend to relativize our success, and I am

Joan Rom, *Monument a peixos morts* (Monument to Dead Fish), 1986, rubber. Photo: Carles Fargas

skeptical as to whether there was real interest in promoting contemporary visual arts. But as you may know, such strategic use of the arts is nothing new. Maybe the most famous case was the CIA investment in American abstract expressionism. The CIA even financially supported the organization of exhibitions abroad. On a very different scale, and with a very different financial budget, this was somehow reproduced by the Socialist government in 1980s Spain."

In a vivid unpublished short story written right after his return from Stockholm, Rom condenses his mixed feelings about the trip. It registers a host of impressions: The hospitality of Kulturhuset's team, the relaxed style of Swedish politics, the cold winter outside—"here and now everyone wants to forget the cold"—the exuberance of the table in the not-so-formal feast that Kulturhuset offered in honor of the artists after the opening—"the most optimistic work in the exhibition." The sophisticated presentation of the food: "I wonder if these three or four dozen half-opened melons, stuffed with chopped fruit, offered to the eyes like a multicolored bunch of juicy promises of Summer,

"Instead of a 'lyric' text we were thinking of writing something in Catalan, something like 'estem aquí' ('we are here') or another short sentence. Is this ok with you, or would you like to propose another phrase?" Elisabet Haglund's note concerning the design of the "6 konstnärer från Katalonien" poster. Photo: Kulturhuset archive 1974–2013, Stockholm City Archives

are more than just decoration." The more prosaic provenance of the wine: "We raise our glasses of Rioja (courtesy of the embassy)." And the communication difficulties: "I don't understand a word of Swedish, so to accompany those present I hang a smile from my face and stay engrossed with my gaze fixed on the melons until they become a fuzzy spot"

Viewed in the context of the other exhibitions and projects presented in "Katalansk vår," "6 konstnärer från Katalonien" evinced less of a sense of belonging and tradition. The work of Joan Rom and the rest of the artists included in the show dealt poorly with *catalanitat* ("Catalan-ness") as a national identity. In selecting artists and projects for the show Haglund had followed a different path. It would be hard to argue that the artists were strategically selected to represent some sort of Catalan singularity. With hindsight "6 konstnärer från Katalonien" was probably not the most critically successful nor the most well attended show in the list of exhibitions produced for "Katalansk vår." Not a turning point in Elisabet

Haglund's trajectory at Kulturhuset, nonetheless the show revealed the complexity and contradictions of the internationalization of Catalan and Spanish art in the '80s.

In Kulturhuset's catalogue for the exhibition a number of art critics close to the Catalan scene including Teresa Blanch and Victoria Combalía introduce the artists and their works. The text for Joan Rom is by Elisabet Haglund herself. In it Haglund situates us in Rom's workspace in the town where he lived and worked, Mont-roig del Camp, on the precise date of October 28, 1988, the day she visited the artist. Haglund describes his space as she saw it, talking about her encounter with the predominant materials the artist was working with at the time: glass, rubber, and copper. At one point, Haglund reflects on the sculptures found there: "the signs interfere, but do not symbolize or depict." Perhaps for this very reason her text takes the free form of a poem in which she evokes the sensuous qualities of matter in Joan Rom's work. As with her other textual experiments in the framework of exhibitions she organized at Kulturhuset, Haglund seems to question here the function and form of the curatorial text. At the same time, she seems to ask: to whom are curatorial texts addressed? Who does the text represent? How much space should be given to the curator's own voice? Despite the rigidity of the overall framework, with this gesture Haglund abandons some of the conventions that govern critical textual production within the institutional context and establishes a new contract between the artist and the curator. Perhaps a less hierarchical relationship, in which language defines a position close to the artist and the artwork.

A Swedish versions of these short-form texts by Elisabet Haglund appeared for the first time in the catalogue accompanying "6 konstnärer fran Katalonien." The titles of the poems refer to the materials employed by Joan Rom at that time. Translation from Swedish by Erik Sandberg.

Glas	Glass
alldeles hårt	entirely hard
alldeles genomskinligt	entirely transparent
glaset öppnar världar	the glass opens worlds
och skiljer dem samtidigt at	and separates them at the same time
—Rom målar ofta ett	—Rom often paints a
tecken på rutan	sign on the pane
som ett meddelande	like a message
ett språk	a language
(tecknet tycks antyda nagot	(the sign seems to indicate
fjärran, okänt)	something distant, unknown)

Gummi	Rubber
mjukt och segt	soft and rubbery
lätt omformbart	easily reshaped
svart och	black and
ogenomskinligt	opaque
gummit är ett	rubber is a
material som ofta	material often
användes I industrin till	used in industry to
att isolera mellan andra	to insulate between other
material	materials
gummi I bildäck	rubber in tires

Mässing (rör)	Brass (pipes)
raka	straight
ihåliga	hollow
formfasta	compact
kommunicerande föremål	communicating objects
då dess inre hålighet	because its inner cavity
har en kommunicerande karaktär	has a communicative character
horisontellt	horizontally
lutande läge I	tilted position in
Roms installationer	Roms installations

Contact sheet from Haglund's trip to Los Angeles: Patssi Valdez in her studio at Self Help Graphics & Arts in East Los Angeles, 1989. Photo: Elisabet Haglund. Kulturhuset archive 1974–2013, Stockholm City Archives

"Änglarnas demon" (The Angels' Demon), 1990
Kulturhuset, Gallery 5, February 7–April 22
Artists: Carlos Almaraz, David Avalos, Rupert Garcia, Robert Gil de Montes, Glugio Gronk Nicandro, Luis Jimenez, Leo Limon, Gilbert S. Luján "Magu," Daniel J. Martinez, Amalia Mesa-Bains, Frank Romero, Robert Sanchez, Eloy Torrez, John Valadez, Patssi Valdez, Max Aguilera Hellweg
Curator: Pascal Letellier
Produced by: erde, Centre de Recherche pour le Développement Culturel, Nantes, France
Co-producer: Departament de Cultura de la Generalitat de Catalunya, Barcelona, Spain
Curator in charge for the exhibition at Kulturhuset: Elisabet Haglund

Änglarnas demon (The Angels' Demon), 1990
Hanna Nordell

"Some borders are clear. Some we do not see. Some open. Others remain closed." These lines are found in the concluding part of an essay written by Elisabet Haglund in the catalogue accompanying "Änglarnas demon," a touring exhibition with Chicano artists that was shown at Kulturhuset in 1990.[1] In the text Haglund situates the Chicano artists within a longer history of movement and displacement across the American continent ranging from the first inhabitants who migrated via the land bridge Beringa, to the Spanish colonization, and continuing through the foundation of the United States of America, down to the present day and the conflicted border between California and Mexico. The exhibition "Änglarnas demon" was curated by Pascal Letellier for erde, Centre de Recherche pour le Développement Culturel in Nantes and included paintings, posters and installations by 16 Chicano artists of different generations. Elisabet Haglund was responsible for taking the exhibition to Stockholm and as part of her research she travelled to California to meet with some of the invited artists. During this journey she also travelled to Cuba, thus moving across the same geographies discussed in her text.

The artist Patssi Valdez (Los Angeles) was one of the artists that Haglund met in Los Angeles. During this time Valdez was working with painting in the form of still lifes, portraits of her friends as well as meditations on the environment of Los Angeles where she grew up. From 1972 to 1987 Valdez was a part of the Chicano artist group ASCO (Spanish for nausea) founded in Eastern Los Angles by Valdez, Harry Gamboa Jr., Gronk, and Willie Herrón. The group emerged as a critical response to political and socioeconomical issues affecting the Chicano community including the effects of urban planning, racial discrimination, police brutality and mass media stereotypes. One method they used was public performance including works such as *Walking Mural* (1972) and *Asshole Mural* (1974), departing from the static murals of the previous generation to create a new form of mobile artistic protest. Patssi Valdez came to Stockholm for the opening and made one of her "home altars" on-site for the exhibition.

Some of Haglund's own photographs from the trip to California have been included in Kulturhuset's section of the Stockholm City Archives and the following dialogue includes a selection of these images. They are accompanied by installation photographs of the Kulturhuset show from Patssi Valdez's personal archive with captions written for this publication by the artist.

Patssi Valdez, *The Bathroom* (1988), acrylic on canvas, 91.5 x 91.5 cm. It was among the works included in "Änglaranas demon" at Kulturhuset. Kulturhuset archive 1974–2013, Stockholm City Archives. Photo: Olof Thiel

Recollections of Änglarnas demon, by Patssi Valdez

Hanna Nordell: Can you tell us something about what you remember about the context of this photograph? Is it taken in your home in Los Angeles?

Patssi Valdez: No, the photo was taken at a time when I had a residency at Self Help Graphics & Arts in East Los Angeles, an important cultural arts center that

was started in the 1970s during the Chicano Civil Rights movement. This was my studio at that art center. I had lived my whole life in East Los Angeles which is a poor neighborhood where many Latinos lived. Taking part in a touring exhibition in Europe was basically the first time I travelled and going from this isolated lifestyle was a life changing experience. It gave me a broader perspective about the world.

HN: The work *The Bathroom*, shown in the exhibition at Kulturhuset, could be described as a painted snapshot from the corner of a bathroom. A sink is being filled with water and the still-life format makes ordinary personal objects appear charged with greater meaning. Was this work typical of how you were working at that moment in your life as an artist?

PV: This was the time when I started to paint seriously. The works that were selected for the show were the first paintings I had ever done so it was both surprising and exciting. Before this I had primarily been working with photography and performance. The bathroom piece is a sort of narrative of my life at the time using my environment and the objects around me. This way of working is still recognizable in the works I am doing right now. I am trying to tell a story about my culture, myself and my environment through objects and personal as well as public spaces. Previously I had done a lot of portraits but at that point I felt I could express a lot by going into someone's environment, they did not even have to be there just the things that they own and energetically how it felt in the room. That was the idea behind the artwork. And if you look at this painting, you can see that at that point in my life it looked quite dark and dangerous, right?

HN: In addition to the paintings, you also made an installation on-site at Kulturhuset?

PV: My idea for the installation work was to bring in some of my experience from that city that hosted the exhibition and to combine it with some of my culture. Looking back at that installation I start to giggle because it is a bit naïve and seems so religious. I am not religious at all, but it is part of my culture, of course. I think I was lucky to be able to have the experience and to try things out. And I think curators like Elisabet Haglund and Pascal Letellier, who embraced this work, were taking an important risk in inviting young artists and letting us develop our work on-site. Even to this day, we are still struggling to be recognized and to be collected by major museums. So not much has changed.

Patssi Valdez, *Altar* (1990), installation created on-site at Kulturhuset for "Änglaranas demon." Photo: the artist

Patssi Valdez: This is a photo of the installation I created directly on the gallery wall. I used acrylic paint, metallic paper, and plastic angels and Virgin statues. The plastic statues are from either Woolworth's or J.J.Newberry's which are both stores in Monterey Park, California, close to where I was living at the time. I remember walking past one of these stores and seeing rows and rows of plastic Virgins and angels. I decided to buy some because kitsch-looking things like this were an inspiration for the installation. I wanted to take a piece of my culture and bring it into another context. I am not a religious person, but these are ubiquitous images in the community I grew up in. For me it stands for something very popular and familiar and in this form the icons become very accessible.

Patssi Valdez, *Altar* (1990), installation created on-site for the exhibition at Kulturhuset. Photo: the artist

I painted directly on the gallery wall with acrylic paint, and in the middle of the crosses I placed the plastic angels with shredded metallic paper. Next to the crosses is a column with a vase of flowers. The color scheme for the whole piece is also evocative of the community and environment I grew up in, very bold and bright.

Looking at this panoramic shot, I remember thinking that I wanted to evoke a sense of mystery and mysticism in the gallery space. Working closely with the technicians at Kulturhuset was very important to accomplishing my vision. Especially when it came to the lighting where I decided to keep the space dim with only certain elements brightly lit. What I remember most about Stockholm was the support allowing me to do whatever I wanted in the space.

Florian Reiss, *Untitled*, 1990, Latin American Library, Stockholm University. The sculpture was part of "Sex skulpturala projekt," curated by Elisabet Haglund for "viva BRASIL viva." It was purchased by the university after the exhibition and displayed in the library. Photo: Erik Sandberg

"viva BRASIL viva" (1991)
viva BRASIL viva, 1991 at Kulturhuset:
"Sex skulpturala projekt" (Six Sculptural Projects), 1991
Kulturhuset, Gallery 3, April 19-June 9
Artists: Frida Baranek (São Paulo), Mauricio Bentes (Rio de Janeiro), Karen Lambrecht (Porto Alegre), Jac Leirner (São Paulo), Florian Reiss (São Paulo) and Tunga (Rio de Janeiro)
Curator: Elisabet Haglund
"Arthur Bispo do Rosário"
Kulturhuset, Studio 1
Curator: Kerstin Danielsson
"Brasiliansk verkstad, Copacabana" (Brazilian Workshop, Copacabana), Installation and open space for workshops, Allrummet
Artist: Jorge Barrão
Curators/project managers: Ingemar Andersson and Kerstin Danielsson
"Sans och hetta i dagens brasilianska konst" (Contemporary Art from Brazil)
Liljevalchs konsthall
Curator: Bo Särnstedt, Director

viva BRASIL viva, 1991
Hanna Nordell

"viva BRASIL viva" was a collaboration between Kulturhuset and Liljevachs konsthall that took place during the spring of 1991 and that consisted of exhibitions in both institutions, a lecture program, a film program and workshops for children. The idea as well as the funding came from the Swedish Institute who took an active part in planning and coordinating the project. For Elisabet Haglund the work towards it began in 1989 and included two research trips to Brazil together with Kulturhuset colleague Kerstin Danielsson, Bo Särnstedt from Liljevalchs konsthall as well as Ewa Kumlin who was coordinating the project on assignment from the Swedish Institute.

Recollections of viva BRASIL viva, by Ewa Kumlin

Hanna Nordell: What was "viva BRASIL viva" and can you describe how the project came about?

Ewa Kumlin: "viva BRASIL viva" was a ground-breaking art project. Not only with regards to how it was realized across different venues in Stockholm, but also for bringing artists from Brazil to the city. It opened up exciting possibilities in a time when Brazilian art was not shown outside of the country so extensively. Twenty-two of the invited artists came to Stockholm for the opening and there was a range of activities taking place in conjunction with this. The project was funded by a special support for culture exchange from SIDA (Sweden's Government Agency for Development Cooperation) and that was administrated by the Swedish Institute. My task was to coordinate the different parts, including research on-site in Brazil and the different exhibitions in Stockholm.

When the idea for "viva BRASIL viva" emerged in 1989, I was living in Brazil where my husband held a position as a Swedish diplomat which had given me the opportunity to get to know the art and culture of the region. I was working for the Swedish Institute and for the art magazine *Paletten*, reporting from the São Paulo biennial among other things. For me it has always been important to study things on-site, and I have always made sure to be up to date on what is

Tunga was among the artists who came to Stockholm to participate in "viva BRASIL viva." This photo was taken during the curators' research trip to Brazil, coordinated by Ewa Kumlin. Photo: Ewa Kumlin

going on in the contemporary cultural scene in the place where I live. And I make contacts.

At that time Anders Clason was the director of the Swedish Institute and Arild Berglöf was responsible for international relations. In those days the people who held such positions operated like their artistic directors in some ways. I had just done a large assignment for the Göteborg Book Fair where I had invited writers from Brazil to Sweden and after that Arild Berglöf suggested that I should look at what was happening within the field of contemporary art. We started the project, and I initiated a collaboration with the curator Marcus de Lontra and the gallerist Claudio Telles, who both had great insight into Brazil's art scene, and we started to map what was happening in different parts of the country. Elisabet Haglund and Kerstin Danielsson from Kulturhuset and Bo Särnstedt from Liljevalchs were invited to curate the

exhibitions in Stockholm. The whole project was based on collaboration. Haglund, Danielsson and Särnstedt came to Brazil twice and we travelled to different parts of the country to meet all the artists that Telles and De Lontra had suggested. Then Elisabet Haglund, Bo Särnstedt and Kerstin Danielsson chose which of the artist they wanted to invite for the exhibitions in Sweden.

HN: How would you describe these joint trips in Brazil?

EK: It was a very open kind of research. We went around the country from São Paulo to Rio de Janeiro, Bahia and Recife and saw some of the most interesting contemporary art of that time. We made individual studio visits and the galleries arranged for gatherings and large parties where we got to meet many artists. I learned so much when I traveled with Elisabet Haglund and just being with these artists for a few hours in their studios and seeing the context in which they are working. For example, in Belém where the rain comes every hour, and you see the palms growing into the studio of Emmanuel Nassar, you understand their artistic motifs. We had a fantastic time traveling together, observing things. Elisabet

Haglund is a very spontaneous person and she had very clear understandings of what she liked. She was not driven by side-agendas of any kind. She was not affected by anything but her own judgement and that was exciting. She was just following her own mind.

HN: What happened when the different exhibitions opened in Stockholm? What kind of activities took place?

EK: As I mentioned, twenty-two artists came over for the opening and met with artists in Sweden. There were large-scale events at both Kulturhuset and Liljevalchs konsthall and there were meetings at Kungliga Konsthögskolan in Stockholm (The Royal Institute of Art in Stockholm). There was also an exchange-project that continued afterwards led by participating artists Mauricio Bentes and Enno Hallek who was a professor at Kungliga Konsthögskolan. Some also stayed and put on exhibitions in art galleries. They had quite a free program.

Following pages: *Palindrome Incest*, 1991, installation created on-site by Tunga as a part of the exhibition "Sex skulpturala projekt," curated by Elisabet Haglund. Tunga's work was bought by Moderna Museet in Stockholm in conjunction with the exhibition. Kulturhuset archive 1974–2013, Stockholm City Archives

Sex skulpturala projekt (Six Sculptural Projects)

In Frida Baranek's installation it is as if the pillars that normally support a building have been dispersed into floating clouds of steel wire and marble, frozen in time and lending a sense of movement to a space in which everything stands still. Small gaps between the rusty iron threads allows the eye of the viewer to wander through the room and on to the cityscape that looms large on the other side of the transparent glass facade. The installation was a part of the exhibition "Sex skulpturala projekt" that took place on the third floor of Kulturhuset. For this exhibition Haglund had invited a younger generation of artists from Brazil, primarily working with sculpture and installation. The curatorial intention was to invite each artist to make an installation in dialogue with the space, and several of the artists' projects were produced on-site with the assistance of Kulturhuset's workshop and technicians. Frida Baranek was joined in the exhibition by Mauricio Bentes, Karen Lambrecht, Jac Leirner, Florian Reiss, and Tunga.

Frida Baranek, *Bullriga pelare (Noisy Column)*, 1990. Detail from the catalogue for "Sex skulpturala projekt," published by Kulturhuset. The show also included works by Mauricio Bentes, Karen Lambrecht, Jac Leirner, Florian Reiss, and Tunga. Kulturhuset archive 1974–2013, Stockholm City Archives

Carlos Capelán, *Kartor och landskap* (Maps and Landscapes). Installation at "Bedia och Capelán—Resa i Sverige," Kulturhuset, 1993. Photo: Carlos Capelán

"Bedia och Capelán—Resa i Sverige" (Bedia and Capelán—Journey in Sweden), 1993
Kulturhuset, Gallery 3, February 12–March 28
Artists: José Bedia and Carlos Capelán
Curator: Elisabet Haglund

Bedia och Capelán—Resa i Sverige (Bedia and Capelán—Journey in Sweden), 1993

Hanna Nordell

The exhibition "Bedia and Capelán—Resa i Sveriga" took place in 1993 and combined installations by artists Carlos Capelán (Montevideo/Lund) and José Bedia (Havana/ Miami). In the 1990s Carlos Capelán exhibited widely internationally, playing an active role in a discourse that critically reflected on art's capacity to represent the world and the relationship between center and periphery. Using earth, ink, red ocher, and mud he explored surfaces beyond the canvas and extended his painting to, for example, walls, rocks, books and maps. Texts are a key component in his installations during this time, often appearing in the form of open-ended quotes from post-colonial thinkers, inviting the viewer to complete the message.

José Bedia has an eye for combining local knowledge, colonial histories and resonances across cultures and geographies. As the '80s shifted into the '90s, he was engaged with a series of works related to the experience of indigenous cultures across the American continents, and also Afro-Cuban religious beliefs and practices. Before the exhibition at Kulturhuset, Bedia had participated in seminal exhibitions such as "Magiciens de la Terre" in Paris as well as "The Third Havana Biennial," both taking place in 1989. Bedia was among the many artists who left Cuba because of political oppression at this time. During the exhibition, he was living in exile in Mexico.

Traces of these exhibitions in the Kulturhuset archive are scarce except for a few photographs and some press material. A small catalogue was produced for the exhibition that included essays by Elisabet Haglund as well as texts introducing Bedia and Capelán written by curator Cuahutémoc Medina and Pehr Mårtens, assistant at Kulturhuset. The following section of the chapter include a newly translated version of an essay written by Haglund that was composed by a collage of quotes from the artists and also Sweden-born professor, botanist, taxonomist and zoologist Carl von Linné (Linnaeus, 1707–1778). Linné is widely known for creating a system to classify and name natural organisms that is still in use throughout the world. As part of his research Linné conducted several journeys in Sweden and beyond to find and classify plants, animals and minerals. The essay by Haglund is followed by Capelán and Bedia's recollections of the exhibition.

BEDIA AND CAPELÁN
Journey in Sweden
Essay by Elisabet Haglund

They are standing on Skeppsbron. It's Carlos Capelán, Carl von Linné and José Bedia. Carlos Capelán (born in Uruguay) has been living in Lund and Stockholm for 8,500 days. Carl von Linné (Småland) has been living above and below ground in Sweden for 286 years. José Bedia (born in Cuba and living in Mexico) has as of the 12th of February 1993 been here for 53 hours. A heavy truck booms past and we hear their conversation through the noise. A Sámi village floats by in the stream on its way towards the open seas.

Carl von Linné: "When I reached the top of the mountain, I did not know whether I was in Asia or Africa, for both soil, situation and all of the herbs were to me unbeknown."

Carlos Capelán: "In my art there is one aesthetic that is connected to Lund, but also one from Uruguay and Mexico. I belong to those precisely as I belong to 'the red earth's' mainstream art. The red earth forms a straight line from the South African cliff paintings, through the cave of Altamira directly into my installations and paintings. I'm working with an aesthetic that joins: the anthropologic with the ethnographic, the individual with the universal, center with periphery, the political with the cultural etc."

Carl von Linné: "The people who were 16 persons lie awake, washing themselves stroking downward and not up, not drying themselves, washing the vessels with their fingers, spraying water from the mouth onto the spoon, ladling the boiled reindeer milk, which was thick as egg cream but rich."

José Bedia: "The transcultural process that many indigenous artists are subsumed in is something I try to create in myself but in its opposite. I'm a westerner who tries to approach these cultures with my spontaneous and well-prepared systems. In a transcultural way I also experience their influence on me. Them and I both stand half-way between the 'modern'

and the 'primitive': between the 'civilized' and the 'wild': between the 'western' and the 'non-western'—but in directions and situations that among them are opposites. From this confession and from this border, which is breaking up, my work is born."

Carl von Linné: "The minor rock ptarmigans, scolpacino colore, alis albis (from a woodcock's color and with white wings) had their chicks. I took one, she (the mother) ran towards me, /…. / I gave her son back again."

Carlos Capelán: "Art is a mode of organizing knowledge."

An airplane descends upon the Stockholmers. The pilot is a reindeer and behind him sits his friend the wolf. On the wings are the letters B and C. Is it Bedia and Capelán who leaves...who travels or comes back?

Elisabet Haglund's essay was written in Swedish for the exhibition's catalogue. Translation by Erik Sandberg.

José Bedia's installation in the exhibition "Bedia och Capelán—Resa i Sverige" at Kulturhuset. Left: *Untitled* (1992/1993). Right: *El Poder del Hierro* (The Power of Iron). The works recreated a series of pieces originally produced by the artist for an exhibition at Museo de Arte Contemporáneo Carrillo Gil, Mexico City, in 1992. Photo: José Bedia

Recollections of "Bedia and Capelán—Resa i Sverige" by Carlos Capelán

Hanna Nordell: Could you tell us how the idea for the exhibition at Kulturhuset came about and describe your installation for us?

Carlos Capelán: Elisabet Haglund was actually the first ever to write about my work. This was back in 1978 when I had my first solo show at the internationally connected Anders Tornberg Gallery in Lund. Elisabet wrote a few lines about the exhibition and this is how we got to know each other. We became friends and have been in dialogue since then. José Bedia was also a very close friend of

mine for a few years, and we did lots of things together during this time.

Before this exhibition I just had a rather big show at Lunds konsthall in the south of Sweden. For my installation at Kulturhuset I continued on a similar path and I ended up turning this experience into a site-specific piece that was about the concept of home. We generated a room within the room, and I painted both the inside and the outside with mud using my bare hands. It was very dark on the outside and lighter on the inside. In the bigger room I had vitrines

Above and following page: Carlos Capelán, *Kartor och landskap* (Maps and Landscapes), installation at "Bedia och Capelán—Resa i Sverige." Kulturhuset, 1993. Photo: Carlos Capelán

with a collection of objects. I tried to represent the world of a hunter, who instead of hunting animals was hunting objects. The small room was a much more personal kind of space. Outside of that room there was a big self-portrait alongside piles of books. The installation circled around the idea of my home as being a part of your home at the same time as it is a place for culture and language. It was an installation about the general and the peculiar, the personal and the social. That was the intention. And José Bedia's pieces were absolutely beautiful. I helped to paint one of his works. It was a black figure painted directly on the wall.

HN: In the catalogue the botanist Carl von Linné is thrown into the **conversation in quite a humorous way. Linné is also someone who has been on the agenda again quite recently with regards to his classification of nature and race. I understand that you have been interested in him in your previous work.**

CC: Yes, I have always been very curious about him, maybe more back then than now. I went to his birthplace several times and I was especially intrigued by his travels in Sweden that he did before he continued with rest of the world. But in this case, it was because Elisabet Haglund has a fantastic imagination, and she actually wrote this piece without consulting us. The text is all by her.

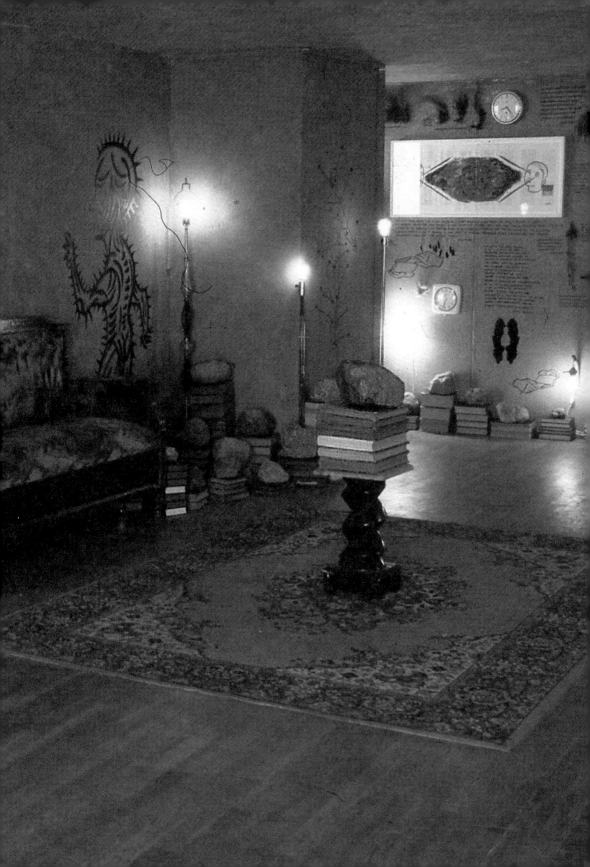

Recollections of "Bedia and Capelán—Resa i Sverige" by José Bedia

The original idea for the exhibition was that Carlos Capelán and I would make a journey together: from Cuba to and around Sweden. Capelán often spoke about Lapland, or Sapmi, which is a region in the north of Sweden traditionally inhabited by the Sámi people. But unfortunately going there together never happened. This was a transitional moment for me because I was leaving Cuba permanently to live in exile in Mexico and my legal status made it more difficult for me to travel for longer periods of time. However, we decided to keep the exhibition title "Bedia and Capelán—Journey in Sweden." That is why I made that drawing for the cover of the catalogue with a small airplane, and with me and Capelán as pilots in the form of a dog and a deer, or the hunter and its prey, as a subliminal reference to the nature of Cuba. The thorny lines resembling clouds or mountains were done by Carlos Capelán and connected to the work with ink that he was making at that time.

Carlos and I had met in Mexico, because we were both looking into ancient traditions linked with South and Central America. Basically, we were a group of artists, including Ricardo Rodríguez Brey (Havana/Ghent), Adolfo Patiño (Mexico City 1954–2005), and Juan Francisco Elso (Havana 1956–1988), moving more or less in the same direction: looking for traditions and mythology, studying anthropology, playing with archetypes, and trying to develop an idea of something that was still alive in the cultures that we encountered. We had an ethical position because it was a moment when everybody tried to rush to the top of the art world, and we were looking for different things. Maybe we were wrong, but we did what we felt in our hearts.

In this exhibition I worked with a series of themes that were important for me at the time. My contribution was a recreation of a series of works that I had shown in Mexico the year before. I used the image of railroad tracks on a stack of concrete bricks to create a particular balance. God-like figures were painted directly on the wall and some of the works were on paper. In the works on the walls, I used my bare hands instead of brushes. Some of the figures had masks with different machines attached, like a big cargo boat or an airplane. For these drawings I was using so-called *amate* paper, which is a paper made by bark that was used by the Otomí, an indigenous population in Mexico. What I tried to prove in some way, was the spiritual force manifested in and through those intangible figures, and who were able to move and lift the railroad tracks. The tracks formed a line as a horizon, separating the world of the living from that of the dead. I paid special homage to the figure of Ogun, the God of metal in the Afro-Cuban diasporic religion. I tried to play with that idea to

recreate the image of the hero or the god related to iron. The railway tracks had already been a central motif in the installation that I did for the exhibition "Magiciens de la Terre" in Paris in 1989.

Detail from the "Bedia och Capelán—Resa i Sverige" catalogue. Front-page drawing by the artists. Photo: Hanna Nordell

INVASION AND DISPERSION
Tracing the Curatorial Trajectory of the Artist Carlos Capelán

Giulia Floris, Edy Fung, and Hanna Nordell

Left: Pablo Uribe, *Pax in lucem* (Peace in the Light), 2018, oil on stairwell wall. "Aquí soño Blanes Viale: Una exposición de Pablo Uribe" (This Is Where Blanes Viale Dreamt: An Exhibition by Pablo Uribe) at National Museum of Visual Arts, Montevideo, 2018–19. Photo: Rafael Lejtreger

Introduction

Imagine finding yourself in a mud-covered interior where the aesthetics of the living room collide with the organizing systems of the museum. Disparate collections—potatoes and fossils, nails and leaves—are mixed together alongside piles of books and pieces of furniture. A self-portrait is made directly onto the wall. Fragments of text connect the objects in the space to the ideas of thinkers from different times and places across the globe. The distinction between center and periphery is put in question and its hierarchy undermined. To enter an installation by the artist Carlos Capelán in the 1990s was to be immersed in a universe where familiar objects and concepts are at once intermingled and estranged, charged with new meanings.

The exhibition "Kartor och landskap" (Maps and Landscapes) at Lunds konsthall in 1992 described above is one example of what could be regarded as a series of rearticulations of the art institution. When transforming the whole structure of the exhibition, it was only logical that Capelán should attend to another key power relation at work in the art system: the conceptually distinct roles of curator and artist. In a series of independent projects, he began to treat these functions as interchangeable, fluid categories providing him in turn with a fresh set of tools for his artistic practice.

In the '90s, Capelán was one of the most frequently exhibited Sweden-based artists internationally, from biennials in Havana, Johannesburg, and São Paulo to institutions such as Ikon Gallery, Birmingham, and Museum Carrillio Gil, Mexico City. Capelán has continuously engaged with a variety of media beyond the canvas such as letters, maps, and books and has for many years explored ways of working outside the studio. Linguistic twists and a critique of the power relations of the art system are key elements in his work, seen for example in the conceptual piece POST-COLONIAL LIBERATION ARMY (rematerialización) PCLA (r) from 2001.

As a part of his practice as a visual artist, he curated a wide range of projects, from small-scale presentations to larger museum interventions. Rather than seeing curatorship as a profession, Capelán proposes it as a practice that is embedded in all levels of art and culture. He has optimized the role of curator to experiment with the culture surrounding him and to generate situations in museums and galleries. Curating has also provided him with an occasion to work closely with other artists in a way not possible were he present solely as an exhibiting artist.

The chapter consists of a series of conversations with Carlos Capelán, tracing and pinpointing some of the ideas and methods that are central to his curatorial practice. The starting point for the conversation was the exhibition "Fem trädgårdar" (Five Gardens) that took place in 1996 in Simrishamn, a picturesque coastal town in the southernmost Swedish County of Scania, a region primarily associated with summer tourism and fishing and not with contemporary art. When Capelán was invited to do a solo show at Kulturhuset Valfisken—a small-scale municipal cultural center with a library, a space for exhibitions, and ambitions to combine the local context with an international discourse—he decided to shift positions and responded by turning a solo manifestation into a collective experience and a group exhibition proposal. Since "Fem trädgårdar" Capelán has continued to move between positions of facilitating and participating, through cities and peripheries, thinking about roles and identities, always keeping friendship and trust as cornerstones in his way of working.

While sustaining an active artistic practice, one year after "Fem trädgårdar" Capelán co-curated "Runt om oss, inom oss" (Around Us, Inside Us) in 1997 at Borås Konstmuseum (Borås Art Museum) in southwest Sweden with curator Elisabet Haglund. He also curated the exhibtion "Tiempo (Tiempo) Tiempo" (Time [Time] Time) with works by the artist Wifredo Díaz Valdéz in 2013 togther with curator Veronica Cordeiro at the 55th Venice Biennale, and "Aquí soño Blanes Viale: Una exposición de Pablo Uribe" (This Is Where Blanes Viale Dreamt: An Exhibition by Pablo Uribe) at National Museum of Visual Arts, Montevideo, Uruguay, in 2018. Looking back even farther in time, interesting examples of Capelán's curatorial work can be noted as early as the mid-'80s when he curated a program with international exhibitions at Café Ariman in Lund—a small but highly significant spot for intellectuals in the region.

Through Capelán's narration of these past projects one gets a sense of his practice's characteristic navigation of multiple forms of ambivalence. This chapter will reveal some of the propositions of Capelán's practice as a curator—and more broadly as a professional in the art field. Among these are the choice related to the use of power, the idea of reciprocal trust, and the abolition of categories. Throughout his practice, Capelán has evinced a sense of transnationalism which, as a curator, comes through in his choice of artists to collaborate with, where invitations often have been extended to colleagues beyond the West. This is also apparent through where he chooses to work curatorially, shifting and connecting localities and horizons across continents.

As an artist who curates exhibitions, Capelán employs a critical approach to the type of "power" that is associated with curators and a position often considered hierarchically

different and stereotypically "less bohemian" than that of the artist. For him, curators take on the role of maintaining relationships with institutions; aligned as a result with this institutionalized "power," they can choose to put themselves at the service of the artists and their creation of the work. Building a generous working relation—even though this might not be defined as entirely symmetrical—toward a common goal, a curator can at least aim to achieve balance, fairness, and reciprocity. It is from this perspective that the associated idea of mutual trust emerges as one of the principal aspects of Capelán's trajectory, along with a playful use of curatorial power.

By toying with tensions between seemingly dichotomous categories, Capelán triggers a critical awareness that labelling and categorization are simply useful representational tools. He is keen on mastering the interplay of the natural and the acculturated, of intuition and rationality, improvisation and structure, "tradition" and the contemporary "avant-garde," center and periphery, inside and outside the museum, site and non-site, invasion and dispersion. His work demonstrates no difference in the type of content that is created within a given professional discipline, whether that of artist-curator, producer, or academic professor. Rather, it is through the intentions, actions, and mutual trust of those developing the project, that the essence of these practices can be seen.

Carlos Capelán was born in Montevideo, Uruguay in 1948 and has since lived between different European and Latin American towns and cities with regular long stays in Havana, Bergen, Santiago de Compostela, Montevideo, and Moravia (Costa Rica). Capelán came to Lund in Sweden in 1973 seeking refuge from the political oppression taking place in Latin America at that time. His first exhibition was at the international Anders Tornberg gallery in Lund and at the end of the 1970s he attended Grafikskolan Forum in Malmö. Capelán can be designated as a "post-conceptualist artist" working as he does with idea-structures while insisting on a material and formal diversity of approach. Workshops, conferences, talks and teaching are all significant parts of his artistic practice, as (equally) are drawing, installation, painting, performance, objects and writing.

Right: Working outside the white cube, Lund 1985. Photo: Carlos Capelán

Four Projects: A Conversation with Carlos Capelán

Fem trädgårdar (Five Gardens), 1996
Runt om oss, inom oss (Around Us, Inside Us), 1997
Tiempo (Tiempo) Tiempo (Time [Time] Time), 2013
Aquí soñó Blanes Viale: Una exposición de Pablo Uribe (This Is Where
Blanes Viale Dreamt: An Exhibition by Pablo Uribe), 2018–19

The dialogue that follows is based on conversations between Carlos Capelán, Edy Fung,
Giulia Floris, and Hanna Nordell that took place online in fall and winter 2020.

Edy Fung/Giulia Floris/Hanna Nordell: What does the practice of curatorship mean for you as an artist?

Carlos Capelán: As an artist, I have personal motives for seeking places of action beyond the studio. In more theoretical terms—and within what has been called the "crisis of representation"—it is interesting to invade and reconsider that instance of power called the "curatorship" of an exhibition.

EF/GF/HN: What do you mean by the crisis of representation in relation to your motivation to curate?

CC: The crisis of representation is an old issue in anthropology as well as in philosophy, politics, literature, gender, religion, semiotics, etc. Speaking about the question of representation in art, I often ask myself: can art represent the world? If so, how much, how efficiently?

In symbolic terms, can we [artists] represent the world? The crisis of representation is the condition in which art has to ask itself: what am I saying? And for what reasons, to what ends, by what formal means? If art represents, curatorship is one of the instances through which art is represented. Curiosity is what makes me want to "re-present" the art curator.

EF/GF/HN: In 1996 you curated the exhibition "Fem trädgårdar." How did this project come about?

CC: Let me start by describing my personal context at the time: in 1995 I produced fourteen international projects with talks, solo shows, and biennials. I spent six months living in five-star hotels. I met many, many people within the art system. Some of those I met were absolutely wonderful and very important for me at the time, and some still are. But to be

Carlos Capelán, *Förnuftets Sömn* (The Sleep of Reason/El Sueño de la Razón), 1996. The installation was created for the exhibition "Fem trädgårdar" (Five Gardens) at Kulturhuset Valfisken in Simrishamn. Photo: Carlos Capelán

honest I also got extremely tired, and I realized that I did not start working with art to be part of this whole thing with drinks in hotel lobbies, etc. So, my family and I decided to move to Costa Rica, believing it was outside the mainstream—which of course it was not. Then at the same time as we were planning this move an invitation came which caught me by surprise: I was asked to do a solo show in this tiny little space called Kulturhuset Valfisken in Simrishamn. It was a cultural center established in 1990 and which included a space for contemporary art and a library. I knew the director, Susan Bolgar, who invited me to do a site-specific installation. But then I started thinking and suggested we instead produce a group show with local, as well as international, colleagues. Susan and I realized very quickly that the space was too small to produce a group show with all the artists I had in mind, and that we would have to look for additional venues for the exhibition. Instead, we conceived the whole project as a decentered, delocalized kind of show. I invited two local colleagues, artists Max Liljefors and Madeleine Tunbjer, and then two international artists, Sissel Tolaas and Ronald Jones, whom I knew very well.

"Fem trädgårdar" (Five Gardens), 1996
Site: In the Kulturhuset Valfisken, as well as public spaces in the cities of Simrishamn and Ystad, Sweden
Artists: Carlos Capelán, Ronald Jones, Max Liljefors, Sissel Tolaas, Madeleine Tunbjer
Photo documentation: Åke Hedström
Curator: Carlos Capelán

"Fem trädgårdar" took place in Simrishamn at the Kulturhuset Valfisken cultural center, peripheral to the Stockholm–Malmö axis and the art system of the time. Carlos Capelán turned an invitation for a solo show into a group exhibition, taking part both as curator and artist. The exhibition used both the interior of the institution and the public space outside and beyond it. Taking the notion of "the garden" as a point of departure or central metaphor, artists Ronald Jones, Max Liljefors, Sissel Tolaas and Madeleine Tunbjer were invited to create new works relating to it. Ronald Jones' artwork was rejected by local politicians on account of its historical content, so the project was instead realized in the nearby city of Ystad at the municipal art museum, creating a site of exile within the exhibition.

In "Fem trädgårdar" artist Max Liljefors chose to work in a meeting room between the library and the exhibition space at Kulturhuset Valfisken. Here he constructed a glasshouse that followed the shape and proportions of the room but smaller in scale, like a transparent replica. The installation *Växthuset* (The Greenhouse) included video components and centered around the greenhouse as a metaphor for selfhood.

Left: Madeleine Tunbjers' artwork, *Sanatorie Trädgård* (Sanatorium Garden) in the square outside Kulturhuset Valfisken. This installation addressed the culture-nature divide and featured enlarged images of medicinal plants installed in flowerbeds of bright pigments. In the center of the installation, there was a sandbox-like square with blue pigment in place of sand or soil. Inside this square the artist placed a vitrine of garden tools.

Photos: Åke Hedström/ Malmö Museer

EF/GF/HN: Could you talk more about how you chose the spaces in the exhibition and what it meant to realize this project in Simrishamn?

CC: Simrishamn and Ystad are peripheral to the better-known Stockholm-Malmö axis, both geographically and in terms of the art system. The relative "social mobility" of this system today makes it worth trying to set up independent projects embracing the local and the global while working outside conventional limitations. So, the idea was to produce independent projects in not so mainstream places, with a very diverse set of people.

I knew that the project would be based on collaboration and that it would be produced in a local venue, far away from big institutions and large cities, and that

was important. I wanted to think about notions of place from very different perspectives.

The idea was to produce five spaces, one for each artist involved, that were very different from each other but that together would have a form and shape. It was about creating a landscape: a cultural landscape, surrounding the institution and in the institution.

Defining the space for each of us was easy: I was going to make a major piece for the central main room of the art gallery; Max Liljefors intended to construct a room within a room and, since the art gallery shared a building with a public library, we were able to find a place for Max's project there. Then, Madeleine Tunbjer suggested working outdoors: she was educated in Holland and was into working physically outside of the institution, so she got the square space, just in front of the gallery. She wanted to work with plants and healing so that was a perfect site for her. Ronald Jones decided to produce a work inspired by a garden that he discovered through one of the aerial photographs of the concentration camp in Auschwitz-Birkenau. To do that he needed a specific place where he could plant and organize a garden, and the staff at Kulturhuset Valfisken helped us to find it. It was more difficult to find a place for Sissel Tolaas' work since she

intended to create an installation totally surrounded by nature. She had been working with smells for several years and she was—and still is—a very well-established artist dealing with these issues. Studying the site, I realized that there was an abandoned rail track close by the museum, so a train wagon was set there to allow her to place the work.

We came up with all these conclusions together, talking to people, walking around, and looking together. So, I cannot say that I was the only mind producing all the situations exhibited. It was a collaboration between many people.

EF/GF/HN: As with "Fem trädgårdar" you had already made projects outside the conventional white cube, for example in abandoned housing and factories. How did your occupation of public space come about?

CC: It is related to the notion of the zeitgeist and the spirit of the times. In the 1980s, the forces of neoliberalism were very strong, following the government of Margaret Thatcher in the UK, Ronald Reagan in the USA and so forth. At that time, there was also a movement coming from the punk scene that was trying to get away from the hippie context to become political and to get real weight in the social context.

Carlos Capelán painting forest and rocks with indian ink in Tuscany, 1985. In the 1980s Capelán started to work in occupied houses, in the streets, and in the woods together with a group of friends. Photo: Joseph Montague

During this time, there was a whole bunch of people in Lund that were squatters. I was not one of them, but I had friends in that group. They were dealing with music, theatre, poetry, and art, and we used to do things together, trying to produce things for each other, for a few friends, and perhaps an audience. It was not very clear.

We started to produce anonymous pieces of work in occupied houses, in the streets, in old factories, producing situations and performances at home. At that time, I was also working outdoors in the woods, in Italy, in the USA, but mostly in Sweden: I painted rocks and leaves and I left them as they were in the woods. Sometimes it happened that young people discovered them and started gathering there, doing their stuff, like a ritual. It is kind of punkish when you think about it.

During that period, I also had the good fortune to meet other young artists who were working in this direction. Leslie Johnson, who is now a teacher of Valand School of Fine Arts in Gothenburg, was one of them. Back then, she was based

Painted rocks by Carlos Capelán. Photos: Joseph Montague

in New York where she produced shows in the windows of tiny little shops. The same was also happening in Cuba where artists were very radical because they were working despite the political system and making a critique of the Cuban Revolution, not as an anti-Cuban or anti-socialist but to go further. In order to do so, they had to work with alternative spaces, etc. Then, in some places, like Germany, people were working with theatre on buses, subways and other similar places.

So, something was in the air of the times, but it was not part of the mainstream: it was always like some sort of underground moment. I very much enjoyed participating in that until the point at which I felt I had to try my luck within the white cube.

To come back to this idea of invasion and occupation, I can say that you can anonymously invade the woods, the streets, as well as empty spaces in town. But can you invade the white cube? Can you really occupy it for a short period and do something there and then get out?

EF/GF/HN: What did it mean for you in these situations to invade a position and to occupy spaces?

CC: The situations I described were tools that several people at that time had been using, not as an exercise of

imperialism but more as a process of exercising freedom and self-defense. It could look like an invasion, but it is not: the intention behind the momentary occupation of space for certain goals is not to establish a new state or a new political situation. It only lasts for the moment that the space is occupied, when what is needed is done the space can be left. It is a political idea, of course, but it is the idea that I have been working with.

EF/GF/HN: Are there any other early examples of your curatorial work?

CC: During the years 1986–89, I was in charge of the art gallery of the so-called Café Ariman in Lund. At the time, it was a gathering point where well-established artists, writers, musicians, academics, and the like, mingled with people, particularly youngsters. The writer Birgitta Trotzig and gallerist Anders Tornberg used to sit there, as well as the artists that we associated with Tornberg's gallery that was located on the same street. Everybody was there: it was a place for seeing and being seen. Café Ariman produced poetry events, lectures, movie projections, shows, performances and amazing sandwiches.

The owners of Cafe Ariman were two young and interesting women, Renée Tunbjer and Lisbeth Brunn, who were studying anthropology at the time and

decided to start the café because they wanted to generate a much-needed gathering point. That is exactly what happened and then, when it became established, they symbolically sold it for one Swedish krona.

EF/GF/HN: Were you responsible for the exhibitions from the beginning?

CC: Practically, yes. Café Ariman started at the end of 1983 while I was living in Stockholm, but I moved back to Lund in 1985, so Renée and Lisbeth asked me if I could help them to organize the gallery. I was of course delighted, and I got paid in free sandwiches and coffee.

There was quite a big room in the back where there were some panels and where they used to show things. In that space I organized a series of exhibitions, performances and actions with Joseph Montague (Montreal/Vancouver), José A. Suarez Londoño (Medellín), Jaime Palacios (Chile/New York), Leslie Johnson (Illinois/Bärfendal), Annila Sterner (Stockholm), Dietmar Brandstädter (Lüneburg/Martfeld), Glexis Novoa (Holguín/Miami) among others, plus young local artists that showed their works there for the first time.

This program got regular attention from the press and soon it was part of the local cultural life. For me, it was an exciting experience working with art in a specific context and showing the work of artists I knew. This is one of those situations when culture happens not because a bureaucrat person decides it and not because an institution with good money provides the opportunity. Unfortunately, this kind of experience cannot be expected to last forever because it will not. People make something happen and then they have to pass the experience to others, and this is what Renée and Lisbeth did with Café Ariman.

In 1989 I also curated a show of Cuban graphic works for the Galerie El Patio in Bremen. The exhibition consisted of art pieces that I got as presents during my three months stay in Cuba the same year. The works were part of my personal collection and they were not for sale.

EF/GF/HN: Your stay in Cuba in 1989 was at the same time as the Biennial in Havana was happening, a project which is now acknowledged as a major event within the history of global art?

CC: Yes, I got an invitation for the Havana Biennial by the curator Gerardo Mosquera. I was not showing my work, but I was invited as an ally and to spend three months teaching at the Instituto Superior de las Artes, in Havana, which was an amazing art school. Teaching there was a wonderful experience, and, during this time, I got to know several

Cuban artists very well. Most of them went to live in exile afterwards, first to Mexico and then to the USA. It was an interesting experience, meeting colleagues and discussing politics, economy, art, philosophy, etc.—because in Cuba this is common practice.

During my time there I went to visit many artists and I was also invited to produce a couple of graphic works myself. Through that, they started to show me their own graphic projects and we ended up exchanging images. Eventually, I had a little collection of works by very interesting artists—some of them became very well-known later.

After my staying there, I was going to show my work at Galerie El Patio, so I told the gallerists about my experience in Cuba, that I got to know so many artists, getting some works from them, and they asked me if I would consider showing these works. The exhibition was produced, and I gave a gallery talk about this new generation of Cuban artists.

Please note that curating things is just part of what I do, I am not trying to be a curator. I accept the role as a curator out of responsibility, but I am not trying to make a career or anything like that. But I take it seriously, that is different. To me it is part of the same thing as teaching, working with my own pieces or writing a text.

EF/GF/HN: The exhibition "Runt om oss, inom oss" took place at Borås Konstmuseum in southwest Sweden. It was a group show that you curated together with Elisabet Haglund, who was the director of the museum at that time. How did this project come about and what did the process look like?

CC: The first ideas about the show probably happened during the many informal conversations Elisabet Haglund and I had at the time. When she and I started to think about the project in practical terms, I called the Iranian artist Chohreh Feyzdjou whom I had recently met in Paris. We had shown our works at Galerie Le Monde de l'Art and met thanks to the curator Catherine David. When I contacted Chohreh, she was enthusiastic about taking part in a project that was still undefined but sounded a lot of fun, so she accepted the invitation at once. Unfortunately, a few weeks later Chohreh passed away and Elisabet and I had to proceed without having her around. We then dedicated the show to her memory.

I knew all the artists included in the exhibition well except for Ann-Sofi Sidén who was proposed by Elisabet Haglund. It was a wonderful feeling of joy and enthusiasm when we finally all—artists and curators—gathered in Borås and all the conversations between us really started. It began to feel like an intensive

"Runt om oss, inom oss" (Around Us, Inside Us), 1997
Site: Borås Konstmuseum (Borås Museum of Art), Sweden
Artists: Xu Bing, Jimmie Durham, Chohreh Feyzdjou, Monica Girón, Fernanda Gomes, Ronald Jones, Gülsün Karamustafa, Nina Katchadourian, Lilian Porter, Ann-Sofi Sidén, Nedko Solakov
Curators: Carlos Capelán, Elisabet Haglund

The exhibition "Runt om oss, inom oss" proposed a view of the world where center and periphery could become interchangeable and where the borders of the internal and the external had become irrelevant. Eleven artists were invited, primarily to show existing works. In Xu Bing's classroom the visitors were invited to study large exercise books that used a language the artist constructed by combining Chinese and English letters. In Chohreh Feyzdjou's installation "Boutique," a bazaar-like structure displays self-fashioned "products" she fabricated out of cheap materials and covered with a layer of black pigment. Displacement, cartography, and representation were among the subjects discussed by the invited artists. The catalogue included contributions by Gerardo Mosquera, Catherine David, and Maria Thereza Alves, among others.

Above and left: Mónica Girón, *Ajuar Para un Conquistador* (Trousseau for a Conqueror), textile work in knitted wool, 1993, Borås Konstmuseum. Girón (San Carlos de Bariloche/ Buenos Aires) was one of eleven artists of many different nationalities in "Runt om oss, inom oss" (Around Us, Inside Us). Photo: Alfredo Pernin

seminar, that is how the project looked: with serious talks and lots of fun.

Since I knew they had different perspectives on the field of art, I wanted Thomas McEvilley—art critic, and author of the acclaimed book *Art and Otherness: Crisis in Cultural Identity*— and the Havana-based curator and writer Gerardo Mosquera, to produce texts for the catalogue. Thomas was regrettably too busy with other projects and was not able to take part in "Around Us, Inside Us."

EF/GF/HN: How did you think about these text contributions in relation to the exhibition?

CC: The texts do not have to address the show itself, but its ideas. They are

Chohreh Feyzdjou, *Boutique, Product of Chohreh Feyzdjou*, 1995–96, Borås Konstmuseum. The artist Chohreh Feyzdjou participated in the exhibition with the large-scale installation *Boutique, Product of Chohreh Feyzdjou*, a room filled with self-made, labeled products, each covered in black pigment. Photos: Alfredo Pernin

something that can work in parallel with the exhibition. I even like the idea that both texts and works could produce what I call a "scratch," that is when they generate some contradicting friction between each other. The way I see them, both texts and works, are different kinds of things and they do not play symmetrical roles. Encounters themselves take place in the realm of difference, I believe.

I think that all shows are collaborative projects. I create a certain situation by putting people in contact with each other and try to find a common ground. It depends very much on collaboration, and how this gets established. I do not aim to have control. When we began to organize "Runt om oss, inom oss" there was a big portion of trust, both from Elisabet Haglund's side and from the side of the artists involved, and in many cases, there was friendship, as well.

EF/GF/HN: This is something that is quite apparent in the way you talk about your work; you always seem to have fun with people you work with and you frequently talk about friendship in relation to your projects.

CC: My friend Nikos Papastergiadis, an academic and researcher in the field of public cultures, just published a book called "On Art and Friendship." The idea of friendship is something that I have been discussing with him and artist Jimmie Durham for years. I believe in friendship, but it is not necessary. "Trust" is the keyword here: I usually work with friends, but I do not have to be friends with them, I have to trust their intentions.

EF/GF/HN: In the exhibition catalogue for "Around Us, Inside Us" the idea of invasion touched upon at the beginning of this conversation is very prominent. How did you see such an act of resistance in relation to this specific project?

CC: Concerning the notion of "resistance" primarily I have to say that I work for or about something, not necessarily against. Trying to be "real"—here and now—is a powerful form of utopia, trying to enjoy oneself and others can be a strong form of resistance.

Coming to the notion of "invasion" in Borås, it could be perceived through the ironic perspective of an "invasion from outer space." On the one hand, I wanted to present a certain context that, with very few exceptions at the time, was not so visible in Sweden. On the other hand, I had the secret wish to expose and clarify the international context for my own work outside of Sweden.

EF/GF/HN: How did you approach your task at the Venice Biennale? What were you trying to achieve?

"Tiempo (Tiempo) Tiempo" (Time [Time] Time), 2013
Site: Venice, Uruguayan Pavilion at 55th International Art Exhibition of the Venice Biennale
Artist: Wifredo Díaz Valdéz
Curators: Carlos Capelán, Veronica Cordeiro

Carlos Capelán was invited by the Uruguayan Minister of Culture to curate the State Pavilion at the 55th International Art Exhibition of the Venice Biennale in 2013. The Pavilion invoked the Encyclopaedic Palace—self-taught artist Marino Auriti's unrealized project for an imaginary museum intended to house all global knowledge, registered at the US Patent office in 1955, and from which the Biennale took its title. The 55th Venice Biennale investigated figures from across the ages who attempted to organize all-encompassing and imaginative knowledge, giving shape to the human presence in the world.

Carlos Capelán accepted the invitation, choosing to invite Veronica Cordeiro to co-curate the Pavillion with him. Together, they invited the self-taught Uruguayan sculptor Wifredo Díaz Valdéz to show his work. Valdéz mainly investigates the mechanisms of wood-based utilitarian artifacts, exploring cultural meaning and the way time modifies them both.

The exhibition analyzed the fragility that can emerge in every product and aspect of human existence.

CC: While most major art events around the world present spectacular and high budget works, their focus on mass audiences, high-end collectors, mainstream art galleries and art fairs, makes one think that these events have a deal with the entertainment industry.

Together with co-curator Veronica Cordeiro, I took on the curation of the Uruguayan pavilion knowing that, because of their avid hunt for big names and trademarks, the average spectator does not stop for more than a few seconds in front of a work—if they stop at all. Veronica and I also knew that the tiny Uruguayan Pavillion space would be surrounded by the much bigger and stronger pavilions of USA, Australia, France and Israel. So, we agreed to proceed keeping in mind that an art project's value does not have to be a mere extension of its economic value.

At the time, artist Wilfredo Díaz Valdéz was 81 years old, very quiet as a person, not so well known internationally, and he was producing a time-consuming kind of work which demanded a certain peace of mind and attention from the spectator.

If some artists of his generation aimed to dematerialize the art object, Wilfredo felt the political need to rematerialize it, that is, to re-signify the material means used in his work and give them semiotic relevance. His procedures can be considered within a context understood as profoundly political: the aesthetics of production versus the production of aesthetics, sustained by a measure of austerity that operates as a certain form of resistance.

EF/GF/HN: What do you mean by production in this context?

CC: When analyzing a project—any kind of project—it is important to ask yourself: "What is the content of this?" Because there is content when it comes to form. There is content when it comes to production. So, artists and curators have to ask themselves: what kind of investment am I making in production here?

Most of the time, they put together, or try to understand, form and content as a unity, which is not always true: sometimes the form takes over and sometimes the content is the whole piece. So, how can these be put together?

When talking about the production of the aesthetic, I refer to the production of symbolic meaning. Now, the aesthetic of production also produces meaning, but what kind of meaning?

Putting aside for a moment the wonderful intention to dematerialize the art object, nowadays it is possible to

Wilfredo Díaz Valdéz, *Butaca* (Armchair), oak and jute. Work included in the exhibition "Tiempo (Tiempo) Tiempo" (Time [Time] Time), 2013, Uruguayan Pavilion at the 55th Venice Biennale. Photo: Diego Vidart

see artists working with exceptionally large budgets. Visiting art biennials, you get to see magnificent pieces, with wonderful artists working on major, large-scale site-specific projects. In many cases, it becomes more a question of an aesthetic of production than the production of aesthetics. The consequence of these big budgets has been that artists started working as companies. They have so many people working for them that the individual artist working with their hands and mind has now become just a small part of the whole thing because big sophisticated production has taken over. Consequently, fancy production is not only about money, but also about connections: it is about information, experience, going for dinner, meeting the right people and having the right conversations. I've witnessed that and, as a result, I left the mainstream scene in 1995.

In my work—whether it is teaching, doing my own pieces, curatorship or writing a text—I try to conduct my research, asking questions and generating situations. The main questions for me are: What is the context in which I am working? How am I coping with it? Am I producing some kind of aesthetics? Am I just a tool in the hands of the producers? Am I being used by this aesthetics of production? Maybe I am, I just need to know.

EF/GF/HN: You always pay special attention to visitors and audiences when you create your work. What kind of reactions did this work produce?

CC: The audience in major art venues is mixed. To simplify: on one hand you have the high art professionals, who are well informed, and on the other, the stressed, large and quite often disoriented visitors. For many of them, the Venice Biennale is a cool place where it is possible to combine a holiday with "fine" culture. The city of Venice knows very well that it has the peculiar aura of a romantic and sophisticated tourist attraction and it makes good use of that. Certainly, all mixed audiences expect to be amused.

However, it is important to remember that Wilfredo Díaz Valdéz is neither a young emerging artist nor is his work spectacular or entertaining. When Veronica and I showed his work, I did not expect it to get much attention from the professionals, nor did I expect less informed visitors to stand in line to see and marvel at his work. Despite my lack of expectations, there were positive and spontaneous reactions from both sides.

What was significant in this case was that the experience meant a lot to the artist: he was incredibly pleased. It should also be mentioned that the project was a continuation of an already

Wilfredo Díaz Valdéz, *Rueda* (Wheel), 1988, Lapacho and iron. Work included in the exhibition "Tiempo (Tiempo) Tiempo," 2013, Uruguayan Pavilion at the 55th Venice Biennale. Photo: Diego Vidart

ongoing debate in Uruguay regarding the politics of national representation and the need for international prestige.

EF/GF/HN: The exhibition with Pablo Uribe at the National Museum of Visual Arts in Montevideo in 2018–19 brings the conversation back to some of the

issues already discussed. Pablo Uribe's work *Croma* (Chroma) involved cars being parked outside the museum according to a color gradient and which would then split up and "invade the city," loosening the distinction between inside and outside, art and everyday life. Could you tell us more about the specific implications of "invasion" in this project?

CC: Here, the idea of dispersion was perhaps more important than the notion of invasion. The cars went back to what they usually do in the daily life of the city. The joke was then to overlap invasion and dispersion by letting everyday things become part of the collection shown at the museum and, at the same time, they did what they usually do: drive around, park, and drive around again.

While Pablo and I were working within the museum's collections we were getting more and more involved in issues of museology. In the process we came to realize that we needed much more space than we had, not only as we wanted to work with the whole notion of "the Museum" but because we also wanted Pablo to work with his version of a national museum. So, we asked to do exactly that: to allow Pablo to rearrange the museum's collection.

It must be considered that by allowing an individual artist to curate the collection of a National Art Gallery it is almost possible to talk about a real invasion of the museum and in particular of the notion of national identity that a National Art Museum represents.

It was a very political move, very difficult to achieve, and we had to be very clear about what we were going to do, but in the end we got the permission—under certain conditions, of course.

Penetrating and momentarily invading the administration of a national structure, the exhibition had a significant political dimension. This is particularly true if you consider all the negotiations Pablo and I had with the Ministry of Culture and the Cultural Council in Uruguay, in order to get the approval to do the project as we imagined it: to totally re-arrange, for a moment, the practice of a major museum. In this sense, I see the project as succeeding in an act of momentary invasion.

EF/GF/HN: Do you mean that you were addressing the audience by engaging both with the museum and everyday life outside it?

CC: To reply, I would like to bring to your attention another example of Pablo's proposed displays for this exhibition. It consisted of a reference kind of wall with a related map that presented a

"Aquí soñó Blanes Viale: Una exposición de Pablo Uribe" (This Is Where
Blanes Viale Dreamt: An Exhibition by Pablo Uribe), 2018-19
Site: National Museum of Visual Arts, Montevideo
Artist: Pablo Uribe
Curator: Carlos Capelán

In 2016, Carlos Capelán proposed Pablo Uribe's solo exhibition "Aquí soño
Blanes Viale" to Enrique Aguerre, head of the National Museum of Visual
Arts in Montevideo, Uruguay. The titular dreamer is the painter Pedro
Blanes Viale (1879-1926), born in Mercedes, Uruguay. His colourful landscape
paintings in oil deployed a palette of complementary colours, drawing
on European scholarship, and chiaroscuro technique. The exhibition was
unusual, almost three-years in preparation, with a large budget, and free
access to the whole museum's collection. The show consisted of a new body
of work titled *Croma* (Chroma), and its cross-disciplinary approach included
research engagement with the restaurateur Mechtild Endhardt. There was a
new site-specific commission challenging institutional power, museology, and
authenticity, and a new wall painting using deconstructed color palettes of
the damaged Torres Garcia's murals in the circulation space between floors,
immediately outside the exhibition room.

Pablo Uribe, *Accidente* (Accident), 2015–18, performative action on the sidewalk of Av. Tomas Garibaldi composed of 18 parked cars (variable dimensions) as part of the exhibition "Aquí soño Blanes Viale: Una exposición de Pablo Uribe" (This Is Where Blanes Viale Dreamt: An Exhibition by Pablo Uribe). Photo: Rafael Lejtreger

plan of the show and a plan of the works exhibited on the wall. In this way, visitors could see relationships between these pieces hanging on the wall and what was in addressing the museum. Right in front of this reference wall, there was a bronze sculpture of a girl, a walking girl, that for the exhibition was reproduced by digital means. Six copies of the sculpture were made, and they were placed all around the museum as they were looking at the show.

Among other things, this piece commented on the presence of the audience looking at art since in that case the art was also looking at art, walking around, seeing works and watching them. In the same series of works, entitled "Fake, copies, authorship and the originals" there was another piece that interacted with the gallery space and it consisted of a person sitting in the chair, acting as a security man. He was not a real one—he was an actor who played a role—and he was sitting in front of a copy of a large, and very well known, painting by Juan Manuel de Blanes from 1877 called *Juramento de los 33 Orientales* (Oath of the Thirty-Three

Easterners) which, in the case of Pablo's exhibition, was a total fake.

Thanks to these examples you can see how, when I curate, I try to show certain complexity, allowing the audience to get in between the interstices, in between the gaps. I do respect a lot the intelligence of the audience: I do not have to lead it, people can do their thinking and come up to their conclusions. Artists and curators do not need to be paternalistic towards the audience and have to respect their intelligence because they can handle complexity.

EF/GF/HN: How do you see your background as an artist has influenced your role as a curator in an exhibition such as this one with Pablo Uribe?

CC: I see myself as a facilitator. In some of the shows I curated, I was able to do that because, as a curator, I had a certain prestige and institutions trusted me somehow. In these cases, the core-question has to be: "If I do have some power, how can I use this?" To me the response is: "to empower other people," where with that I don't mean only giving the chance to show their own work, but also to help them, as much as I can, to understand what they are doing, to get deep into their own way of thinking. In that sense, I consider myself a "soft curator," because I try to get deep into

the artist—into the individual—that I'm working with. I do not try to conduct what they say or what they are doing, I do not try to produce a certain result. I do not care about that, but I care about the process, how to allow them to take the lead and get in deep into what they are trying to say. This is one of the many aspects of trying to be a soft curator.

EF/GF/HN: What you are describing sounds more like a partner.

CC: Yes, that is true. As colleagues, I can discuss with the artists among equals. With them I discuss the pieces, like in-between partners, never trying to change the work but to get to the very point of why the piece is getting that shape, that form, that way.

EF/GF/HN: What do you think about the art system's conventional perception of the roles of curators and artists? Are you attempting to break these stereotypes with your practice?

CC: Artists, do not have the same status as curators: a curator is considered to be more serious than an artist, who sounds a little bit crazy, subjective and bohemian—which I do not think is true. I remember having this discussion with art historian Benjamin Buchloh who at that time was saying that many contemporary artists are so articulate that they do not need a curator because

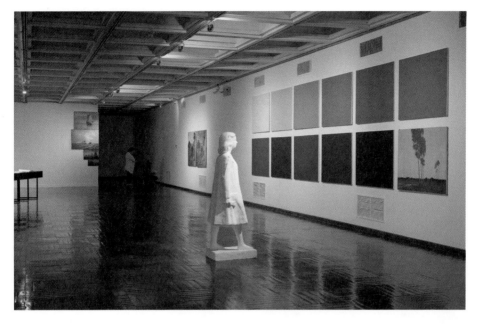

Installation view of "Aquí soño Blanes Viale: Una exposición de Pablo Uribe." On the wall: Pablo Uribe, *I Croma XII [Ernesto Laroche, La canción del silencio]* (Chroma XII [Ernesto Laroche, The Song of Silence]), 2017–18, oil on canvas, 12 pieces. In the middle: Pablo Uribe, *Hostesses*, 2018, plaster rubbings. These figures appeared in multiple locations in the museum positioned to look at different groups of works in the exhibition. Photo: Rafael Lejtreger

they know what they're doing: "they are producing aesthetics and they know what kind of aesthetics they are." On the other hand—he added—curators had started to act quite strangely and to now become the weird ones, the Bohemians.

This is what we discussed during the '90s, when curators were losing power and they began to reconceptualize art in order to regain it in some way. Of course, I do not want to generalize about the two roles, but I feel it is important to understand my position in the context of this discussion.

EF/GF/HN: You see your curatorial work as modifying and completing your work as an artist. How has curating several projects served your artistic practice and thinking?

CC: I believe that, as artists, as curators, as an audience, as consumers, as intellectuals, we all organize knowledge, and I think that it is important to be loyal to this idea. No matter what an individual is doing, they are sort of organizing knowledge, which is pretty much about organizing stupidity and organizing everything they do not know about the

Pablo Uribe, *Citas Citables* (Quotable Quotes), 2018, installation (variable dimensions) as part of the exhibition "Aquí soño Blanes Viale: Una exposición de Pablo Uribe." Photo: Rafael Lejtreger

world, or themselves, as well as things they know, and they share with others.

Organizing knowledge is not a defined idea, it is a zone, something to work with. As a professor, as an artist, as a curator, as a writer, as a family member, the difference is not that big—it is the same action all the time, with different tools, different contexts, but always connected.

In this sense, I would suggest that this is also about the complexity of language. I have always been fascinated by language, and art is just one of its many tools. Language is indeed about how to formulate things and how to build up the symbolic structures of the world.

EF/GF/HN: In the projects you curate there is more emphasis on creating a situation in which artists can experiment than on imposing a "curatorial voice." Is there a conscious effort not to intervene, to let their voices lead? As an artist yourself, how would you differentiate your approach from that of other curators?

CC: Working as a colleague, I can enter the intimate space of the artists I work with because for them I do not necessarily represent a judgmental or hierarchical instance. They trust me as some kind of intermediary, and I perceive myself as someone who tries to generate the best possible conditions so that the

artists can articulate themselves fully. I sincerely want them to make full use of their voice and I enjoy the experience.

I do not feel the obligation to be pedagogical, to interpret the intentions of the artists, or to explicitly enact the role of curator. The different position that I take potentially makes it easier to work with the artists and, at the same time, to work for the artists. It does not mean that I keep silent, of course: maybe it is not always visible, nor obvious or loud, but my voice is there. Instead, I prefer to point to the context or the conditions in which the project is produced.

If an artist I am working with and I agree it is needed, I enjoy producing a text in the form of a conversation. Neither the artist nor the curator is a ventriloquist: each one of them talks by themselves, and with each other, and with the audience. They do it knowing why they are doing what they do for each specific project—after all, they are always dealing with representing things.

So, the question cyclically recurs: what sort of self-representation can be expected—or demanded—from a project's curator? One should neither be too visible, nor avoid adding to what is already being presented with one's own discourse. Neither should one project into words what is implicit in the language shared during a certain

process. That is what I would like to demand from myself. I do not feel the obligation to be pedagogical, to interpret the intentions of the artists, or to explicitly enact the role of curator. The different position that I take potentially makes it easier to work with the artists and, at the same time, to work for the artists. It does not mean that I keep silent, of course: maybe it is not always visible, nor obvious or loud, but my voice is there. Instead, I prefer to point to the context or the conditions in which the project is produced.

Of course, a curator can have a powerful voice. Of course, a curator can be a very interesting solo singer. Of course, the project might need such a clear voice. But not all projects, and certainly not all curators, have to take such an approach.

MUSEUM IS A VERB
Mapping Jan-Erik Lundström's Curatorial Work, 1980s–Present

Edy Fung, Simina Neagu, and Erik Sandberg

Mona Hatoum, *Bukhara (maroon)*, 2008, carpet. Photo: Bucharest Biennale 3

Introduction

How can the museum be a verb? Or, in other words, how can institutions become a place of constant inquiry and action, rather than a repository of objects? At this moment in time, institutions across the world grapple with manifold challenges: dealing with colonial legacies deeply embedded in museological practices and becoming representative spaces of larger society. This would require creating institutions as verbs, according to Jan-Erik Lundström. In his words, "the museum is not a noun. It's a place of doing, of activity, of actions. It's not a place of objects. I think of it as a way of undermining some of the norms and value structures—since the museum is also a child of coloniality-modernity, an Enlightenment project—the museum has evolved, including curating art and exhibition-making." Throughout his curatorial work, writing and teaching, Lundström tried to create exactly that: spaces of dialogue, research, and occasionally, repair.

During the autumn and winter of 2020, we had a series of conversations with Lundström, covering his trajectory over almost four decades. Inspired by his interest in critical cartography, the map became a starting point for this chapter. Focusing on the relationship between image and text, and breaking with the primacy of the written word, spurred the production of an annotated mind map to guide us through the interconnected themes and issues that are at the core of Lundström's practice and thought. Connections and parallels between the many themes he followed are central to the map—from his time as a photographer at the Visual Studies Workshop in Rochester, New York, and throughout his many curatorial positions and projects. Furthermore, the map is in many ways central to Lundström's ideas and approaches, emerging from a childhood interest in cartography, making its way into the projects he has curated, and becoming a decolonial tool. In turn it helps us to understand his vast body of work in the fields of contemporary art and visual culture.

One of the first questions Lundström encountered as he advanced his curatorial practice was: What is the place of contemporary photography in the institutional framework of a modern art museum? Fotografiska Museet (The Museum of Photography), to which Lundström was appointed as director and curator in 1992, had been founded in 1971 as a department of Moderna Museet (The Museum of Modern Art) in Stockholm with the aim of one day becoming an independent institution. Instead, the department was fully integrated into the museum, a process overseen by Lundström in 1998. By the time he joined Fotografiska Museet, he had already established himself as a noteworthy curator,

writer, and translator. Having been the artistic director of the Pohjoinen Valokuvakeskus (Northern Photography Center) in Oulu, Finland, he published articles on photography in Swedish and international publications and translated the works of notable writers such as Noam Chomsky and Vilém Flusser. During his years at Fotografiska Museet, Lundström curated exhibitions of groundbreaking artists, such as the "Tahualtapa Project," by Lewis DeSoto, a North American artist of Cahuilla heritage, in 1993, or the exhibition "On Display," featuring Pia Arke in 1996. Pia Arke's photographic art addresses the effects of the colonization of her native Greenland. Moreover, he presented a new postmodern Swedish generation of mostly female artists through exhibitions such as "Prospekt," that was shown in 1993 at Fotografiska Museet. In the same year Lundström edited an anthology of photography theory called "Tankar om fotografi" (Thoughts on Photography). It featured writers that had been important in shaping a shift in the photographic field which Lundström was a prominent part of.

At that time in Sweden, Lundström's new take on photography helped photographic art to be seen by the museum as something not outside of the field of modern art but rather as an integral part of it, focusing on the genre of "new documentary," and politically engaged photography and showcasing indigenous artists to a larger extent than was done before at Moderna Museet.[1]

A few years later, Lundström's next challenge was a little different, as he tried to resolve another question: How can a university museum bring global contemporary art to its core? Lundström left Fotografiska Museet to become the director of Bildmuseet (literally translated: The Image Museum) in Umeå in 1999. Founded by Umeå University in 1981, Bildmuseet had the purpose of exhibiting state-owned art collections in the northern part of Sweden, as a way of decentralizing the art world from the capital. In an interview by artist Andreas Gedin in Moderna Museet's Bulletin, conducted in conjunction with Lundström departure to Bildmuseet, he states: "Bildmuseet's direction [...] will first of all face towards contemporary art. Its pulse is one of the phenomena that may elevate and charge a museum. Although by contemporary art I do not refer to the limited point of view where nothing but London/New York/Los Angeles is made visible. I perceive it as an obligation to always question the curiously homogenous and consensual image of contemporary art we most often are provided with." Aiming not only to break away from the western axis of contemporary art, Lundström's plans for Bildmuseet also encompassed the desire to broaden the scope of the museum's practice to include visual culture as a whole. During this time, Bildmuseet produced key exhibitions such as for example "Oscar Muñoz" (2009), "Ursula Biemann: Mission Report" (2008), "Contemporary Arab

Representations. The Iraqi Equation" (2006), "Människor i Norr" (Peoples of the North, 2005), "Carlos Capelán: Only You" (2002), "Politics of Place" (2002), "Mirror's Edge" (1999), and "Democracy's Images: Photography and Visual Arts after Apartheid" (1998).

In parallel, Lundström delved deeper into a set of questions that would continue to mark his practice: post-colonialism and indigenous practices in the Nordic context, with the understanding that the local and global are in a constant process of entanglement. Or put more simply in Lundström's words: "If we don't pay attention to our backyard, attention to the world doesn't make any sense." In 2001, Lundström was the guest editor of a special issue of *Paletten*, Sweden's longest-running art magazine, called "Bortom Västerlandet." (Beyond the West]. In this issue, perhaps for the first time in the history of the magazine, Lundström focused on topics of post-colonialism and the global conditions of visual art. The issue featured, among others, texts by important theorists such as Trinh T. Minh-ha and Homi K. Bhabha, and texts and artworks by artists Yinka Shonibare, Jamelie Hassan, and Olu Oguibe.

At the same time, concomitant with the so-called biennialization of the contemporary art world in the '00s, Lundström tried to tackle the following question: How can the biennial form respond to urgent social and political issues while highlighting a global perspective? Beyond Sweden, he has acted as curator and artistic director for several art biennials and festivals, such as "Killing Me Softly," at Tirana Biennale (2001), "Double Vision," at Prague Biennale (2005), and "Being Here: Mapping the Contemporary," at Bucharest Biennale (2008). "After the Fact" (2005), which he curated at Berlin Photo Festival, organized in partnership with European Photography at Martin-Gropius-Bau, addressed a world altered by the explosion of digital images and photographs, and new forms of reproduction and dissemination through media technologies. Along with 33 artists including Fernando Alvim, Jiri David, Bertien van Manen, Adrian Paci, and Joachim Schmid, the exhibition dealt with growing concerns about the fusion of fact and fiction and the mass media control of information. At Thessaloniki Biennale of Contemporary Art, "Heterotopias: Society Must be Defended" (2007), he considered Foucault's idea of spatial otherness and acknowledged the biennial as a form providing this alternate order of space, social relations, and belonging, with 30 artists such as Camille Norment, Latifa Echakhch, Nikos Giavropoulos and Tracey Rose.

Nonetheless, as evidenced in the quote above, Lundström didn't lose sight of the local context and its specific complexities. At Bildmuseet, Lundström curated "Same Same but Different" (2004), a group exhibition showing works by Geir Tore Holm, Lena Stenberg,

and Marja Helander, at a time when Sámi culture and art was under-researched and being overlooked by both cultural institutions and academia. Lundström gave an account of what the definition of the Sámi identity was in legal terms at the time, accompanying the reading of the exhibition. The exhibition represented Lundström's recurring collaboration with Lena Stenberg and Marja Helander after working with them for the exhibition "Curt Bröms," at Pohjoinen Valokuvakeskus, 1992, and continued his engagement with and focus on indigenous artists' practice, in particular in the Nordic context.

This led to a larger challenge that Lundström faced as he tried to answer the question: How can one build an institution dedicated to contemporary indigenous artists and what are some of the challenges of this endeavor? He went on to publish several essays as well as catalogue texts about Sámi art, such as "Looking North: Visual and Literary Representations of Sámi" (2007), with Heidi Hansson, "Decades of Change: Visual Arts in Finnmark, Norway in the 1970s and 1980s," "Northern Beauty" (2014), "Reassemble, Remap, Recode: Some Strategies Among Three Contemporary (Sámi) Artists," and "Visions of Sápmi" (2015). Furthermore, he also set up the Sámi Dáiddaguovddáš (Sami Center for Contemporary Art) in Karasjok in the northernmost part of Norway. Lundström became its director in 2011, staying there until 2013, and then coming back for a second term between 2016 and 2018. He spent the interim years, 2013 to 2016, as director of the regional institution Norrbottens museum. Key projects during his time at Sámi Dáiddaguovddáš include "Being A Part: 30 Years of Sámi Art" (2009), "Sámi Contemporary" (2014–15), "Čájet Ivnni: Vuostálastte, Čuožžil, Ovddit" (Show Me Colour: Resist, Stand Up, Advocate, 2017–18), and "Sissel M Bergh: Okside ríhpesieh" (2018). Yet, as he admitted in our conversations, this endeavor was not without problems: "There are the very real issues precisely of cultural sovereignty, capacity building, there are the nested problems of essentialist identity politics and real intercultural exchange, the traps of a lame practice of inclusion and recognition, blocking real change, and the asymmetries of power."

More recently, Lundström, along with co-editors Anna Hudson and Heather Igloliorte, has been working on a major anthology focusing on contemporary Inuit, Kalaallisut (Greenlandic) and Sámi artistic practices across most disciplines called "Qummut Qukiria! Art, Culture, and Sovereignty Across Inuit, Nunaat and Sápmi: Mobilizing the Circumpolar North" (2021). The publication contains more than 30 contributions of essays, visual essays and more.

In reading this chapter, we encourage you to engage with both the writing and the visual elements to trace the correspondences in and developments of Lundström's thinking

around these questions. We hope that the questions and dilemmas posed above will find some answers through this chapter. Or, rather, following Lundström's advice: "I would not claim any closure, or any ultimate resolution. Only to be able to listen, rethink, revise, as one moves on."

1. "New documentary" refers to a discourse and practice in photography that sought to redefine what documentary in photography entails. Leading proponents in the field included Allan Sekula, Abigail Solomon-Godeau, and Laura Mulvey.

The Mapping Impulse

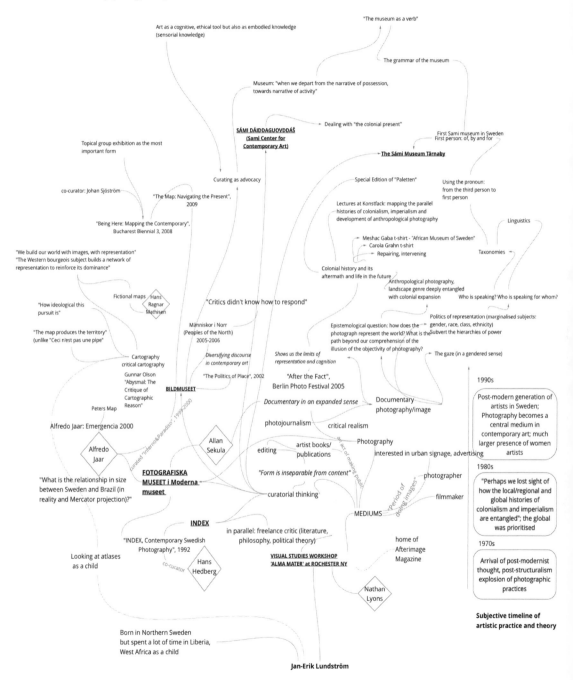

"The museum as a verb"

Art as a cognitive, ethical tool but also as embodied knowledge
(sensorial knowledge)

The grammar of the museum

Museum: "when we depart from the narrative of possession,
towards narrative of activity"

Dealing with "the colonial present"

First Sami museum in Sweden
First person: of, by and for

**SÁMI DÁIDDAGUOVDDÁŠ
(Sami Center for
Contemporary Art)**

The Sámi Museum Tárnaby

Topical group exhibition as the most
important form

Curating as advocacy

Special Edition of "Paletten"

Using the pronoun:
from the third person to
first person

co-curator: Johan Sjöström

"The Map: Navigating the Present",
2009

Lectures at Konstfack: mapping the parallel
histories of colonialism, imperialism and
development of anthropological photography

Linguistics

"Being Here: Mapping the Contemporary",
Bucharest Biennial 3, 2008

Meshac Gaba t-shirt - "African Museum of Sweden"
Carola Grahn t-shirt
Repairing, intervening

Taxonomies

"We build our world with images, with representation"
"The Western bourgeois subject builds a network of
representation to reinforce its dominance"

Colonial history and its
aftermath and life in the future

Anthropological photography,
landscape genre deeply entangled
with colonial expansion

Who is speaking? Who is speaking for whom?

Fictional maps Hans
Ragnar
Mathisen

"How ideological this
pursuit is"

"Critics didn't know how to respond"

Politics of representation (marginalised subjects:
gender, race, class, ethnicity)
Subvert the hierarchies of power

"The map produces the territory"
(unlike "Ceci n'est pas une pipe")

Människor i Norr
(Peoples of the North)
2005-2006

Epistemological question: how does the
photograph represent the world? What is the
path beyond our comprehension of the
illusion of the objectivity of photography?

The gaze (in a gendered sense)

Cartography
critical cartography

Diversifying discourse
in contemporary art

Shows us the limits of
representation and cognition

Gunnar Olson
"Abysmal: The
Critique of
Cartographic
Reason"

"The Politics of Place", 2002

"After the Fact",
Berlin Photo Festival 2005

1990s

BILDMUSEET

Post-modern generation of
artists in Sweden;
Photography becomes a
central medium in
contemporary art; much
larger presence of women
artists

Peters Map

Documentary in an expanded sense

Documentary
photography/image

Alfredo Jaar: Emergencia 2000

photojournalism

critical realism

Alfredo
Jaar

Allan
Sekula

Photography
interested in urban signage, advertising

1980s

"What is the relationship in size
between Sweden and Brazil (in
reality and Mercator projection)?"

editing

artist books/
publications

"Perhaps we lost sight of
how the local/regional and
global histories of
colonialism and imperialism
are entangled"; the global
was prioritised

**FOTOGRAFISKA
MUSEET i Moderna
museet**

"Form is inseparable from content"

photographer

curatorial thinking

filmmaker

MEDIUMS

INDEX

in parallel: freelance critic (literature,
philosophy, political theory)

1970s

home of
Afterimage
Magazine

"INDEX, Contemporary Swedish
Photography", 1992

Arrival of post-modernist
thought, post-structuralism
explosion of photographic
practices

Looking at atlases
as a child

Hans
Hedberg

**VISUAL STUDIES WORKSHOP
'ALMA MATER' at ROCHESTER NY**

co-curator

Nathan
Lyons

**Subjective timeline of
artistic practice and theory**

Born in Northern Sweden
but spent a lot of time in Liberia,
West Africa as a child

Jan-Erik Lundström

curated "Inferno&Paradiso", 1990-2000

act of making public

period of
doing images

Producing Worlds: A Conversation with Jan-Erik Lundström
Curating, Writing, and Exhibition-Making

Edy Fung/Simina Neagu/Erik Sandberg: We were looking for previous interviews that you've done and the only one we managed to find was from before you started at Bildmuseet. We were wondering, is there a conscious choice behind this?

Jan-Erik Lundström: I guess I have not always been a public figure. In the sense of being the face of an institution has not been the most important element for me. It's been more to simply promote and disseminate information and focus on the work. My personal perspective in an interview has been less interesting than the work itself. And now that you ask, I understand that this is not conducive for smooth interviewing.

Moreover, you are correct. The interview is definitely not a format that I have actively explored. There's a fine anecdote—I was working on a project with the Swedish photographer Hans Gedda, in collaboration with a Swedish publisher who had the idea of publishing a monograph of his work and including both an interview with the photographer and a text of mine. I followed their advice, wrote my essay and conducted an interview. But I found it difficult to make a satisfactory

text out of the interview and ended up focusing more on the essay, even if also in dialogue with the artist. The interview format did not work out. The essay was fine. And, in fact, the book was never published. Maybe I've ignored the interview for that reason. It has not been the best tool in my toolbox. But now we're here doing an interview, so let's see how it goes!

EF/SN/ES: Your perception of interviews already provides a context for our first question. What do you think about the writings you have published and the exhibitions you have produced in terms of their capacity to advocate for art or the artist, and in terms of reach and legacy?

JEL: I like your use of the verb "advocate." That's an important element. A lot of the work one is doing in terms of curating and writing is advocating in the sense of forwarding, manifesting, empowering, or giving space.

Not to dispute the question, but I think of all of this as publishing—in that both an exhibition and the publication of texts is an act of making public. There are of course ways of addressing the exhibition as text, but this notion of

making public is important to me. Teaching is also a public space. That has always been important to me. Whether it's writing or curating, teaching or organizing a seminar, these different practices always have to do with making something public, with making work and ideas and knowledge available. And, thus, advocating.

EF/SN/ES: Since you have been active in both writing and in producing exhibitions, in what ways do you think these practices serve your intentions?

JEL: Writing comes first. That is, chronologically, it comes first in my life. My attempts at poetry in teenage years are refused. But I start working as a freelance writer in the late '70s—not with an exclusive focus on art or photography, but more as a critic or reviewer for daily newspapers. Curating was something I began exploring in the late '80s.

Moreover, text writing and criticism was a very vital platform in the '90s and a period when the critic was kind of a leading figure in the art world. In my work, this is a period, roughly around the late '80s and early '90s, when there was perhaps a stronger focus on texts. For example, the collaboration with the magazine *Bildtidningen*, which turned into *Index* as it shifted towards a broader perspective on theory and

visual culture. That coincided with a great development of photographic journals, with a good strong opening for theoretical perspectives internationally. I worked a lot in that circuit of both Swedish magazines, like *Bildtidningen/Index*, and international ones like *Katalog*, *Afterimage* or *European Photography*.

In that sense, comparing writing and curating, the '90s offered a particular arena for textual work. Moving towards the new millennium, greater traffic in curating evolved. Not that we were not curating in the '90s. This was obviously my job as director of the Fotografiska Museet; but there was a shift in the discourse from the textual to the curatorial.

EF/SN/ES: What do you think are the strengths and weaknesses of both approaches of writing and exhibition, in terms of what you try to achieve as a curator?

JEL: Curating and writing have been complementary practices for me. I've been able to work with thematic exhibitions and have them complemented by an exhibition catalogue, or the solo exhibition of an artist accompanied by a monograph that addresses that artist's work in a more extensive manner. Or working with theory in publications, testing its

practice in exhibitions. Sometimes, a topical exhibition could generate other textual works, like an anthology or some other independent publication. For me, working with exhibitions, texts, and publications, I have often enjoyed the privilege of being able to pursue them together—curating and writing—and make them complement, comment upon, and extend each other.

EF/SN/ES: This all seems to echo your text *Visualitet: om bild som bild, som tal, och som skrift* (Visuality: on the image as image, speech, and writing) where you describe how written language in itself has direct consequences for image use and image comprehension.

Visual discourses and visual practices shape the visual world that constitutes both the content and the object of these discourses. Can you elaborate more on 'complementary platforms' through your projects? How do the two mediums function independently and when they reinforce one another?

JEL: The 2008 Bucharest Biennale "Being Here: Mapping the Contemporary" is a gratifying example of the interplay that can happen between exhibitions and texts. It actually began with a small exhibition at Bildmuseet, part of the plan to produce exhibitions of visual culture at the museum. This modest exhibition explored different ways of making a world map. It was inspired by the work of the German cartographer Arno Peters, but also included numerous other examples of world maps.

After the first presentation of the exhibition at Bildmuseet, we developed a guide and a teacher's manual for libraries and schools in the region of Västerbotten, a pedagogical platform that addressed in particular students of junior or senior high school level. This then was the seed that eventually grew to become the third Bucharest Biennale, a large exhibition at seven venues with more than 30 artists—such as Mona Hatoum, Emma Kay, Maria Lantz, Armin Linke, Yoko Ono, and Katarina Pirak-Sikku—exploring a cartographic theme. The Biennale also had a reader consisting of two publications, one focused on the exhibition and one with more contextual contributions, including texts of Gunnar Olsson, Achille Mbembe, Brian Holmes, Marina Gržinić and more.

This exhibition then went through three extensive revisions for other presentations: first for two venues in Sweden, and then for two venues in Colombia. Parallel to the Bucharest Biennale project, that engagement with cartography also meant working on a special issue of the magazine *Glänta* (no. 3–4, 2002) dedicated to maps

and for which I wrote the essay "Ett Pappersark, en planet och det kartografiska begäret" (A sheet of paper, a planet, and the cartographic desire). It does not always work out so beautifully; but I have tried to explore this sort of parallel work with curating and writing, hoping that they can inform, support, enrich, and sometimes also battle with or critique each other.

EF/SN/ES: Rather than giving interpretations of participating artists' works, your texts in the exhibition catalogues were distinct pieces of literature; they generated dialogues through which traditional approaches to practices and disciplines were rethought.

JEL: We often think of texts and exhibitions as two different mediums with distinct and differentiated properties. Certainly, there are things that are more productively managed or articulated in one medium than another. For instance, we think that theory is the toil of the text, and practice is the toil of the exhibition. But in juxtaposing these two mediums, there is a wide range of possible outcomes. In some cases, an exhibition has the ability to process theory or theorize in an equally powerful but distinct manner from text. "Real Stories: Revisions in Documentary and Narrative" (1992) was an exhibition where the invited artists processed or

worked through theories of the new documentary genre in profound ways. At the same time, my contributing essay attempted to bring to bear a discourse of critical realism in relation not only to photography and art but also mass media society at large.

Similarly, the exhibition "Killing Me Softly" (2001), which began as part of the Tirana Biennale and then came to Bildmuseet, illuminated and articulated the topics of migration and the ongoing refugee crisis with such force and precision hardly achievable in reporting, journalism, or any textual work at that historical juncture. Your question reminds me that the exhibition can sometimes also be a form, a medium that pays attention to what we otherwise would have thought only textual work could address.

More pertinent to your question, however, is a project such as *EMERGENCIA*: a breath-taking installation by Alfredo Jaar. Here, the catalogue turned into a book for which 24 African authors were invited to write a piece on the brink of the new millennium. All texts were completely independent, and did not attempt at all to engage with the art work. Yet all generated an intense dialogue, a polyphony that still included and fertilized Jaar's installation.

Issues of Representation: Themes in Lundström's Curating

EF/SN/ES: You are known for having introduced new interpretations of photographic practice through your work, building a new space for different discourses that had not previously been represented in art spaces in Sweden, or indeed other Nordic countries. Let us trace this back to its source. We found some early photographic works of yours in the Visual Studies Workshop's collection in New York that you participated. How did your interest in the art of photography began?

JEL: Now, that is a long time ago! But if there is an alma mater in my work, it is the Visual Studies Workshop (VSW).

I was at that time more interested in photography and in becoming a photographer, rather than a curator, critic, theorist or historian. I went to the US to study photography and film at another educational institution in the same city, the Rochester Institute of Technology (RIT), at the time a huge school of photography. It had almost 1,000 photography students when I was studying there. This was just before the collapse of analog photography, when photography still was a labour-intensive profession and industry. Once in Rochester I encountered VSW, this other small cutting-edge institution where

I initially went to continue studying photography, with VSW's founder, Nathan Lyons, as the main teacher. VSW then turned out to be the place where I encountered critical thinking on photography, visual theory, and visual culture. Furthermore, cultural studies and its interweaving of art, media and politics, addressing issues such as critical realism and emergent documentary work—and much more.

VSW offered a master's program with a broad interdisciplinary focus, from photography to media arts to artists' bookmaking, performance, and theory. The master's program had a remarkably open format with a rich flow of seminars, lectures, intense workshops with visiting artists and theorists. VSW also had its own press and was the publishing house of the magazine *Afterimage*, which was at the time a leading journal of visual theory, photography theory, critical theory, art in the socio-political field, and much much more. I was very privileged to be able to both participate in all that was going on at VSW at the time and to get to know *Afterimage*.

My first text on photography, I think, was written for and published in *Afterimage*, a review of Swedish photography [Notes on Swedish Photography, 1987]. So VSW

was a very important encounter for me. Those photos that you miraculously were able to find, are a manifestation of my ambition then in trying to find my way into photographic discourse as an artist. I was interested in the representation of an urban field of communication, signage, and advertising, of a kind of verbal-visual discourse in contemporary society. But this is, curiously, something I gradually left behind, as here—due partly to VSW— began my interest in curating, writing, and lecturing on photography and art. These practices took over and since then, I sometimes say, I've been doing everything else with photographs except for taking them myself.

EF/SN/ES: Representation seems to have played an important role in your work: In critical discussions about photography, as representation of marginalized subjects or ethnic groups, and the way the world is represented through maps both as a tool of power or resistance. What is your own interpretation of the word "representation"?

JEL: First of all, certainly the documentary genre in an expanded sense, has been a strong interest throughout my work, an interest linked to what I would call "critical realism." The documentary genre brings together two distinct but related issues of representation. On the one hand, it is the issue of representation as "political representation" or the "representation of politics" —in the sense of the representation of marginalized subjects, representation in relation to hierarchies of gender, ethnicity, race, and class. On the other hand, representation is connected to the "politics of representation," the epistemological or philosophical aspect of representation. Documentary photography, for example, is a meeting point of these dual aspects, and an arena of issues such as the question of who is speaking in a documentary image, who is speaking for whom, and who is addressing what. To me, it has always been a practice where these philosophical, epistemological, and political issues of representation are fleshed out or worked with; to deal with them becomes very acute and pressing when one is engaging with documentary work.

So, in a very fascinating way, I felt that with that interest in documentary photography and film I could link these two aspects of representation. It was a way of dealing with the politics of representation and subverting the hierarchies of power. How can you challenge the given orders of representation of gender, class, or subjects that have been made invisible in the existing orders or norms of representation, and at the same time weave those questions together with

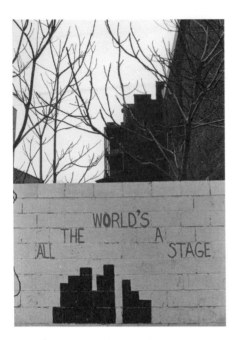

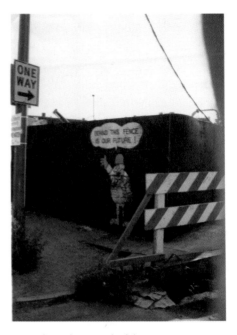

Jan-Erik Lundström, *All the World's a Stage*, 1983. Courtesy of the Visual Studies Workshop collection, Rochester, New York

Jan-Erik Lundström, *Behind the Fence is Our Future*, 1983. Courtesy of the Visual Studies Workshop collection, Rochester, New York

issues of how photographs or images represent the world? What is the path beyond our realization of the illusion of the objectivity of photography? How can we understand that the photograph is this realist modality per se, different from any hitherto existing medium when it was invented, but that at the same time photography also manifests the limits of representation? Our only way of accessing the world is through representations that are always limited or insufficient to our quest for knowledge. The birth of photography, as a language in a broader sense, brings us to that understanding.

EF/SN/ES: "Real Stories" highlighted issues of subjectivity and objectivity in documentary photography, contemplating the practice relative to "the capacity of all representations to subjugate and falsify." Following that, at the 2005 Berlin Photo Festival "After the Fact" emerged out of the need for alternative perspectives on the practice due to a recognition of the limits and deficiencies of the documentary genre that evolved in line with the shift to postmodernity. Would you agree that these are among the projects of yours that speak to these themes?

Jan-Erik Lundström, *Peace Through Strength*, 1983. Courtesy of the Visual Studies Workshop collection, Rochester, New York

JEL: The time of those VSW images was a very precise starting point for much of this. My work was largely influenced by the thinking on representation that was being developed in the '70s and '80s. The late '70s saw the first explosion of sharp thinking and writing in terms of photographic representation and theory. It was also a moment of important developments in structuralist and post-structuralist theory that dealt with related issues. In addition, the arrival of postmodernist thought highlighted and began to explore our entire visual culture, examining how our worldviews and the understanding of self and identity are formed in and by the world of images. There was a range of developments in debates, discussions and theories that linked with these issues, where documentary work ends up being a focal point through which to discuss and articulate many of these things. It was an encounter and discovery that influenced and had long-term impact on my work, as a curator but also as a theorist and critic of photography.

"Real Stories" was an exhibition curated for the Museum of Photographic Art in Odense, but also shown at Aines Konstmuseum in Tornio; Museum Folkwang in Essen; Norrköpings Konstmuseum in Norrköping, and Fotomuseum Winterthur as well. It also opened up an axis of issues that came to characterize some of the work later at Fotografiska Museet as well. So, it's an exhibition that explored a strong and fascinating development in the late '80s and early '90s of artistic practices which questioned the ruling documentary paradigm and realism in photography and art. In that quest, artists were developing new strategies to deal with such topics and issues. This was also linked to important theoretical developments at the time which, in parallel with this exhibition, I worked on introducing to the Swedish and Scandinavian context.

For example, "Real Stories" presented the first chapter of Allan Sekula's *Fish Story* (1995), which would became an iconic work in the field of documentary work, photographic practice, and contemporary art in general—a monumental piece in post-WWII art. The entire *Fish Story* project came to Moderna Museet a couple of years later. It's an immensely important work and I was very pleased to be able to first show the first chapter in "Real Stories." And then in collaboration with Witte de With [now Kunstinstituut Melly] in Rotterdam and Moderna Museet, the full work was produced, simultaneously with the book. The entire project premiered in Rotterdam and then went to Stockholm. And Sekula, as you know, also was a leading theorist and historian of photography, in parallel with his photographic, artistic work.

As said, the essay that I wrote for the exhibition "Real Stories" was an early attempt to think around the documentary image and critical realism at the time. More or less in parallel, I edited the anthology *Tankar om Fotografi* as a broader exploration of photographic theory. This was also the moment in which I started to work through notions of the gaze, the gendered or the classist gaze of the camera as structured by our heteropatriarchal, misogynist and classist society. I found photography, in

the sense of curatorial practice, artistic practices, and theoretical work, as a space where those issues could be explored. There was a richness at the time in the exploration of documentary practices and critical realist work to deal with those issues.

Certainly, my work here, my coming of age if you wish, was contemporaneous with a generation of artists that emerged in the '90s (sometimes referred to as the first postmodern generation in Scandinavia or Sweden), when photography became a dominant or central medium in contemporary art. It was also the first generation that had a much larger presence of female artists, like Annika Von Hausswolff, Ann-Sofi Sidén, Maria Miesenberger, Anneè Olofsson, Lotta Antonsson, who were all in one of the first exhibitions I did at Fotografiska, titled "Prospekt: Nyförvärv och visioner i 90-talet" (Prospect: New Acquisitions and Visions in the '90s, 1993). Classical documentary work did not dominate that generation, but rather photographic work exploring how the photograph depicts or produces the real—or even how fiction turns the wheels of fact—in the interfaces between image and world.

EF/SN/ES: We have touched on the subject of representation and documentary photography. Can you take us through how that also links

up with your work with maps and critical cartography? And how does that connect to the other types of representation you've already been talking about?

JEL: Photography introduces to the world a medium with these remarkable powers of realist representation. By compelling us to deal with these issues, I suggest that photography makes us aware of or illuminates some fundamental conditions of human cognition and perception. What I wanted to grapple with were the ways that we represent the world in the making of images. We build our world with images, hence with representations. But it then slowly became clear to me how maps were a parallel world, or rather discourse, incredibly complex and rich, of processes of representation. It's like in Magritte's painting: "This is not a pipe" (*La Trahison des images*). One used to say the map is not the territory, which of course is true in a certain way, but my engagement with maps has been a way of stating, or realizing, that, no, the map is the territory. The map produces the territory. The map generates the territory. Without the map, we wouldn't know the territory, at least not in the way that the map has taught us or created it for us.

Anyhow, maps—that's a childhood interest. I recall dark winter afternoons with my best friend looking through atlases and testing each other on knowing all the capitals of African nations. We were 10 or 11 years old. We also made fantasy maps of non-existing countries and worlds. However, the interest that brought maps into my professional practice came during a project with Alfredo Jaar, preparing his solo exhibition for Fotografiska Museet in 1994. For that exhibition, which would include a revised version of his 1989 work *Geography—War,* a work addressing the case of multinational companies' reckless dumping of toxic waste in Nigeria. In that work, Alfredo planned to use an edition of the German cartographer Arno Peters' world map. Both of us were immensely absorbed by this map, and we discussed making some kind of publication or project with it. That publication in the end instead became this wonderful book—artist's book, indeed—"A Hundred Times Nguyen" (1994), based on the work *Four Times Nguyen* that premiered in that exhibition, and eventually also ended up in Moderna Museet's collection. So, the map didn't become part of that project but has stayed with me ever since.

The encounter with the Peters' map taught me something about the nature and powers of representation in general, and of the nature and powers of particular mediums of representation, or systems of knowledge, such as maps. The map

Alfredo Jaar, *Geography=War*, 1989. Installation image from Jaar's solo exhibition in 1994 at Fotografiska Museet. Photo: Moderna Museet

is, perhaps similar to photography, something that we are inclined to perceive as an objective depiction. The world map is a mathematical/geometrical representation of the world, and we tend to think that mathematics is an objective medium, a neutral science. A mathematical proposal is either true or false. It doesn't have an ideological element. It is not a value statement. Now, the Arno Peters map is a map that represents all areas on the globe, in correct proportions; it is a so-called equal area projection. It also represents the precise relational north-south position of all the points on the globe, unlike for example the standard Mercator projection map that correctly represents directions but not proportionality, area, or relation. The encounter with the Peters map, understanding it in relation to other maps and to the history of mapmaking, meant realizing how the discipline of cartography is an ideologically charged enterprise, and a praxis related to power,

to discourses of power, to hierarchies. That each cartographic statement is also a statement of values, norms, hierarchies, and power. This is the starting point of the work in critical cartography.

EF/SN/ES: You mentioned earlier that the Arno Peters world map informed the critical ideas behind the Bucharest Biennale, "Being Here. Mapping the Contemporary," where you suggested the introduction of a "geographical or spatial turn in contemporary thought." Was the project with Alfredo Jaar the first time that you explored the subjects of critical cartography in relation to maps and mapping as a refiguring of the real?

JEL: My first curatorial intervention with maps, a couple of years before the Bucharest Biennale, was the small exhibition of world maps, titled "Peters' Projection." Before that, it was more like single works—such as Pia Arke's multi-material maps. I'm still shaken, stunned, by that discovery, that insight, of the history of mapmaking and the nature of maps, and how we have dealt so innocently with such a powerful medium. Everybody from my generation—and actually it is not that different today—have the Mercator map with them from school as the real—and correct—image of the world, the real world map. When one encounters Arno Peters' map it is, thus, a visual shock

since it looks so different, since we are so conditioned by the Mercator map, it looks *wrong*. But then one starts to understand the limitations of the Mercator map and how it promotes a particular worldview and particular qualities of the world, as opposed to other possible worldviews.

I used to have a favorite example to illustrate the differences between those two projection methods, Peters and Mercator. Since Sweden is relatively near the North Pole, it has a privileged status in the Mercator map as its projection method enlarges what is nearer to the poles, while reducing in size that which is nearer to the equator. Sweden and Brazil are thus a wonderful illustration of how the Mercator map and the Peters map functions. I used to ask what people think is the relation between Sweden and Brazil in size in lectures, or when we had pedagogical tours of the exhibition "Peters' Projektion: On the World Map" (2000). People would answer that Brazil is at least three, five, sometimes even seven times larger than Sweden. Well, on the Mercator map, the difference in area, in physical size, is about 3:1: i.e. Brazil is represented as being approximately three times the size of Sweden. In reality, Sweden fits twenty-one times into Brazil, which is also what the Arno Peters map shows. It means that the Mercator map in this case is 700% incorrect! Anyway, it gives us a sense that the discipline

Mona Hatoum, *Bukhara (maroon)*, 2008, carpet. Photo: Bucharest Biennale 3

of cartography is such a rich, diverse and multifaceted tool for generating knowledge, for producing worlds, and that it deserves to be paid attention from that perspective.

However, when it comes to cartography, there was also another later source of knowledge and inspiration for me who I think is important to mention and is far too little recognized. And that is the Swedish geographer Gunnar Olsso— who in his academic career was mostly active at the University of Chicago—and especially his book *Abysmal: A Critique*

of Cartographic Reason (2007). It's an extraordinary book that maps out mapmaking as a central way of knowing the world in human culture. Olsson calls it a critique of cartographic reason and explicitly relates it to Kant's three critiques. For Olsson, the critique of cartographic reason is the fourth and missing element in Kant's critique—pure reason, practical reason, and judgement. Olsson was an important source for me and that book *Abysmal: A Critique of Cartographic Reason* is, moreover, in a remarkable way, a history of art as well, because it deals a lot with how

maps appear in artists' work. Or rather, it looks at art works as maps. It writes the history and nature of cartographic reason through the history and practice of artistic expression.

EF/SN/ES: We appreciate that you brought in this reference to Kant. It feels like a critique of the Enlightenment, that it's also very tied to colonial expansion. A lot of these practices that you look at, thinking about the relationship between documentary photography or filmmaking, to anthropology or ethnography and cartography, they're practices that are somehow implicated in an imperialist, colonial history of cataloguing and indexing the world. But you're also looking back at those histories and it feels like you're changing the narrative. Was there an intention, perhaps from the beginning, to repair some of these histories?

JEL: Noam Chomsky has said that his work has two simple objectives: one is to know the world and the other is to change the world. And he adds, that knowing enables changing. His work with linguistics, philosophy and cognitive science falls perhaps more in the first category. While his work with politics, power, with the history of war and conflict, with media, with the US empire, recently also with climate change, etc, is perhaps more of the second—to

uncover injustice and inequality to make change possible. Translating Chomsky into Swedish and reviewing his work, he is an influence in regard to your notion of changing the narrative. I could not claim a conscious premeditated effort to repair colonial history and its aftermath—or rather its continuation— into the present and the future. But to find those other histories, narratives, it has certainly been a nexus of attention, concern, and engagement throughout my work, from different angles and perspectives, in different disciplines— from the colonial Eurocentric structure of the art world itself, the asymmetries of power, photography as a tool for the conquest of the Other, Scandinavia's colonial history, etc. In all this, there is not a neutral stance. And in that sense, your idea of repair and also revision seems reasonable.

Your question makes me recall a funny scene from this morning. I was looking for which shirt to put on in my temporary drawer—temporary because I'm in between homes, where shirts and T-shirts now are together. And on top this morning happened to be two T-shirts: one was Meschac Gaba's T-shirt: "Fund the Museum of Contemporary African Art in Sweden," which he did in 1999 for the exhibition "Mirror's Edge" at Bildmuseet. Next to it, a T-shirt by Carola Grahn which reads "Elsa Laula for President." It was made

Synnøve Persen, *Tricolour*, 2017, installation view at "Čájet ivnni: Vuostálastte, Čuožžil, Ovddit" (Show Me Colour: Resist, Stand Up, Advocate, 2017), curated by Jan-Erik Lundström for Sámi Dáiddaguovddaš, touring to Kunsthall Trondheim, shown above. The exhibition included projects by Synnøve Persen and Geir Tore Holm; performances by Elina Waage Mikalsen, Marita Isobel Solberg, Anders Sunna, Suohpanterror; and pop-up T-shirt store by Sámi Girl Gang. Synnøve Persen's installation was shown again at documenta 13 after its presentation in Trondheim. Photo: Arne Skaug Olsen © Synnøve Persen / Bildupphovsrätt 2021

for "Show Me Color: Resist, Stand Up, Advocate," a project in Trondheim in 2017, where Grahn worked together with Silje Fingenschou Thoresen under the name of Sámi Girl Gang, creating a small T-shirt collection. Elsa Laula was a Sámi activist in the early 1900s and it was she who organized the first Sámi national conference in 1917 in Trondheim. Those two T-shirts seem to illustrate and summarize your question quite nicely, spelling out that panorama of the internal colonial history of Scandinavia

and the colonial history at large of imperialism and the colonizing of the other continents. I fully support what you suggested, that photography is one central element there. In many ways, photography as a medium has a parallel history with colonialism. When one engages with the history of photography, the properties of the medium and its development in human society, one encounters its profound entanglement with colonialism. In a very concrete manner, the discipline of

anthropology is born to support and accompany the imperial and colonial narrative. As such, the expansion of the empires and the colonization of the globe by the Western powers work hand in hand with the development of anthropological photography. Also, the landscape genre, in photography in particular, is charged by its extensive use in the territorial expansion of the Western powers. This also brings us back to cartography, as a medium and discourse put to work in the colonial project. All of which also brings us full cycle to the issues of representation that we discussed earlier. And so on.

This intersection of colonial history and photography is also something I have explored and worked with as a lecturer. At Konstfack (University of Arts, Crafts and Design, Stockholm) for example where for many years I have been giving a series of recurring lectures. They've evolved over the years, but one recurring lecture has aimed at mapping this parallel history of colonialism/imperialism, the Enlightenment heritage, with the development of genres such as anthropological photography, the use of photography in the human sciences, and the overall development of the representation of the Other; not only in the sense of the native, the indigenous, but also the other in the sense of the woman or the criminal or the insane.

That aspect of colonial photography is something that brings us back to how the Western bourgeois subject develops counter images or builds that network of representations of the Other as a way to confirm itself, its identity, its presence at the seat of power, as the one who represents but never is represented. *A subject that is always behind the camera.* In any case, I think you're right in observing that there are some interests in repairing, intervening, revising the given narratives, to give visibility, space and capacity to unheard voices, to unseen or untold narratives.

EF/SN/ES: "A subject that is always behind the camera"—we have definitely come across that in your writing, in your introduction text for "Real Stories." It seems that the exhibition was less about repairing the gap between the subject(s) in front of and behind the camera than acknowledging the truth surrounding the subject matter: the representation of the subject within the narrative of journalism and within documentary constitute two separate entities. Moreover, the vulnerability of the subject, who may not have access to other narratives to represent them, might also be the reason why the subject is the target/feature in the first place.

JEL: There's no neutral decision in whatever we decide to do. Curating

is to say yes to something, and thus no to other things. It is always to bring forth a worldview. I have engaged with intervening in the colonial world of art as well, trying to bring in other narratives that rectify or redress or open up to other voices than majority culture or the mainstream. For example, the engagement with Nordic colonialism. Since the Scandinavian countries have long lived with the fantasy that there is no history of colonialism in our countries and that colonialism was practiced somewhere else. There's an interventionist and perhaps also a redemptive element to that. Or repair, which was the word you used. I've never had any doubt that my work in that sense is advocacy, to take a stand or a position, to be *pro* something.

The work at Bildmuseet was an attempt at simply expanding the discourse in contemporary art around representation, and to diversify the discourse. It began at Fotografiska Museet and continued at Bildmuseet. As an intervention in what I then saw as a very limited worldview and a very limited representation that existed in the art field and the art world at the time. There are a lot of projects, curated projects that are explicitly dealing with sort of colonial aspects, colonial history, or the colonial present. Looking for example at exhibitions such as "Pierre Bourdieu—Images of Algeria" (2004), "Adriana

Varejão" (2000), or "Jean-François Boclé: I Did Not Discover America" (2008), all of which were shown in Bildmuseet.

But back to what you were asking about, "Real Stories." Yes, it offers visibility and space, I imagine. Importantly, however, it was a rather multifaceted exhibition, a variety of thematics, many modalities of expression—the staged tableaux of Condé Beveridge [Carole Condé and Karl Beveridge] dealing with workers' rights, the visual-verbal essay of Sekula, the cabinets of history by Vid Ingelevics, or Jamelie Hassan's deconstruction of Lévi-Strauss...

EF/SN/ES: In the anecdote with the two T-shirts, you actually revealed quite a lot about how, when dealing with global colonial history—and let's say a more regional or localized history, or looking at one's backyard— we're looking at the kind of global entanglement, a double focus that rarely happens within one person's curatorial practice. Sometimes that creates a bit of an either-or situation, where in fact these histories are always entangled. Other curators might separate, or recently there's more a tendency to look at the regional, the local, and global in the same way, but it seems it wasn't always like that.

JEL: That is absolutely important. If we don't pay attention to our backyard, the

attention to the world doesn't make any sense. Since if we don't link those narratives or themes or try to place them on the same level, we will neither be relevant nor convincing.

I can recall that there was a moment when it felt like we lost sight of the local in the globalist movement, a moment when we lost touch with the circles of influence or interaction, how things spread from the local to the global and back. For me, it was just somehow natural or intrinsic to my work to try, to keep more fires burning, to make connections and create a dialogue. The first larger exhibition I curated was the Northern Photographic Triennial in Oulo, Finland in 1991. Titled "At the Borders," it featured Sámi artists Lena Stenberg and Marja Helander as well as Latin American photographers, among some six or seven exhibitions altogether. I think that more than a theoretical or methodological argument, I arrived at what you're pointing to, out of a combination of intuition and conviction. But then intuition is maybe simply a form of highly compressed knowledge. Maybe one could even link it to a biographical aspect. One is inevitably grounded in one's early experiences in many ways. I was born in northern Sweden and spent a good part of my childhood in Liberia in West Africa and I imagine that combinatory geography offers a sort of worldview or horizon of

experience that has deeply affected my professional practice.

One exhibition that, in a different way from my work in curating contemporary art, brings out the issue of colonial history and colonial representation was titled "Människor i Norr" (People of the North) (2005), a successful exhibition in the sense that it toured for several years and was shown at quite a few venues such as Historiska Museet in Stockholm and in Norway and Finland but was produced for and premiered at Bildmuseet. It's a selection of 12 portfolios, one could say, of photographers. Well, there were one or two portfolios that were drawings, and the rest was photography. Portfolios, a selection of images, that were all depicting the Sámi, selected from the first century of photography, from about 1850 to 1920. Three of the photographers were themselves Sámi, like Nils Thomasson (1880–1975), representing their own culture. While the other image-makers were anthropologists, there was a nomad school teacher, who photographed his pupils, travellers, and professional photographers, such as Lotten von Düben (1828–1915) and Borg Mesch (1869–1956).

In my work, this was an important project that tried to bring home how the processes of representation were involved in the making of colonial

history. For while they are a source of historical knowledge of how colonial history evolved, images and photographs have also been agents in that history. Curiously, this exhibition did not receive any reviews. Critics did not know how to categorize it or tackle it, because it was not an art exhibition but neither was it put together by a historical museum. This project also brought to the fore the centrality of the right to your own representation, your own voice, your own image.

EF/SN/ES: You approached your exhibitions in response to all kinds of asymmetrical relationships evident in both the politics of representation and the representation of politics, sometimes working outside the traditional selection of visual artists if needed. How do you make use of your role as curator to draw the art world's attention to unheard voices and, as you mentioned, to urgent situations they have overlooked?

JEL: When an exhibition targets underrepresented topics, I don't see this as its only task. Instead, things come together, and the "unheard" or the "urgency" is not the sole content or raison d'être for an exhibition. Actually, I think that it very often might simply begin with artists who do brilliant, strong, relevant, good, challenging, and "hardcore work." And then this art is

dealing with topics in need of attention or belongs to underrepresented parts of the art world. And, of course, it is all inseparable: form and content, context and work. Just as showcasing the indigenous artist is not the same as addressing colonialism. Moreover, for anything to become really good and have any impact, there have to be things that set you on fire... Nevertheless, the work I've encountered among artists from an "underrepresented background" —think of "underrepresented" here as an abbreviation which links to many things—has been the refractory work, the work that is on fire, the work that touches on the most important issues of our day. It's really in and through the processes of empowerment, advocacy, lending space, and agency, broadly of listening and looking, that I've encountered the most brilliant, beautiful and important works of art.

EF/SN/ES: You have walked us through a lot of examples of group exhibitions that you curated. In terms of creating an impact in art or visual discourses, how do you see the distinction between solo exhibitions focusing in depth on the practice of artists from an underrepresented background and group exhibitions mediating a theme or narrative that needs attention?

JEL: Solo exhibitions and thematic group exhibitions are the two most useful

tools in the curatorial toolbox. The solo
exhibition has the potential to engage
in committed and deeper dialogue
with single artists and their work, and
the group exhibition has the capacity to
explore a topic or a thematic, allowing
and making the different perspectives,
ideas, and insights of different artists
meet, collide, interact and clash. They are
two formats or tools to put to use, albeit
with many variables. In the context of a
specific institution, those two kinds of
exhibitions need to be thought through
as part of making a program that is
worked out in terms of chemistry, a
sense of balance, and flow of its output;
how the exhibitions together build the
totality of what the institution views as
important to offer. It's not necessarily
that one has a great big plan from the
beginning, but each project leads to
the next; maybe one project needs a
sequel, a companion, or maybe it calls
for something completely different, a
counter-project. Often, of course, this
plays out on a combinatory palette,
such as at Bildmuseet, where several
simultaneous exhibitions would interact
and converse—or not—with each other.

Institution Building: Photographic Practice and Contemporary Art in Sweden

EF/SN/ES: As the director and curator of an institution, how do you perceive the shift in your role between curating and institution-building, and the necessity of that shift?

JEL: I think it's a realization that when you're given the privileged position not only of curating but directing an institution, it of course immediately brings additional questions about how we operate within that larger ensemble of the institution. What sort of things are made possible by the way we operate as a whole, what kind of practices, focuses and profiles can be built into the walls, so to speak? How do we build the identity of institutions? In fact, change has been a constant in my work with institutions. All institutions I have entered have been in a position where change, even dramatic change, was called for. Surely, I realize that the sense of a need for change always comes to some extent from my own judgement and interests. And change, then, in terms of institutions, does not only concern output. Institutional change involves team building, empowering your co-workers, your infrastructure of production, capacity and competence building, developing all elements such as communication, pedagogy, and more.

An aspect of curating in the context of institutions and institution building is that it kind of de-dramatizes the single exhibition because you can focus on how the puzzle is built and what puzzle is built through all the pieces that you put there. The institution—perhaps especially the smaller institution—offers special liberty in that sense, freedom to test limits and borders and thus expand one's range.

EF/SN/ES: In the context of working with your team and capacity building within the institution, what is your take on collaborations in your work? Here we are thinking of several curators you have worked with: Katarina Pierre from Bildmuseet who was in-house curator of "Democracy's Images: Photography and Visual Art" and "Isaac Julien—True North," among other projects; Johan Sjöström, your co-curator for Bucharest Biennale 3; as well as Brita Täljedal from Bildmuseet who curated "Britta Marakatt-Labba: Kosmos."

JEL: At Bildmuseet, collaboration in terms of curating could perhaps be called organic. We developed a structure that was implemented rather quickly I think—Bildmuseet did not curate or produce that many of its own

exhibitions before my arrival—where more or less every exhibition would have a responsible curator from my extraordinary team of curators: Katarina Pierre and Brita Täljedal when I arrived, adding Johan Sjöström and Anna-Lena Lundmark, for some years. Also, our museum educator, Lisa Lundström (no relation) curated several exhibitions. This team were employed as "intendenter" (curators), and had initially little or no experience in curating. So, this was a practice evolved more or less collectively as we built a structure for Bildmuseet to initiate, curate and produce exhibitions. As director, I was involved in each and every exhibition—more in some, less in others. But there is co-curation in just about every project. We were a team. The curators also evolved their existing focuses, interests, profiles. Katarina Pierre, for example, had had some previous experience with and contacts in South Africa, and thus was an in-house curator for "Democracy's Images," and some other projects with South Africa. The cartographic thematic of the Bucharest Biennale had its roots in Bildmuseet's map projects. But the biennale developed in conversations between myself and Johan Sjöström, who also proposed many of the artists. Altogether, the curatorial team and work structure developed at Bildmuseet was an absolute key to Bildmuseet's capacity to do all that it did—in quality and in terms of output.

EF/SN/ES: Could you say something about the reception and experience of your work not only on the part of the public but also of the critics who, as you mentioned, were so important in the '90s art world but did not know how to tackle your work "out of the box," as you were curating? Also, how was your work received by the institutions that you were in?

JEL: Bildmuseet is perhaps the most distinct example, so I will start there. It was a very clear and visible process, in how the work at Bildmuseet was received, disseminated, and recognized—in what I take to be the three senses of your question.

In a very corporeal and explicit sense, we worked diligently for and were able to build and engage an audience for contemporary art—not any contemporary art, but contemporary art socially, politically, and existentially engaged, representing global diversity, in what became Bildmuseet's profile. I don't recall the exact numbers but I believe that initially Bildmuseet had something like 30,000 to 40,000 visitors annually; and we then had years when we reached 100,000 to 120,000 visitors, quite extraordinary numbers, especially given the size of the city of Umeå. Our number of visitors per year exceeded on occasion the number of people that lived in the city. So, that was very, very

rewarding. One year we also eclipsed, in a friendly neighborly competition, the number of visitors to the nearby football stadium. Even though at the time they had the best female football team in Europe (led by the legendary Marta from Brazil). However, sometimes there were fans of the football team not able to afford the entrance fee that would come to our café and enjoy the game from the café window. We were unsure how to count their presence in the comparison game... Anyhow, audience building was a very, very important element of our work and of course incredibly rewarding to see how one could attract people to our profile, to our output, as we did.

Secondly, perhaps equally importantly, and connected, the work we did at Bildmuseet did engage the attention of media and critics. Bildmuseet ended up being reviewed quite extensively also by national newspapers and media—which just then was slowly being developed—in the online websites of reviews and critique. Bildmuseet was reviewed and critiqued locally, nationally, and even internationally. This was a real discursive change. Both in terms of content, of the issues our profile at Bildmuseet brought to the fore, and also that prior to this, art criticism was immensely Stockholm-centered with occasional excursions to maybe Malmö and Gothenburg. Outside of the capital, critics paid attention to the Venice Biennale or documenta.

Period. The fact that Bildmuseet was able to gather this media attention was a powerful and rewarding experience. Of course, the criticism was not only positive. Bildmuseet did receive its good share of the neoliberal/conservative/populist spectrum that would pull out the utterly brainless and meaningless PC [political correctness] labelling weapon. Or very particular peculiar critical somersaults such as critics accusing Sámi artists of not being Sámi enough in their art.

Thirdly, I would claim that Bildmuseet, looking at the years around the turn of the millennium, did influence or contribute to changing the overall discourse on contemporary art in Sweden or Scandinavia towards a more global and diverse scene. The simplest way to phrase this is that Bildmuseet pioneered in terms of looking outside of a Western context and mainstream, in terms of both the artists we worked with and in terms of thematics. Our exhibitions addressed and involved art from outside of the then completely dominant West European/North American scene—exploring an extended geography, working with Africa, Latin America, the Arab world, beyond the ex-Iron Curtain, you name it. However, it was also about the domestic blind spots, such as minorities, the indigenous, the Sámi, and the Nordic colonial context. And, when that discursive

shift then happened, when the profile of Bildmuseet was recognized, the scene could never return to the same Eurocentrism, at least not of the same magnitude.

An anecdotal but concrete example is that from the late 1990s Bildmuseet involved itself in a range of projects working with contemporary African art, artists, and institutions. When Moderna Museet had their "Africa Remix" (2006) exhibition, their first-ever exhibition including African artists, a touring exhibition from Belgium, a majority of the artists had already been presented at projects organized by Bildmuseet.

Bildmuseet was founded in 1981. When I joined there in 1998, I received a very strong mandate from the board of Bildmuseet to develop, reorganize and reprofile the institution. I also came to the institution and encountered a team that was very supportive, engaged, and committed to working for change—plus I also could recruit additional key staff. My reception within that institution was very positive. And everyone worked immensely hard to develop that space, to realize change.

EF/SN/ES: You just mentioned Moderna Museet where you worked as chefsintendent (director) for 8 years in the '90s. What did Moderna Museet look like during the time when you

directed the Fotografiska Museet department within Moderna Museet?

JEL: Fotografiska Museet was a very different kind of story—an institutionally unclear structure that had not found a productive way forward. Like you said, it was a museum within a museum, the full name was "Fotografiska Museet i Moderna Museet." The term Fotografiska Museet had been in use since it was founded as a department of Moderna Museet, but with the ambition of becoming an independent museum. In addition, Fotografiska Museet was the only department within Moderna Museet; there was Fotografiska and then everything else was simply Moderna Museet. In other words, photography was the only medium singled out as separate, organized by itself.

As such, Fotografiska Museet was an island within Moderna Museet, isolated and inactive. My task, explicitly and implicitly when I joined as the director of this department/museum was to lift photography into a contemporary space, find paths to make the discourse of photography and photographic practices part of the entire Moderna Museet, integrating it into the art scene at large. The department also suffered from a kind of inferiority complex, a common feature of photographic institutions or individuals in the field of art at the time. Moreover, it was a

challenge to arrive in this department, being its youngest member and working to change things around. But with time, we evolved into a stronger team, and a department less isolated within its institution. Eventually, however after my departure, the department Fotografiska Museet was dissolved, leaving instead a medium-specific curator.

CL: One of the reasons we asked was because your program for Fotografiska Museet differed a lot from both Moderna Museet and most of Stockholm at the time, which was still very focused on the Western art world and traditional notions of art. As you said it wasn't until 2006, almost fifty years since its opening, that Moderna Museet exhibited artists from the African continent. We were interested if there was some sort of institutional resistance towards your work from inside Moderna Museet?

JEL: I feel that the exhibitions I did during those years were well received by the art world at large in Stockholm and Sweden. This was also the case in the institution itself on the whole—with some initial exceptions from some colleagues and co-workers. But so it is, always, with change. The narratives are quite complex and convoluted, however. "Real Stories" as an exhibition had quite an impact. It seemed to speak to a moment when these issues of critical realism, new

documentary practices, ideas of the "gaze," and the hierarchies enacted in representation, focused and gathered attention and interest. But when Allan Sekula's work came to Stockholm in 1995, with "Fish Story"—from which a chapter was included in "Real Stories"—the scene was simply not ready for it. It was not seen, hardly even by cutting-edge critics. Sekula was received as a mediocre photographer that liked to include a lot of boring text in his exhibitions. It was disappointing to witness a work that I thought was mind-blowing being treated in such a way. However, "Fish Story" and Allan Sekula's work in general was really slow in garnering the recognition it deserved—internationally, also. It really took until Okwui Enwezor showed it in documenta 11 (2002) for it to begin to acquire its now iconic status.

At Fotografiska Museet, I also curated a large solo show with Pia Arke. A major retrospective exhibition of her work, right after "Fish Story." She's a Danish Greenlandic artist, an absolute pioneer in the Scandinavian context in addressing indigenous issues, Scandinavian colonial history, speaking with and developing a post-colonial voice, disclosing or overturning the codes of representation. She was also a writing artist and produced a little pamphlet that now is a pivotal text from the '90s, called Ethno-aesthetics. Nonetheless, to my recollection,

Charlotte Nilsen, *Nøkkelen ligger under matta*, 2009. Installation at Tromsø Kunstforening in "Being a Part: 30 Years of Sámi Art." Artists in the show: Jon Ole Andersen, Victoria Andersson, Monica L. Edmondson, Per Enoksson, Aage Gaup, Bente Geving, Marja Helander, Geir Tore Holm, Annelise Josefsen, Aslaug Juliussen, Per Isak Juuso, Iver Jåks, Inger Blix Kvammen, Britta Marakatt Labba, Unn Kristin Laberg, Hans Ragnar Mathisen, Joar Nango, Charlotte Nilsen, Synnøve Persen, Jorma Puranen, Alf Salo, Lena Stenberg, Katarina Pirak Sikku, Morten Torgersrud, Nils Aslak Valkeapää, Liselotte Wajstedt. Photo: Tromsø Kunstforening

her exhibition did not gather much attention or recognition at the time.

Another element, which you are kind of suggesting, is that the profile of Fotografiska, during my years, was interpreted as a break with both the dominant schools of photography in Sweden at the time as well as with the established focus of Fotografiska

Museet itself. In retrospect, I think that's only partially correct. I didn't then, nor do I now, see my work as in absolute discontinuity with prior work. But it was largely interpreted as such.

However, the work that I advocated— performative, postmodern, or politically engaged photography—and global, looking beyond Western Europe and the

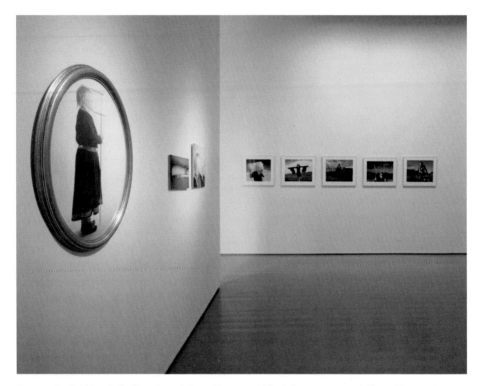

Katarina Pirak Sikku, *Dollet (Grasp)*, 2006; Jorma Puranen, *Alpha & Omega-series*, 1996. Photo: Tromsø Kunstforening © Katarina Pirak Sikku / Bildupphovsrätt 2021

USA—did not have many precedents. In terms of photography, that was one of those fractal points where the established line of conflict was between straight narrative documentary work and fine art photography; whereas I was interested in exploring other modalities—new documentary such as "Real Stories," or the "postmodern shift." You're right that there's something at stake there. The second exhibition I did at Fotografiska Museet, "Prospekt" (1993), was a large group exhibition but not really thematic. Rather, its ambition was to review and present a then-emerging generation of artists. "Lika Med," curated by Irene Berggren in 1991, together with "Prospekt," which it preceded, outlined a rupture, a break with existing practices, and gave hints of emerging ones. Fotograficentrum (The Photography Center) at the time was primarily a space for rather straightforward documentary photography, but then slowly evolved into INDEX—The Swedish Contemporary Art Foundation, after an exhibition of the same name that

Hans Hedberg and I curated in 1991, which then became a platform for an emerging postmodern generation.

EF/SN/ES: Can you tell us more about your work with the Sami Center for Contemporary Art and how that institution formed?

JEL: I had the privilege to be able to plan, develop, and realize the building of an entirely new center, with exhibition galleries, museum shop, archive and library for the Sami Center for Contemporary Art or SDG—from its name in Sámi: Sámi Dáiddaguovddaš. Founded in 1986 by the Sami Artist Union, which organizes Sámi visual artists in all the countries of Sápmi— Russia, Finland, Sweden and Norway— SDG is grounded in Sámi art and culture. Its purpose is to support and promote the work of contemporary Sámi artists, in the context of the geopolitics of Sápmi and Northern Fennoscandia, including the context of global indigenous issues as well. An institution also dedicated to the ever-evolving decolonial artistic practices.

So when I was offered the job as director, the funding partially existed for establishing this new space and reorganizing the institution as an independent art center while maintaining its focus on mediating and advocating Sámi art. It included

evolving a profiled exhibition program, collaborating with other art institutions and so forth. I initially worked for a three-year period during which the new center with magnificent new galleries was planned and built, opening shortly after my first period there ended. I also returned for another two-year-plus period continuing to build and expand the Sami Center. It is during this second period that what has come to be termed "the indigenous turn," more or less happens, and we collaborated with various national and international institutions including documenta 14. The work with SDG was a project of capacity building, of working towards cultural sovereignty, of building an institutional infrastructure—to function as a base and node for the work of Sámi and indigenous artists. And to open the doors also to collaborations with and the recognition and inclusion of Sámi artists within the national and international structures and scenes. Again, both discursive transformation and institution building.

EF/SN/ES: Today these questions of identity politics and representation are so fraught—who can tell somebody else's story? As curators, it is important to think about that. When you were at the Sami Center for Contemporary Art, SDG, what did those conversations look like and who were those conversations with? How did you, as a director and

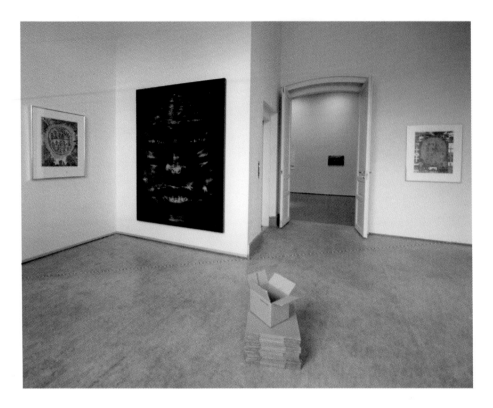

Hans Ragnar Mathisen, *Keviselie's drum* series; Joar Nango, *The Jubilee* (box, print on cardboard), 2009. Photo: Tromsø Kunstforening © Hans Ragnar Mathisen / Bildupphovsrätt 2021

curator, talk to others and the public about championing Sámi art and representing Sámi art through this cultural center?

JEL: My relationship with the board—of which a majority was Sámi artists and the other members of the Sámi community, so a 100% Sámi board, with the Sami Artist Union, and with the larger Sámi community was complex, fragile and charged. But actually, mostly supportive, constructive and, positive.

Now, I certainly had encounters where I was not accepted as a director of SDG, simply because I'm not Sámi. But equally positions—as for example that dominated my relationship with the board of SDG—recognizing the input and work needed to develop SDG into a professional contemporary art institution and the kind of practices necessary in order to mediate, exhibit and manifest the work of Sámi artists, working with me to achieve that. It was a challenging learning experience, in

the sense that I had to continuously update my own practice, perspective, and ideas on what I was doing. And how I was doing it.

One illuminating story is that at one point when the new space opened, and SDG now had this grand, beautiful and extraordinary exhibition space and art center. When this new space opened, it became necessary for me to always address the audience in Sami. It also became necessary to make sure that that institution in all its public output was fully fluent in Sami, which was more challenging than it might sound. Kárášjohka (Karasjok), and the neighboring municipality of Guovdageidnu (Kautokeino) were the only municipalities in the world with a majority Sámi population and a majority Sámi speaking population. Nonetheless, due to the devastating colonial policies of Norwegianization, or Swedification on the Swedish side of Sápmi, many Sámi do not speak their mother tongue, lose it as they grow up, or never learn it at all. I had Sámi people as my co-workers, but not all were fully fluent in Sámi. So, to continue to build and establish this institution, it was essential to develop language practices. Part of this was that, to be credible and to really work towards Sámi cultural sovereignty, I personally, as a director, had to develop the skills, for example, to be able to give an opening speech in Sámi. Now I

didn't become at all fluent, far from it; I had good translators helping me, but at least that—the simple public address—I learned to manage.

In the larger scheme of things, I imagine I could rely upon some credibility from my long-term involvement with indigenous artists. But at the same time, there are the very real issues of precisely cultural sovereignty, capacity building. There are the nested problems of essentialist identity politics and real intercultural exchange, the traps of a lame practice of inclusion and recognition, blocking real change, and more. And the asymmetries of power. I would not claim any closure, or any ultimate resolution, only to be able to listen, rethink, and revise, as one moves on.

EF/SN/ES: The news about the Nordic pavilion becoming the Sami pavilion for the 2022 Venice Biennale is exciting. How do you see this decision? How do you relate to it?

JEL: That's a complicated question. I am happy on behalf of the three brilliant Sámi artists that I'm sure will develop a great project in the pavilion, but I am skeptical about the curatorial—and symbolic—gesture of making it a "Sámi Pavilion," I do read it, still, as a kind of colonial gesture, surely benevolent but paternalistic, and it communicates no

clear or solid sense of empowerment or of addressing, again, the asymmetries that persist. I'm eager to see how the actual exhibition will turn out, but not convinced of the curatorial framing.

I cannot make any definite causal extrapolation of events like this from my involvement with Sámi art. But I do think that the work with building and establishing the Sami Center for Contemporary Art as an actor with an agency is at least one of the pieces in the puzzle, for example influencing or enabling, in a kind of low intensity manner, "the indigenous turn," or the "decolonial moment." In developing a Sámi institution, there is a process involving recognition of the impact of indigenous cultural production on the majority culture. It is not the goal but a tangential outcome. The goal is to build capacity and agency from within the Sámi community. I have obviously been active, so to speak, on both sides, from the positions of Fotografiska Museet, Bildmuseet, various independent projects, working with "white," institutions, to the Sami Center, where I am involved in developing an indigenous institution. In any case, all of that piecemeal work, I believe, does pave the way for changes in the mainstream, also—you know, as the waterdrop erodes the stone. In Sweden we have seen it recently not only in the visual arts, but also in film, literature, music and theatre.

But the issues of recognition and inclusion are complicated, thorny, and nested processes. I am thinking of documenta 14. That edition did give serious consideration to quite a number of indigenous artists, not that it colored—pardon the cheap pun—the entire exhibition as such, but it was an important element in documenta 14. The Sami Center for Contemporary Art was a partner or collaborator in documenta's selection of artists in attaining knowledge of the Sámi art scene, even though recognition or credit was slight. Not so important or even surprising perhaps, but it illustrates the complexities of recognition and/or empowerment. I think one such contradictory example from documenta 14, is the participation of three Sámi artists that were members of Mázejoavku, the Sámi Artist Group, an important and pioneering Sámi artist collective that existed for a few years in the late '70s and early '80s. Since then, almost all artists from the group have continued with successful individual careers and several from the group are among the most influential and important Sámi artists. Three of them were invited to documenta 14, where they were presented as the Sámi Artist Group, although only three out of seven were featured and the exhibited works were largely from other contexts than the Sámi Artist Group. Not that this was incorrect, but there's

a slippage here that undermines the gesture of inclusion. I think that when we want to talk about these issues of representation, recognition, inclusion, these are important elements which we have to make sure to navigate with precision and care, and to know what we're doing.

EF/SN/ES: Your work as a curator and editor has touched on a variety of disciplines across the spectrum of visual art and visual culture. As such confronting issues of taxonomy and categorization is unavoidable. An audience will always interpret these subjects through the mediation of a curator or editor's language. With an awareness of the impact of words, how would you describe your approach to the organization of knowledge?

JEL: One way of working through these important issues that you raise, for me, has been through considering the uses of pronouns, where quite obviously the first-person pronoun is the most contested territory, just like how I myself have used "we," throughout our conversation in not always such a precise or balanced or transparent manner.

But a recent project that I've been engaged with is the development of a new Sámi museum in Tärnaby in Sweden. This is an initiative by local

Sámi—individuals and organizations. I think it's fair to say that it will really be the first Sámi Museum in Sweden, because it will be the first museum to shift the pronoun from the third person to the first person. This museum will be working with Sámi culture from a first-person perspective, "I," or "we." It's a museum by Sámi and for Sámi. The pronoun is a fine indicator of how we approach various contexts, of how to identify ourselves and our actions in various contexts, and of how we organize, categorize, include or exclude, lend space or appropriate as we proceed. Now, as for a Sámi museum there are of course existing institutions such as Ájtte, a place that really is doing a lot of good and important work. But the pronoun element is telling. Its full name is Ájtte, the Swedish Mountain and Sami Museum. So, it is a Swedish museum first, a Sámi museum second. Moreover, the name suggests that it is first a nature museum, and second a cultural museum of the Sámi. It wavers between the 3rd and the 1st person. It is a museum about, but not fully a museum of and for. As said, Ájtte is an important museum and a pioneering development in the Swedish museum landscape. But the new museum in Tärnaby, Aejlies, is being conceived, conceptualized, and organized fully as an indigenous museum grounded in decolonial practices, developing its intrinsic organization of knowledge,

evading or undoing Western museology and taxonomies.

I also like to think of *the museum as a verb*. The museum is not a noun. It's a place of doing, of activity, of actions. It's not a place of objects. I think of it as a way of undermining some of the norms and value structures—since the museum is also a child of coloniality-modernity, an Enlightenment project—the museum has evolved, including curating art and exhibition-making. When we depart from that narrative of property and possessions and objects, representing culture, and instead start to think of it as activities, actions, acts, where we engage in interpretations, evaluations, the production of meaning; it is there we can also deal with the established structures of categorizing and taxonomizing. Attention to the pronoun, to who is talking, who is doing, who is stating what for whom, and to whom, is all a part of it. How does that link to knowledge? Well, just as categorizing is a knowledge process, even if unequal and unsettling, so is the unmaking, the deconstructing, of taxonomies, categorizations, also knowledge processes. And the unmaking always includes a making, the deconstructing a constructing.

I guess I've been guilty of often suggesting or working with art as something that produces knowledge and art as a cognitive tool. It's not a simple issue or question, but there are many good reasons for looking at art in that way, to try to work with all elements of the human being, the cognitive, perceptual, and ethical faculties. Art concerns the entire being. Contrary to the Kantian system, we—here we go again—do not separate them, aesthetics involves all the faculties.

Since we're talking about curating and the exhibition medium, it is also experiential knowledge. it is embodied knowledge, multi-sensory knowledge, the exhibition attends to the entire human being. The knowledge that we are organizing in exhibitions is experiential knowledge, tactile, spatial, corporeal—which does not exclude cognitive—dependent on the encounter between the artwork and the viewer/reader/listener. That is when knowledge happens. The unexhibited artwork that has not reached a public cannot yet generate or organize knowledge or produce knowledge. This happens in the encounter between the artwork and the viewer.

EF/SN/ES: Could you give any examples of this type of knowledge in a work of art or curated project?

JEL: I associate it with a work by Willem Boshoff, a South African artist, called *Blind Alphabet*, that was only directly

accessible by those who could read braille. The non-braille reader and seeing person, could only access it through a person that could read braille. This blind person would then hold one of the sculptures in the exhibition—it was a project of sculptures in wood embodying various terms of shape or form or structure—and explaining how the work felt by touch. Only through a kind of ekphrasis, performed by a blind person could I attain this knowledge, experience the works, the sculptures, in that installation.

The topical group exhibition has maybe been the most important format to ground, investigate and then articulate such knowledge bodies or structures. How artworks generate experiences, meaning, cognition, knowledge on a particular topic.

One project that comes to mind is the exhibition "Politics of Place" (2002) that featured photography and film looking at space, landscape and land as charged with meaning, as contested territory, as having history and space and landscape relating to identity. That group exhibition was able to really embody and share experiences of such a broad and essential topic around land, landscape, space and place in remarkable ways through the work of the artists involved. Curating is not only what you call organizing knowledge.

Curating is not only the selection of the works. It's all the details until the exhibition is finally complete, because that knowledge that might then appear between the artwork and the viewer has much to do with the exhibition as a physical entity of order, structure, sequence, tone, density, cadence and so forth—all elements that conspire and collaborate in generating knowledge. Curating is all the things, from selecting the artworks to all those final touches to the exhibition, that define what possible experiences and the knowledge might occur in the encounter. The thematic group exhibition is a good example of what you're asking, of how to explore art as a mode of producing and organizing knowledge.

EF/SN/ES: What about the editorial approach?

JEL: It's quite similar to editorial work. I find a lot of similarities in doing things like an anthology or organizing a course with different lectures or a seminar or to use one particular example: that special issue of *Paletten*, which was a kind of introduction of postcolonial theory and art to Sweden. All these are of course curatorial projects in their own right, only with the outcome of a book, a magazine or a conference rather than an exhibition... an ensemble that explores a topic in multiple ways. One should maybe add that topic does not only

equal what the content means in some literal way. It always has to do with form and articulation. "Politics of place," is not about photographers working with the motif of the landscape. The topic is in the how, it's never only what is depicted, but how it is framed, represented, articulated, conceptualized. I don't mean to reduce knowledge to just a topic or a motif.

EF/SN/ES: Finally, would you like to name some artists, writers, colleagues or others that you feel has been influential on your practice?

JEL: Oh, this will be much much too limited a selection—many unnamed but not forgotten. I have already mentioned Nathan Lyons, director of the Visual Studies Workshop, who was influential both in terms of photographic practice and photographic theory. And whom I kept in touch with a bit over the years. Allan Sekula and art historian Abigail Solomon-Godeau were extremely important, in terms of the politics of the documentary, the politics of meaning, representation, feminist art history, overall cutting-edge thinking on history, theory and practice of photography and art. Both were long term collaborators and colleagues that visited Sweden and Scandinavia in multiple contexts and projects, and that I kept conversations going with for years.

W.J.T. Mitchell was another early and very formative acquaintance—decisive influence in terms of visual culture, visual theory, all thinking about images. I was privileged to invite him to Linköping University, while I was doing PhD studies in visual culture in the early '90s, where he worked on two chapters of his book *Picture Theory: Essays on Verbal and Visual Representation* (1994). He then invited me to Chicago, where I could enjoy both his, Homi K. Bhabha's, and the eminent photography historian Joel Snyder's work, lectures and conversations, including staying in Mitchell's house and watching Michael "Air" Jordan's final game before retiring to the kitchen together with those three colleagues. Bhabha, initially through Mitchell's journal *Critical Inquiry*, was my first real serious brush with postcolonial thinking. Moreover there was the philosopher Marina Gržinić, whom I got to know while guest lecturing in Antwerp (1998–2003), an absolutely cutting-edge theorist.

In the early '90s I met Mary Kelly who became an important liaison and influence, as an artist, theorist, and educator. In the '90s, colleagues in photographic institutions were also important contacts and relations— Urs Stahel, director of Fotomuseum Winterthur, Finn Thrane at Museet for Fotokunst and Ute Eskildsen, director of photography at Museum Folkwang

Essen for example. Hans Hedberg, who I met through teaching at Konstfack, and then collaborating extensively—and co-curating—with Fotograficentrum/INDEX and Bildtidningen/Index.

Meeting Okwui Enwezor in Johannesburg in early 1998 was, indeed, a formative and important relation. Influential in terms of curating, theory, writing, networking, and friendship. Equally, Okwui introduced me to Isaac Julien who—together with partner Mark Nash, curator, film theorist, etc.—became important and influential friends. And they were connected, through crucial and decisive relationships and collaborations, particularly with Irit Rogoff and Stuart Hall, to institutions such as Goldsmiths. Also, during this time there were formative encounters—through the South African projects at Bildmuseet developed with Katarina Pierre—with postcolonial theorist Achille Mbembe and artist Tracey Rose, each absolute pathbreakers in their work. This reminds me also of early encounters with artists Lena Stenberg and Marja Helander and their influence on understanding the dimensions of indigenous art, just as artists such as Alfredo Jaar and Carlos Capelán have been influential and important both as artists but also through ongoing conversations, as colleagues, friends, and thinkers.

This text is based on a series of conversations between Jan-Erik Lundström, Edy Fung, Simina Neagu, and Erik Sandberg during the autumn of 2020.

Contributors

Ulla Arnell (Stockholm) has an academic background in sociology, art history, art theory, and Nordic and comparative ethnology. Between 1966 and 2007 she was an employee at Riksutställningar (The Swedish Exhibition Agency) where her tasks included social research, managing sociological surveys of museums and exhibition visits, curating, and project management. Between 1988 and 1994 she was chair of InSEA European Regional Council and InSEA (International Society for Education through Art).

José Bedia (Havana/Miami) is an artist working with painting and installation with a special interest in cultural heritage and its influence on our daily lives. As a teenager, he joined the famous San Alejandro Academy in Havana. Bedia was part of a new generation of Cuban artists who came together around the school, and who had a great impact on the local art scene as well as on the global discourse of contemporary art as it developed in relation to the Havana biennales of the 1980s. Bedia left Cuba in 1990, settling initially in Mexico and subsequently, in 1993, in Miami, where he is currently based.

Carlos Capelán (Montevideo/Lund) is an artist residing in multiple countries (Sweden, Costa Rica, Norway, Spain, and Uruguay). Capelán's practice is an instance of what has been termed the "post-conceptual" artistic condition, working with idea structures while insisting on materiality and formal diversity. Workshops, conferences, talks, and teaching are all a significant part of his artistic practice, as (equally) are drawing, installation, painting, performance, objects, and writing.

Elisabet Haglund (Stockholm) was born in 1945 and grew up in the region of Scania in the south of Sweden. After studies in art history at Lund University, she continued her research for a PhD. Her dissertation on artist Victor Brauner (1903–1966) was presented at Lund University in 1978. For some years she wrote art criticism for the art magazine *Paletten*, among other publications. For short periods she worked at Nationalmuseum and Moderna Museet, and then later as the director of the Scheffler Palace, also referred to as the Haunted House, an institution with an important art collection belonging to Stockholm University. Haglund later served as the director of Borås Konstmuseum (Borås Art Museum) and Skissernas Museum (Museum of Artistic Process and Public Art) in Lund, making her one of few women in Sweden to lead a larger art institution. Writing remains at the core of Elisabet Haglund's practice. Her most recent publication is

Moln i konsten (Clouds in Art) and was published in 2020. Elisabet Haglund currently lives in Stockholm.

Ewa Kumlin (Paris) is the director of the Swedish Institute in Paris and cultural counsellor at the Swedish Embassy in France. From 2004 until 2017 she was the director of Svensk Form, the Swedish Design Society. Prior to these appointments, she ran her own cultural production company from 1991. Kumlin studied at the Royal College of Arts in Stockholm and after a few years with the foreign ministry became a fine art teacher. Kumlin has written articles for Swedish art and design magazines, and has published a book about her family story. Since 2017 she has been the chairwoman of the Royal Institute of Art in Stockholm.

Gunilla Lundahl (Stockholm) studied practical philosophy, art history and literature at Uppsala and Stockholm Universities. Her professional career since the 1960s has developed along three axes: editorial projects, exhibition projects, and educational projects. Her writings have appeared in publications such as *Dagstidningen Arbetaren*, *Paletten*, and *Utställningskritik*, among others. She was editor of *Svenska Slöjdföreningen / Svensk Form*, *Arkitekttidningen* (*AT*) and guest editor of *Arkitektur*. She has been a professor at various Swedish universities and

colleges such as Högskolan för design och konsthantverk (School of Design and Crafts) and Konstfack (University of Arts, Crafts and Design). She has produced and curated exhibitions and specific projects for institutions such as Riksutställningar, Moderna Museet and Konsthall C (Stockholm). Gunilla Lundahl has actively participated in various organizations such as Hyresgästföreningen (Tenants' Association), Kollektivhuset Marieberg (Collective House Marieberg) and Konstkritikersamfundet (Society of Art Critics).

Jan-Erik Lundström (Boden) is a curator, critic, and historian of contemporary art, visual culture, and photography. He is the former director of the Sami Center for Contemporary Art and former chief curator of Fotografiska Museet, Stockholm. From 1999 to 2011 he was the director of Bildmuseet. His latest curatorial projects include: "SÁMI Contemporary," "Surviving the Future," and "The Map: Critical Cartographies, Politics of Place and Society Must Be Defended" (1st Thessaloniki Biennial of Contemporary Art). He was the chief curator of Berlin Photography Festival (2005), and the artistic director of the 3rd Bucharest Biennale. He is the author and editor of many books, including *Thoughts on Photography*, *Contemporary Sami Art and Design*, and *Looking North: Representations*

of Sami in Visual Arts and Literature. Lundström has contributed to major publications such as *Horizons: Towards a Global Africa*, *The Oxford Companion to the Photograph*, and *The History of European Photography of the 20th Century.* He has been a guest professor at, among other institutions, Aalto University, Helsinki; HISK, Antwerpen/Gent; University of The Andes, Bogotá; and Oslo Art Academy.

Sissi Nilsson (Flen/Torekov) is a curator, art historian, and social anthropologist. Between 1985 and 2006 Sissi Nilsson was curator at Kulturhuset in Stockholm, before going on to work as a freelance curator (SnArt Production). She has edited numerous publications in relation to the exhibitions she has curated.

Joan Rom (Montbrió del Camp) is a sculptor. His works characteristically incorporate found materials such as rubber, glass, or wool. In the '80s and '90s, he showed his work in institutions such as Fundació Joan Miró (Barcelona), MACBA (Barcelona), and Kulturhuset (Stockholm). In 1998 he decided to interrupt his artistic activity to dedicate himself to teaching. He was a founding member of the SIEP collective and co-directed the magazine *Fenici*.

Patssi Valdez (Los Angeles) is a visual artist and a founding member of the art collective ASCO. Her artistic contributions in ASCO challenged the dominant narrative of the Chicano Movement and Chicano art to provide an expanded and contemporary vision of Chicana/o identity. In her visual art practice, which includes photography, painting, works on paper, and installation, Valdez works to capture what is going on for her internally and spatially. Her work has contributed to a Chicana feminist critique of the socioeconomic and sociopolitical reality of the Chicano community in the United States. Her artworks feature in major collections, including the Smithsonian American Art Museum, Washington D.C.; the Whitney Museum of American Art, New York; and the El Paso Museum of Art, Texas.

CuratorLab

Anna Mikaela Ekstrand (New York/Stockholm) is an art and design curator and writer interested in feminisms, decolonialism, and social movements. In 2015, she founded *Cultbytes*, an art and culture publication, and serves as its editor-in-chief. Currently she is co-curating The Immigrant Artist Biennial

Giulia Floris (Rome) is an independent cultural worker and researcher based in Rome. She is currently collaborating with VILLÆ in Tivoli as exhibition coordinator,

CASTRO in Rome as grants and public program manager, and ArtVerona art fair as curator for LAB1.

Vasco Forconi (Rome/Stockholm) is an independent curator, researcher, and editor. Since 2019 he has been Curatorial Assistant at CuratorLab.

Edy Fung (Hong Kong/Stockholm) is an artist and curator from Hong Kong, currently based between Stockholm and Derry. Her work focuses on the intersection of visual art, sound, and technology.

Julius Lehmann (Münster) is an art historian and historian with a focus on public art. From 2017 to 2020, he worked as research assistant at the Skulptur Projekte Archives (LWL-Museum für Kunst und Kultur, Münster).

Maria Lind (Stockholm/Moscow) is a curator, writer, and educator currently serving as the counsellor of culture at the Swedish embassy in Moscow. Since 2014 she has been a guest lecturer at CuratorLab.

Marc Navarro (Barcelona/Berlin) is a curator and writer based in Berlin. His recent curatorial projects includes "Gira tot gira" (Turn it all turns) at Fundació Joan Miró (Barcelona) and "Pastoral" by David Bestué at Centre d'Art la Panera (Lleida).

Simina Neagu (Bucharest/London) is a cultural worker, curator, and writer. She works at Iniva (Institute of International Visual Arts) on public programs, exhibitions, publishing projects, and residencies.

Hanna Nordell (Uppsala/Stockholm) is a curator, art historian, and cultural worker with a special interest in collaborative practices and transdisciplinary research, combining contemporary art, text, and academic research.

Marja Rautaharju (Helsinki) is a cultural worker and architect currently working in the Museum of Finnish Architecture.

Erik Sandberg (Stockholm) is an art historian, curator, and editor for the poetry and art magazine *Tydningen*.

Joanna Warsza (Berlin/Warsaw/ Stockholm) is the program director of CuratorLab at Konstfack and an interdependent curator, editor, and writer.

Acknowledgments

Many people have been involved in making this publication and CuratorLab's research from 2020 to 2021. As editors we would like to express our sincere gratitude to all the artists and contributors mentioned in the book. We would also like to thank a number of people and institutions who have generously given their time, and shared their ideas, memories, archival material, and images with us: Stefan Alenius; Jose Bedia Jr.; Karl-Olov Bergström; Loles Duran; Mårten Ehn; Märit Ehn; Mats Eriksson Dunér; Carles Fargas; Mónica Giron; Åke Hedström; Maria José Balcells; Centre de Documentació; Museu del Disseny de Barcelona (Design Museum of Barcelona); Konstfack bibliotek (Konstfack Library); Sara Lagergren, Arbetarrörelsens arkiv och bibliotek (The Swedish Labour Movement's Archives and Library); Rafael Lejtreger; Hans Ragnar Mathisen; Philippe Legros; Anna Lönnquist, Borås Konstmuseum (Borås Art Museum); Joseph Montaguc; Gerardo Mosquera; Kungliga biblioteket (National Library of Sweden); Alfredo Pernin; Eva Persson; Katarina Pierre; Ingalill Rydberg, Kulturhuset (Stockholm House of Culture); Arne Skaug Olsen; Stefan Ståhle (Dept. of Rights and Reproductions, Moderna Museet); Svensk Form (Swedish Society of Crafts and Design); Leif Magne Tangen, Tromsø Kunstforening (Tromsø Art Association); Anna Tellgren, Moderna Museets samling (Museum of Modern Art Collection); Johanna Törnros, Stockholms stadsarkiv (Stockholm City Archives); Diego Vidart; Olof Wallgren; and Margareta Zetterström.

Curating beyond the Mainstream:
The Practices of Carlos Capelán,
Elisabet Haglund, Gunilla Lundahl,
and Jan-Erik Lundström

Series
Konstfack Education Collection 4

Edited by CuratorLab 2020/21
Anna Mikaela Ekstrand, Giulia Floris,
Vasco Forconi, Edy Fung, Julius
Lehmann, Maria Lind, Marc Navarro,
Simina Neagu, Hanna Nordell, Marja
Rautaharju, Erik Sandberg, and Joanna
Warsza

Editorial guidance
Joanna Warsza and Maria Lind

Cover
"Himla skönt. Vad är egentligen
vackert?," curated by Gunilla Lundahl,
1989–90. Photo: Olof Wallgren/
Riksutställningar.

Every attempt has been made to contact
all image authors and originators for
permission to reproduce their work.
The publishers apologize for any errors
or omissions and ask rights holders
who feel they have not been properly
acknowledged to please contact
CuratorLab at Konstfack University of
Arts, Crafts, and Design, Stockholm.

Copy editing and proofreading
Ben Seymour

Graphic design
Józefina Chętko

Printing and binding
Zakład Poligraficzny SINDRUK
www.sindruk.pl

CURATORLAB
Curatorial course at Konstfack University

CuratorLab is a one-year international
curatorial course at Konstfack University
of Arts, Crafts, and Design in Stockholm
under the direction of Joanna Warsza
and guest lecturer Maria Lind. The
course explores radical approaches to
engagement and to the practice of
curating beyond exhibition making,
examining our interdependence
in relation to individual power and
creativity. An accompanying publication
results from the same research and
course: *Assuming Asymmetries:
Conversations on Curating Public Art
in the 1980s and 1990s*, also published
by Konstfack Collection and Sternberg
Press (ISBN 978-3-95679-612-8).

www.curatorlab.se

Published by

KONSTFACK
University of Arts, Crafts and Design

Konstfack
Lm Ericssons väg 14, 126 27 Stockholm, Sweden
www.konstfack.se

Sternberg Press

Sternberg Press
71–75 Shelton Street, London WC2H 9JQ
www.sternberg-press.com

ISBN 978-3-95679-613-5

Distributed by
The MIT Press, Art Data, Les presses du réel, and Idea Books